"In this beautiful and surprising offers a new history of the selfie. Moving past the stale denunciations of generational narcissism, this book delves back into history, covering portraiture and photography from Albrecht Dürer to Derek Jarman, all the way to Britney Spears. Rather than see the selfie as a sign of self-absorption, this engrossing volume understands the selfie as expressing a longing for a kind of self-transformation. Elegantly and stylishly written, this book is the best kind of cultural criticism, sweeping away the worn-out cliches of the familiar for the freshness and wonder of the truly new."

Jon Greenaway, author of *Capitalism: A Horror Story*

"*Narcissus in Bloom* is a fascinating alternative genealogy of our modern obsession with the photographic self-image. With characteristic heart and sensibility, Colquhoun examines the philosophical and art historical roots of narcissism. Mining his emancipatory potential and rescuing him from his liberal individualist sequestering, Narcissus is recast as the fraught, forlorn and fractured face of contemporary subjectivity. To bridge the impossible gap between how we see ourselves and how others see us, this is the paradoxical and panoptical status of the self portrait today that Colquhoun rivetingly gets to grips with. You'll never look at a selfie the same way again."

Isabel Millar, author of *The Psychoanalysis of Artificial Intelligence*

"In Matt Colquhoun we have one of our era's most interesting and incisive new thinkers. *Narcissus in Bloom* is a real achievement... it marks a return to a now lost tradition: big-picture cultural theorising that speaks to and illuminates present-day anxieties in unexpected ways, spoken in the vernacular of contemporary popular culture, of the likes of Richard Hoggart, Raymond Williams, Stuart Hall and more."

Dan Taylor, author of *Spinoza and the Politics of Freedom*

"Relating one's emotional self to those around us is at the very heart of Colquhoun's queer critical and political project. *Narcissus in Bloom* is ambitious, moving, inspirational and loving... a purposeful and universal work driven by the author's passion for photography."

Dr. Michael Waugh, Lecturer in Media, Communication and Cultural Studies, Newcastle University

NARCISSUS IN BLOOM

NARCISSUS IN BLOOM

An Alternative
History of the Selfie

Matt Colquhoun

Published by Repeater Books

An imprint of Watkins Media Ltd

Unit 11 Shepperton House

89-93 Shepperton Road

London

N1 3DF

United Kingdom

www.repeaterbooks.com

A Repeater Books paperback original 2023

1

Distributed in the United States by Random House, Inc., New York.

ISBN: 9781914420634

Ebook ISBN: 9781914420641

Printed and bound in the United Kingdom by TJ Books Limited

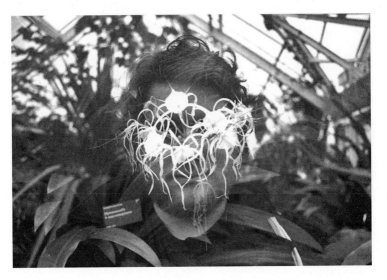

Matt Colquhoun, selfie, 2015.

Be
Undine towards the waters, moving back;
For me
A pool! Put off the soul you've got, oh, lack
Your human self immortal; take the watery track!

D.H. Lawrence

Contents

Introduction

1. Narcissus Unbound

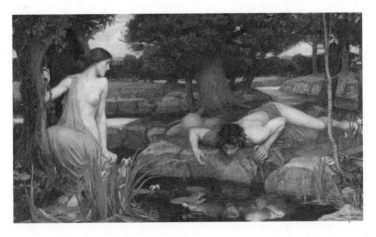

John Williams Waterhouse, Narcissus and Echo, 1903.

Narcissus blooms in spring. They are striking flowers that seem to grow anywhere. Their yellow and white trumpets sprout forth from gardens, roadsides, woods and fields. Around March, the supermarkets start to sell them in little bundles. Along with chocolate bunnies and hot cross buns, they are a sign that Easter is coming.

Better known by its common name, the daffodil, the scientific name for this complex genus of flower is nonetheless loaded with meaning. Many assume that *Narcissus* is named after the hunter from Greek mythology, for instance. In the classic telling of the tale, penned by the Roman poet Ovid in his *Metamorphoses*, Narcissus is a solitary hunter. Out in the

woods one day, he is inadvertently led to a pond by the nymph Echo, who is entranced by his beauty but has no voice of her own with which to entice him. Searching for this strange voice, which echoes his own but only in part, Narcissus stumbles upon his own reflection. But on seeing himself for the first time, and thereby finally coming to know himself, he is trapped in a morbid feedback loop between the self and its gaze.

Though caught in his own reflection, Narcissus is nonetheless still able to reflect on his newfound predicament. As beautiful as he may find himself to be, once he realises that he cannot escape his own gaze, he becomes distraught. With no way to pull himself free, he instead tears himself apart. (In other versions of the tale, he falls into his reflection and drowns.) After his death, the nymphs of spring mourn him and prepare a pyre on which to burn his remains. But when they return to collect his body from the water's edge, it has gone. "Instead of his corpse, they discovered a flower with a circle of white petals round a yellow centre".[1] A *Narcissus* grows in his place.

This was no coincidence. *Narcissus* the flower was already well-known at this time, suggesting that the man was named after it rather than the other way round. Indeed, the hunter is arguably a personification of the flower's cultural associations, just as Echo is the personification of her namesake as well.

These cultural associations are no doubt related to the flower's medicinal uses, of which it has many. Writing around the same time as Ovid, in the first century AD, the Roman philosopher and naturalist Pliny the Elder was among the first to use the plant's now-familiar Latin name in writing, discussing both its curative and toxic qualities in his exhaustive *Natural History*. It nonetheless appears that the question of which came first, flower or myth, was a common question in Pliny's time as well. First, he warns the reader that the flower

is poisonous — when ingested, it is "injurious to the stomach … and produces dull, heavy pains in the head" — before adding that it is presumably for this reason that *Narcissus* "has received its name, from 'narce,' and not from the youth Narcissus, mentioned in fable".[2]

The word "*narce*" remains in use today, becoming the prefix "narco-", as in narcotic, which is common to many Indo-European languages. Narcissus was certainly a man who became intoxicated with himself, but for the ancients, *narce* primarily referred to feelings of numbness and lethargy, and so the flower was thought of as a kind of sedative, associated with tiredness and sleep. This understanding has also survived into modernity. Narcolepsy, for example — literally meaning "an attack of numbness" — is the name for a chronic brain condition related to excessive daytime drowsiness and sudden lapses into unconsciousness. This may explain how the story was later rewritten, swapping Narcissus's violent suicide for a more peaceful and watery end, through which seduction and sedation become fatally entwined.

Despite being renowned for its toxicity, Pliny nonetheless goes on to describe *Narcissus* as a "very useful" flower.[3] When ground down and mixed with oil to create an ointment, he notes that it is an effective treatment for burns and sprains, as well as bruises, frostbite and earache. Though it might make you sick, it is also useful when "employed for the extraction of foreign substances from the body".[4] (Does the ego count?) The plant is also "good for tumours", he says — a usage mentioned by Hippocrates in his writings as well.[5] In fact, for Hippocrates, the application of *Narcissus* oil to a pessary was a recommended treatment for uterine tumours specifically, which has led to the flower being adopted as a symbol of hope by some women's cancer charities today.[6]

Between tumours and sleeping disorders, the flower is unsurprisingly also associated with death. The ancient Egyptians saw it as a tomb flower to be grown around burial sites, and daffodils are still a familiar sight in cemeteries around the world today. But it is also a symbol of life, birth and resurrection — lest we forget its symbolic ties to Easter in Christian countries, with Jesus's resurrection retaining Pagan echoes of seasonal new beginnings. In Iran, too, the flower is synonymous with celebrations of *Nowruz*, or the New Year, held on the spring equinox. This does not make the daffodil an emblem of contradiction, however, but of transformation. With death comes rebirth. The end of winter brings with it a new spring. *Narcissus*, as a perennial, will itself return year on year. As one of the first flowers to show itself after the deep sleep of winter, its droopy appearance is a fitting form for a lethargic creature newly awoken from a long hibernation.

Despite all this, today *Narcissus* tends to remind us of one thing: "narcissism". The hunter's fatal encounter with his own reflection becomes a cardinal sin, or a pathological affliction in the age of psychoanalysis. First coined by the German psychiatrist Paul Näcke in 1899, "narcissism" was, at that time, a term used to describe the "perversion" of autoeroticism, exemplified by a wide range of (largely innocuous) sexual behaviours, including homosexuality and masturbation. (Näcke would change his mind on this, later arguing explicitly that homosexuality, in particular, is natural rather than a mental illness, but he was sadly still well ahead of his time in doing so.)

Sigmund Freud's more popular reading of the term suggested that, whilst he could corroborate Näcke's initial clinical observations of sexual "misfunction", there was much more to narcissism than that. In his case studies, Freud found

that your average narcissist's self-obsession was not always vainglorious but also anxious. Indeed, Freud observed that certain traits described in Näcke's pathology were common to many mental disorders.

Freud initially surmised, then, that narcissism was not just an expression of self-love but of self-concern, and therefore often a product of great pain, since a person in pain so often "gives up his interest in the things of the external world, in so far as they do not concern his suffering".[7] Running contrary to Näcke's earlier analyses, this was not an opportunity for Freud to pathologize *morally* "deviant" behaviours but to recognise the obvious. Drawing on a marvellously succinct couplet from the comic poet Wilhelm Busch, writing about a toothache, Freud defines his broader view of the narcissist as follows:

Concentrated is his soul
In his molar's narrow hole

Though he retains Näcke's earlier view that narcissism is a deviation from nature — through which our sexual and self-preservative instincts are blocked inside the ego, rather than finding satisfaction in external subjects or objects, as they supposedly should — Freud recognises that this pathology can be acquired through trauma, rather than defining a person outright through a series of uncorrected personality traits.[8] This leads him to incorporate narcissism as a central component of many mental illnesses, from anorexia nervosa and hypochondria to the catch-all condition of dementia praecox (or, as it is now known, schizophrenia).

This understanding of narcissism has persisted in psychoanalytic circles ever since. Through a multitude of further studies and therapeutic developments, our

understanding of narcissism has been complexified further still and it is today known as something very difficult to treat. In his seminal 1971 study of the treatment of "narcissistic personality disorders", or NPDs, for instance, Heinz Kohut attempts to develop a systematic therapeutic programme for treating narcissism as a condition generally resistant to more readily used psychotherapeutic techniques. Though Kohut's diagnosis is more clinically robust, it is clear from his analyses that the core Freudian definition of narcissism remains intact. As Kohut explains, NPDs are often "the result of the psyche's inability to regulate self-esteem and to maintain it at normal levels".[9] He also notably emphasises the fact that narcissism runs the gamut of human emotional states, extending "from anxious grandiosity and excitement, on the one hand, to mild embarrassment and self-consciousness, or severe shame, hypochondria, and depression, on the other".[10]

We might expect (or at least hope) that this understanding of narcissism would elicit a certain degree of compassionate awareness in us today. As with anyone suffering from mental illness, though they may not adhere to our ideals of "normal" or "polite" social functioning, we should perhaps give some people the benefit of the doubt. Unfortunately, it seems no such awareness informs our popular use of the term. Contrary to its status as a complex and contentious diagnosis in therapeutic circles, popular culture frames narcissism as a form of sociopathy, since we more readily associate its stereotypical displays of self-centredness with a distinct lack of care for others.

Primarily, at least in popular culture, to be a narcissist is to have an excess of vanity or pride, particularly regarding one's looks, or to indulge in delusions of grandeur regarding one's social status. In the age of social media, it is supposedly

an increasingly common disorder. To be a narcissist is also to post too much online, or to "overshare" the minutiae of your daily existence, as if we are all narcissistic in assuming that the details of our lives warrant so much attention from others. (Those who abstain from social media are by no means exempt, as even cultivating an offline air of mystery is seen by some as an attempt to put oneself above the chattering masses — betraying an excess of concern for how one appears, precisely in not appearing.)

Like the flower from which it takes its name, this "disease" is everywhere today, rearing its heavy head in one-dimensional op-eds and essays on our civilisational discontent. However, though ubiquitous, and therefore surely innocuous, to be a narcissist is one of the worst things a person can be. From behind our computer screens, we repeatedly diagnose both the most deplorable and the most harmless members of society with narcissistic personality disorders. This understanding has only become more pronounced since the United States of America elected a narcissist-in-chief, in the form of Donald J. Trump, to the White House in 2016. Many now see narcissism as the defining pathology of our deluded age.

But we may already sense that there is another "narcissism" here — or, indeed, *multiple* narcissisms — lurking beneath the surface of our shallow reflections. Throughout recorded history, both flower and man have been associated with far more than vanity alone. Behind our popular understanding of the term is the narcissism of self-transformation, rebirth and self-overcoming. And yet, despite being routinely dramatized and depicted in cultures all around the world, any alternative reading of narcissism today is drowned out by a cottage industry of self-help books and works of folk-psychology — which have long had a place in bookstores but arguably became truly inescapable

over the last decade, following the advent of social media — not to mention the casual symptomologies paraded around by the media, which screams *ad nauseum* that narcissism is a plague we're all at risk of catching (if we haven't already). Move over, coronavirus! But to dismiss narcissism as modernity's fatal flaw, heralding the decline of civilisation, is to ignore the libidinal motor driving its spread — that is, our constant yearning for the new (be it new selves or new worlds).

This reading is already present in Ovid's metamorphic myth. Though his Narcissus loved himself to death — and any drive that culminates in one's own death is catnip to the Freudian psychoanalyst — his tale is still not a moral one. Narcissus isn't even described as having an overabundant ego. His beauty is *objectively* recognised by society around him, and it is a beauty that is notably *unrecognisable* to Narcissus himself. In being captured by his own reflection, his demise is narrated almost as an occupational hazard — something bound to happen to someone so impossibly beautiful. In fact, it was Narcissus's curse, foretold prior to his birth, that he would live a long and healthy life so long as he did not come to know himself. Others came to know him, but in sensing the dangers of his attractiveness, they kept out of his way. Narcissus, then, was not fawned over and worshipped like a modern-day supermodel; on the contrary, his beauty was so intense that few allowed themselves to get close to him. Loved by some from afar, he was nonetheless painfully alone. This may well explain his chosen profession as a solitary hunter. Unaware of his own beauty, and distinctly lacking anything we might call "self-knowledge", Narcissus did not understand why he was shunned by the world around him. But he was not so vain as to lash out at society's inattention; instead, he retreated into the wild and into nature.

Though his eventual death gave those who saw and loved him a reason to mourn, his death — a suicide — nonetheless brought him relief from suffering. And Narcissus *did* suffer. When he was eventually captured by his own reflection and experienced what it was like to both see himself and be seen, the torturous feedback loop was too much to bear. "I am in love, and see my loved one", he declares, "but that form which I see and love, I cannot reach, so far am I deluded by my love".[11] Whereas those around him can simply avoid or turn away from the object of their desires, no doubt fearful of their nascent obsessions with the man, Narcissus could not hope to separate himself from himself. He finds himself suspended between his simultaneous presence as a subject and as an object. Soon enough, any distinction between the two is dissolved completely. The self, the ego, becomes a barrier to be torn away.

It is for this reason that Narcissus begins to scratch and lash out at his body, now reflected before him. Though he may love his aquatic *imago*, he is tormented by its inaccessibility, and he soon wishes to shed the outer shell that has so suddenly forsaken his internal self. As Ovid writes:

In his grief, he tore away the upper portion of his tunic, and beat his bared breast with hands as white as marble. His breast flushed rosily where he struck it, just as apples often shine red in part, while part gleams whitely, or as grapes, ripening in variegated clusters, are tinged with purple. When Narcissus saw this reflected in the water … he could bear it no longer. As golden wax melts with gentle heat, as morning frosts are thawed by the warmth of the sun, so he was worn and wasted away with love, and slowly consumed by its hidden fire.[12]

It is surely no coincidence that Narcissus's decay is repeatedly compared to the seasonal transformations of nature in bloom. In the end, though the man may be dead, his desires suddenly seem more befitting of a flower anyway, and so Ovid's Narcissus quickly complicates the convenient view of the early psychoanalysts, who saw narcissism as a deviation from nature. The tale instead depicts nature's return or, at the very least, its transformation into a new phase of itself. The story of Narcissus, then, is not just a story of man's self-love but of nature's self-overcoming. It is the story of the seasons, and of nature's yearly cycle, which may start with pollination and germination, but which always ends with a holocaust of its own making, only to begin again.

2. The Selfie

Can narcissism ever be a positive affliction? Such a question may seem deeply contrarian today. There is already a "narcissism epidemic", or so we're told — we should arguably be doing more to stop its spread.[1] But rather than encourage or discourage narcissism in ourselves and others, perhaps the best way to counter our moral panics is to reinterpret this woeful pathology and consider its status as ubiquitous affliction from another angle. After all, are we not in pain? Is our contemporary self-concern not warranted? Are we not morbidly aware of and rightly worried about our own fragility — not just as postmodern hypochondriacs, but as part of a wider and endangered natural world? Our soul, no longer confined to a toothache, is instead captured by the entwined gazes of culture, nature and all of their inhabitants — ourselves included — who look back at us, beautiful and clearly in distress.

However, our contemporary narcissism is supposedly unconcerned with such grand questions. It is, instead, far more trivial. Take the selfie — that ubiquitous symbol of our contemporaneous self-obsession. We frequently hear stories of people, often tourists, doing incredibly reckless things for a good selfie, so focussed are they on their own presentation that they fall from high places to their deaths. The tabloid press loves to share statistics of these selfie deaths as a kind of sensational *schadenfreude*, or as a macabre measure of social Darwinism, gleefully telling us that more people die taking

selfies than from shark attacks, in a bizarre and perpetual retelling of Ovid's story as a social-media morality tale.[2]

It is easy for us to be cynical about this tendency. We are surely all aware of the ways that our societal self-concern is precisely encouraged by the media and capitalism more generally. By now, most of us know all too well how tech companies the world over take advantage of the data we upload about ourselves, turning it into a lucrative commodity. Our fears and our desires come to form a peculiar ouroboros, which the tabloid press, in particular, feeds upon for its own nefarious purposes: turning a profit by spreading the sickness, then proclaiming it can sell us the cure, in the form of a self-deprecating moral panic. But looking past the tabloid hysteria, even contemporary selfies — including those taken by some of the most shameless self-promotors — have often signalled a silent hope for self-transformation nonetheless.

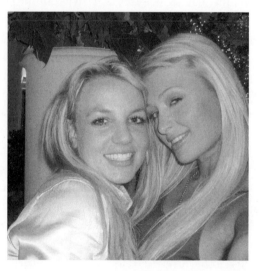

Britney Spears and Paris Hilton, untitled selfie, 2006.

Let us consider a particularly infamous example. In 2017, Paris Hilton tweeted two photographs of herself with Britney Spears. "11 years ago today, Me & Britney invented the selfie!" she announced to her millions of followers — and it wasn't long before objections to her claim started rolling in.[3] One Twitter user suggested, with photographic evidence, that it was not Spears and Hilton but Bill Nye the Science Guy who took the first selfie, whilst onboard an airplane in 1999. Actually, it was Kramer, argued another, in a 1995 episode of *Seinfeld*. No, it was Beatles guitarist George Harrison in 1966, tied with astronaut Buzz Aldrin, who incontrovertibly took the first selfie in outer space that same year. But wait, here's a mirror selfie taken by former US Secretary of State Colin Powell in the 1950s…

The examples were numerous, as were the methods used to make the self-portraits in question. Some photographed themselves reflected in mirrors, whilst others turned their cameras around on themselves with arms awkwardly outstretched. Some came prepared with tripods and shutter release cables, whilst others betrayed themselves as wielders of disposable cameras with a garish flash and a flat focal range. The only thing shared amongst these images was that their subjects were, in some way, famous. Some would only become famous later in life, like the young Colin Powell, whereas others were contemporary celebrities taking selfies with an admirer, as was Bill Nye; Buzz Aldrin's selfie showed him documenting the very event or achievement that made him famous in the first place — being on the moon.

After the argumentative Twitter users had had their fun, some journalists began investigating the history of the selfie for themselves. The *New York Times* went so far as to contact Mark Marino, a professor at the University of Southern

California who teaches a class on selfies, "to see if there was some set of criteria that could justify Ms. Hilton's claim".[4]

Marino argued that the first photographic self-portrait was, in fact, taken by Robert Cornelius, an American photographer, in 1839. Not only that, Cornelius's photograph — or, more accurately, his daguerreotype — is considered by some to be the oldest recorded photograph of a (then) living person. But despite having offered up his own suggestion to the growing list of alternatives, it was not Marino's intention to cynically burst Paris Hilton's bubble and deny her claim that her selfie was the first of its kind. Instead, Marino makes an interesting point: maybe Ms Hilton recognised that she and Ms Spears produced an image quite unlike anything shared previously. "She's not being ahistorical", Marino suggests, "she's saying 'we' did something with selfies that had not to that moment been done" before.[5]

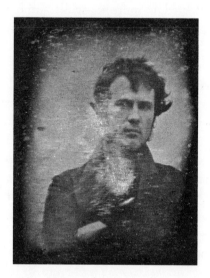

Robert Cornelius, self-portrait, 1839.

Marino seems to be arguing that many of those people replying with photographs of celebrity selfies probably wouldn't find them quite so interesting had Hilton and Spears not made the selfie such an explicitly postmodern cultural phenomenon, innately tied to the otherwise private lives of two very public individuals. Perhaps, in recognising our own fascination with these images, we came to understand how they were accessible to all of us, as if we looked at them with wonder and began to aspire to becoming such spectacles for ourselves.

This is significant for two reasons. Firstly, we might argue that the selfie phenomenon directly influenced the development of modern technology, even if only in a small way — without the Hilton-Spears selfie, would forward-facing cameras now be installed on our smart phones as standard? Secondly, the Hilton-Spears selfie also inaugurated a new era of celebrity. Although, at first glance, we may think there is nothing innately interesting about a picture of two of the most photographed women of the 2000s, it is precisely because they were so frequently and intrusively photographed by others that their selfie inaugurated a more autonomous gaze, providing a privately constructed window into the lives of two otherwise very public figures, seemingly for the first time.

When we consider what later happened to Britney Spears in particular, Marino's argument becomes even more interesting. This supposedly inaugural selfie was taken just a year or two prior to Britney's very public nervous breakdown. Hounded by the paparazzi, she was driven to shaving her own head — in the false hope that this would make her less recognisable or perhaps less worthy of the paparazzi's attention — and infamously attacked the persistent crowd of photographers

who still wouldn't leave her alone. Consistently scapegoated as crazy and violent by the very people who had driven her over the edge, a number of documentaries have more recently attempted to tell a more sympathetic version of her story, some fifteen years later, going into great detail about the lead up to and distressing aftermath of her mental collapse.[6]

The most horrifying outcome of Spears' mental breakdown was that she was placed under a controversial "conservatorship", through which her affairs and finances were strictly "managed" — some might say "exploited" — by her father and others. Despite having been driven to such violent distress by a complete lack of autonomy over her public image, the deeply unjust response was for Britney's general autonomy to be further restricted by a court of law. The #FreeBritney movement later developed, with many fans concerned about her sudden disappearance from the public eye, taking it upon themselves to advocate for her release from this draconian US law. Many, at first, believed the movement to be conspiratorial; fans began cataloguing, interpreting and decrypting "hidden messages" and strange behaviour broadcast on the singer's closely monitored Instagram page. In late 2021, however, the movement was vindicated. Britney's conservatorship was dropped, and in an emotional statement to her fans, she thanked them for seeing the signs and freeing her from an oppressive existence, which she communicated through her persistent exploration of the selfie as an easily accessible form of self-expression.

As the world has come to better understand Spears' ordeal, this original selfie, taken by two friends, starts to look like the tragic beginning of an otherwise avoidable breakdown. Here we find Britney Spears taking a selfie not just to be seen or to appease a fan, but to take control of her own image, affirming

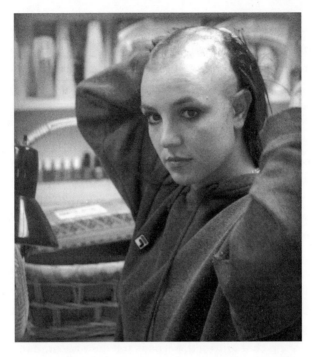

Britney Spears shaving her head, 16 February 2007.

the private self that the paparazzi were compulsively denying her. The selfie, then, was arguably her way of prefiguring or imaging a new version of herself — a new conception of *the* self no less.

What may sound like an overly generous reading of the postmodern selfie's peculiar beginnings is nonetheless corroborated by other media at the time. For instance, we might also consider Spears' 2007 single "Piece of Me", in which she explicitly admonishes a media industry that wants to rip chunks out of her. But the tension explored in the song can be read in two different ways — both positively and negatively. As Mark Fisher argued in his 2014 book, *Ghosts*

of My Life, the song encapsulates the fundamental disunity innate to any contemporary narcissistic capture: "you can either hear this as the moment when a commodity achieves self-consciousness, or when a human realises he or she has become a commodity".[7]

In this sense, Marino is right that Hilton was not being ahistorical. On the contrary, it was her critics who were removing the selfie in question from its historical context. The photo becomes a condensed visual representation of the pair's concerns, as sung about by Spears on "Piece of Me". Though, to many, it is a moment unworthy of any historical aggrandisement whatsoever, the Hilton-Spears selfie *does* signal a fundamental shift in how the self-portrait is understood and utilised, particularly by those in the public eye. It is a decisive moment, cutting out the role of tabloid vultures, and attempting to reveal and affirm a certain authenticity behind the incessantly twisted reality of dishonest headlines. It was a photograph that affirmed, perhaps for the first time in a long time, Spears' own gaze, and — just as significantly — that of a close friend and confidante, over the gaze of others. In this sense, it is an encounter with the self as significant and complicated as Narcissus's own.

3. Collective Narcissism

The politics of narcissism are not limited to crises of celebrity, of course. Though this popular pathology is, more often than not, applied to those who are famous and powerful — who command, rule and conquer, both in business and government, without fear of consequence or reprisal — what of the narcissism of the underrepresented and maligned? Though so many social critics ask these questions only to pathologize Instagram influencers, we might consider how marginalised communities have persistently struggled with scrutiny and self-knowledge in the modern world, and in the age of social media in particular.

We need only look to the recent ascension of the Black Lives Matter movement, one of the defining social justice movements of our age, which supposedly has narcissists on all sides. Articles and op-eds from around the world accuse both the movement's supporters and detractors of a "collective narcissism". Journalist Aaron Smale, for instance, writing about Black Lives Matter in an article for *Newsroom*, argues that all racism is a form of collective narcissism. "Narcissism in individuals is characterised by self-centredness, arrogance, seeing others as objects rather than equals, perceiving themselves as unique or special", he writes.[1] That an individual might see the error of their narcissistic ways is a hope confined to a lifetime, but when this pathology "grips a whole group of people and the institutions they have run for hundreds of years", Smale continues, "it isn't going to die overnight".[2]

This brand of self-concern has more recently led to an increase in populist scaremongering and conspiracy theories, such as the "Great Replacement". First popularised by the French far-right politician Renaud Camus in his 2011 book, *Le Grand Remplacement*, many have since argued that there is a global conspiracy by certain "elites" to gradually replace the populations of majority-white nation-states with immigrants from other countries, particularly those who follow the Islamic faith. Though widely ridiculed, it has since been referenced frequently by white nationalists the world over, even appearing in the manifestos of far-right terrorists who commit horrific acts of violence in overblown acts of "self-defence" or to draw further attention to their plight. As these sorts of beliefs snowball, we see an exponential rise in far-right nationalism and its affiliated groups.

According to Camus's central thesis, white people are framed as an endangered demographic in need of special protection, all thanks to the development of a collective narcissism. But already, we may see one of the problems with such a diagnosis: many opponents of Black Lives Matter *agree* with this critical characterisation, albeit from the other side, when it is used to describe the BLM movement itself. For those who parody the movement's call to action, by insisting that "all lives matter" or "blue lives matter", they dismiss the movement's eponymous motto as the perfect example of an excessive self-concern, which they feel as entitled to as anyone else.

This persistent "whataboutery", which does all it can to avoid any concrete analysis of the material conditions experienced by the vulnerable and truly marginalised, muddies the waters for many. Constituting a peculiar kind of opposition, it is a kind of rhetorical move that does not wholly *disagree* with the lived reality of oppression but rather *generalises* it to

include everyone else. The point argued isn't so much that black communities are *not* oppressed, in one form or another, but rather that everyone is *a little bit* oppressed, and so black communities should stop acting like they're all that special.

This form of argument is very common among right-wing commentators, who tend to mirror Smale's previously described position almost exactly. Whilst Smale disregards the narcissism of self-victimisation that comes *from above*, others suggest a similar narcissism from below is unlikely to die overnight either. Indeed, the problem with empowered black communities is that they just *love* to protest, many commentators argue cynically, and it is for this reason that they don't realise quite how good they've actually got it.

This view is epitomised by the black conservative author Shelby Steele, who has argued that watching "the antics of Black Lives Matter is like watching people literally aspiring to black victimization, longing for it as for a consummation".[3] In his particularly cynical framing, Black Lives Matter is a form of mass hysteria — or, perhaps more accurately, mass hypochondria. Contrary to the movement's protestations, Steele believes that black freedom is far more pervasive today than those who resent their more successful peers are willing to believe. "We blacks are, today, a free people", he writes. "It is as if freedom sneaked up and caught us by surprise".[4] That's not to say that racism has gone away, of course — Steele concedes that there will always be *some* racism in society — but that doesn't mean we need to bleach it clean with some grand revolutionary gesture. Like a mysterious rash, racism is an affliction that might always be with us, in one form or another, and so we mustn't worry ourselves too much about it. Like a hypochondriac making a nuisance of themselves at a hospital, to keep demanding treatment for some relatively

innocuous blemishes, Steele suggests, risks doing more harm than good. This is, it should go without saying, a deeply irresponsible position to take.

But there is a position that exists somewhere between these two mirrored perspectives. In fact, in a blogpost written for *The American Conservative*, the controversial traditionalist Rod Dreher — of all people — makes the implicit connection between Smale and Shelby's positions more explicit. As if sensing our impending collective doom, whether politically or existentially, he notes how all corners of society today rightly feel under threat. If white supremacists and garden-variety nationalists are all "collective narcissists", fearful that their way of life is under attack, then logic dictates that Black Lives Matter are too. However, Dreher does not borrow the phrase "collective narcissism" from Smale; he cites psychology researcher Agnieszka Golec de Zavala instead.

As head of the PrejudiceLab — "an interdisciplinary research team of social psychologists, neuropsychologists and psychophysiologists [who] work on topics related to collective narcissism, prejudice and intergroup conflicts" — Zavala's research around collective narcissism is promiscuous.[5] This is evidenced by an article summarising some of the research team's findings, which is illustrated with an image of English far-right nationalists but discusses Muslims and Argentinians as two groups who have been collectively (and, she seems to argue, disproportionately) offended by perceived insults made by individuals or relatively smaller groups. She describes these "collective narcissists" as follows:

Collective narcissists are not simply content to be members of a valuable group. They don't devote their energy to contributing to the group's betterment and value. Rather,

they engage in monitoring whether everybody around, particularly other groups, recognise and acknowledge the great value and special worth of their group. To be sure, collective narcissists demand privileged treatment, not equal rights. And the need for continuous external validation of the group's inflated image (a negative attribute) is what differentiates collective narcissists from those who simply hold positive feelings about their group.[6]

Though the overall framing of Zavala's argument may have been aiming for impartiality, the result is a now-familiar "both sides" rhetoric, and the conclusion Dreher draws from her team's research is predictable. Whilst the right's "collective narcissism" may well have fuelled wins for Brexit in the UK and Trump in the US, "it's only fair", Dreher says, that we "ask the same about black protesters and their critics", whom many on the right credit for establishing a new cultural (if not so explicitly party-political) "woke" hegemony. What social dysfunction is *their* narcissism responsible for? But rather than indulging in yet more whataboutery, Dreher goes on to make a surprisingly interesting point: perhaps the problem is with the diagnosis. In being so easily applicable to all sides, collective narcissism, he rightly notes, might just be "a way to dismiss a group's grievances by psychologizing them away".[7]

Narcissism, then, at the level of our pop-cultural understanding, is less a useful diagnosis than a blunt scalpel taken to societal scar tissue. But what is missed in Dreher's uncharacteristically centrist analysis is the key tension between conservatives and progressives. One wants change and the other does not. One group believes that things are fine just as they are, and are vainglorious in their political hegemony; the other believes that change must come, and it will risk

self-destruction to free itself from its given image, often brutally insisted upon by a set of broader ideological expectations. And with regards to the latter, who can blame them? Trapped by their own reflection, black communities in particular see themselves routinely frogmarched across television screens and murdered in police body-camera footage. Whereas other, more privileged members of society may look upon these images and find a way to distance themselves from criminals or anti-social persons who otherwise deserve whatever happens to them — whether that means being arrested, harassed, assaulted or even killed — black communities see themselves in perpetual distress and, like Narcissus, are tormented by their own reflection in the media. They may riotously lash out, and politicians may decry the resulting communal "self-harm", but such violence is a sure sign of a need for transformation otherwise denied. In this sense, retaining something of Dreher's provocation, perhaps Black Lives Matter *are* the real narcissists. But they are narcissists in a far more positive sense, and arguably in the only way that really matters.

It is nonetheless hard to imagine the Black Lives Matter movement picking Narcissus — whether the flower or the man — as a political emblem, but the adoption of such a signifier would not be unprecedented. In his 1952 book, *Black Skin, White Masks*, Frantz Fanon argues "that only a psychoanalytical interpretation of the black problem can lay bare the anomalies of affect that are responsible for the structure of the complex" of Freudian narcissism.[8] In this sense, the role of narcissism in black experiences, Fanon argues, is essential for understanding what he calls a "dual consciousness", in which the warring cultural perspectives of blackness and whiteness face off against each other in a society built on the back of class struggle — of which

racialised experiences are, of course, an integral part. As a sort of internalised narcissistic predicament, caught between a sense of oneself as both subject and object, which allows Fanon to painfully understand how he is seen by a white hegemony, he too comes to desire the tearing apart of the racialised *imago* before him. "I grasp my narcissism with both hands and I turn my back on the degradation of those who would make man a mere mechanism", he concludes.[9]

We can also observe how the daffodil has more recently become an emancipatory symbol for other political projects as well. It is the national symbol of Wales, for instance, with ties to the country's patron Saint David, whose national day falls close to the advent of spring. With all of the above in mind, we might draw broader connections between the daffodil's use as a national symbol, the country's blossoming independence movement and the rebirth of Welsh national culture more generally, since the Welsh language has been successfully brought back from the dead in recent decades, following centuries of imperial suppression under English rule.

But perhaps the least contentious use of Narcissus as a symbol of self-transformation comes from queer cultures. Many of the most seminal works of queer art and literature produced over the last two centuries, from Oscar Wilde's 1890 novel *The Picture of Dorian Gray* to James Bidgood's 1971 film *Pink Narcissus* and beyond, have a very different relationship to Ovid's classic tale than that of your average political commentator.

By reclaiming ownership of Näcke's offensive pathologizing — in Oscar Wilde's case, even pre-empting it — artistic explorations of homosexuality have often been as concerned with same-sex love as they have been with self-acceptance in a bigoted world, and the ways that sexual fantasy and

self-reflection are entwined together provide each of these works with a great psychological depth.

What is most notable about these examples is that, alongside their expressions of pain and self-critique, there is a clear striving for self-transformation, and not just a transformation of the individual self but of a queer community's wider social standing as well. In James Bidgood's *Pink Narcissus*, for example, the protagonist imagines himself as such — that is, *as a protagonist* — seemingly for the first time. As a sex worker left alone in a client's apartment, all too accustomed to servicing the needs and fantasies of others, he places himself centre-stage and enacts various fantasies of his own, in which he is cast in various lead roles. Power is not always in his hands — in one sequence, he is a slave to a Roman emperor — but he is nonetheless the focus of attention. (Submissiveness can, of course, be its own kind of sexual power play.) In every scene, the protagonist's fantasies do not define his self-obsession but give form to his dreams of self-overcoming. The pink Narcissus raises himself up in the world, as perhaps only he can.

However, it is more often the case today that even the self-transformations innate to queer culture have become clichéd, with TV shows like *Queer Eye* (formerly "for the straight guy") selling an emboldened and explicitly queer self-concern to everyday people who have lost touch with themselves in the midst of generalised capitalist drudgery or under the weight of what some British physicians have taken to calling (somewhat facetiously) "shit life syndrome".[10] To its credit, *Queer Eye* — at least in its rebooted Netflix incarnation — is often a tandem celebration of both the necessity of self-care and our human capacity for selflessness, but there are frequent moments where the transformations on display are less about self-actualisation for its own sake and more about

a group of outsiders offering palliative social care in the face of generalised injustice and inequality, coaching people in a very postmodern sense of middle-class taste, etiquette and propriety. It would be somewhat unfair to criticise a light-hearted Netflix show for failing to tackle the class war, of course, no matter how indicative it may be of some of society's ills more generally, but the show's success has allowed this culture of queer narcissism to breach the surface of the spring and be seen as a social good overall. There are many more radical examples for us to choose from, and we will explore some of these in due course.

For now, let it be known that this book will attempt to tell this story of positive self-transformation in two parts, with the latter half eventually exploring a queered history of photography and its radical relationship to the self in more detail. But first, to find out how we got here, we need only follow a trajectory laid out for us by art history. We have already discussed the selfie or self-portrait in this regard, and it is an alternative history of the self-portrait that this book hopes to provide. Though it shall nonetheless draw on some art-historically canonical figures, we shall see how this alternative view of narcissism lies before us in plain sight. The history of the self-portrait, in particular — so emblematic of our contemporary narcissism — harbours a radical (if contentious) narcissism of its own, emerging alongside our first conceptions of the individual, and providing a fertile ground upon which we have since explored the desire and discomfort of self-overcoming for many centuries.

In beginning with the painterly self-portrait, we will find that our modern concerns are not so recent. In fact, they have remained largely unchanged since the Renaissance. That period of history was itself a rebirth, of course, but we

have been reborn many times since then, and so, although we continue to moralise and criticise our propensity to gaze at our own reflections, in taking another look at our narcissistic selves, we may well save ourselves the repeated embarrassment of re-discovering, against all the odds, that we retain a capacity and desire for self-renewal.

This squandered potential is so often overlooked by our cultural commentators today, who publicly despair over our propensity for self-obsession. Critics turn their backs on a society tearing itself apart, taking it upon themselves to prepare the funeral pyre on which to lay the dreams of a dozen self-critical social movements and cultural events. But when they return, they too may bear witness to a transformation they did not expect. Not a death, but a new beginning, and the affirmation of a radical future that our past and present selves have been equally desperate to give form to.

Birth

4. Know Thyself

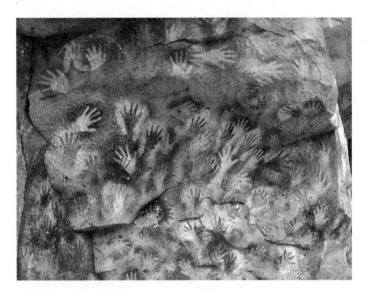

Hands at the Cuevas de las Manos upon Río Pinturas, near the town of Perito Moreno in Santa Cruz Province, Argentina. Picture taken by Mariano Cecowski in 2005. Sourced from Wikimedia.

Understood in the most general terms as representations of ourselves, self-portraits are among the oldest art there is. The *Cueva de las Manos* (or Cave of Hands) in Argentina, for instance, contains dozens of stencilled handprints that are over 10,000 years old, and artists have been using themselves as models or tools within their own paintings ever since. But would the owners of those hands in that Argentinian cave

33

recognise the selves depicted in the portraits of the modern era? Probably not. Though it is impossible to say how those early humans saw themselves culturally, there is arguably no "self" *as such* represented on those walls. What we see is a group, a collective, a community; we see a collection of hands and a sense of identity shared, with each handprint almost indistinguishable from any other. The "self" as depicted in the self-portraits of today is instead the expression of something quite different.

Philosophically speaking, the "self" is a relatively recent, abstract and heuristic concept for our experience of ourselves *as individuals*. Despite what we might now assume, we have not always thought of ourselves in this way — at least not so simply. In fact, the tension between our tandem understandings of the individual and the collective have been a problem within politics and philosophy since human civilisation first started writing such things down.

If we are to consider the function of the "self" in the self-portrait today, it may first be useful for us to address this disparity between the individual and the collective, if only so we can gain a better grasp on how our understanding of ourselves — of *the* self — has changed since we first began thinking about such things.

Consider the Delphic motto "know thyself" — one of the oldest and most enduring sentiments expressed within Western philosophical thought. Discussed repeatedly by Plato, in no less than six of his dialogues, it served as a cultural touchstone long before even he put it on the page. But back then, to "know thyself" typically meant to know yourself *in relation* to others. Self-knowledge does not (and cannot) come from nowhere. To assume otherwise is hubristic. To know thyself is, instead, inherently social; it is to know how others see us.

The ancient Greeks thus argued we always have something to learn from others and exploring these other knowledges is essential because, without some external measurement and dialogue between peers, it is possible to convince oneself of any number of untruths. To know thyself, then, is to *move away* from individuation as a source of ignorance.[1]

Has our sense of self shifted since this time? Do we understand our own capacity for — as well as the very acquisition of — self-knowledge in the same way? Today, we might argue that to know *the* self is to understand your individual essence more explicitly — that which makes you unique and different from those around you. This understanding is still social in that such a self-understanding is, again, always *relative* to one's understanding of others. But modern philosophy has also posited that self-knowledge can be acquired in complete isolation — indeed, the rise of Cartesian philosophy has made the self foundational to thought, as our sense of self is supposedly the only thing we can be certain of. From this vantage point, to "know thyself" today is to understand that individual "core", the unique self, constituted by what is left of ourselves when we strip back everything else that is otherwise shared.

For Plato, this was hardly a stable foundation on which to build a sense of self. Any argument to the contrary almost seems moot. After all, is there anything about ourselves that isn't, in one way or another, a product of our social relations? How is separating ourselves from the social even possible?

If our understanding of the self is always contingent upon our understanding of the world around us in this way, as Plato most famously suggests in his allegory of the cave, it seems that we now live in nested cave systems. Though we might arise from one and become enlightened with regard

to the material conditions that define our existence, there is a persistent doubt in the back of our minds that all of the world may be an illusion and that concrete knowledge as such is impossible. Thus, we tend to fall back on the apparent stability of the self regardless.

But the overarching and more inconvenient truth is that our sense of self is easily manipulated. Little of our lived experiences escapes the bounds of ideology. As a result, we may start to find ourselves adrift in a kind of chicken-egg scenario — which comes first, the individual or society? However we may feel about this predicament, it is clear to many that the idea of the individual is no conceptual life raft in these uncertain times, and our narcissism is surely a symptom of that fact. We look at ourselves so often because we are uncertain of who it is that is gazing back at us. The unsettling reality is that our conceptions of the self are as contingent as the material conditions that define its contours. In fact, "the individual" — as we understand it today — is itself a very recent concept. It was arguably invented to contend with the emergence of this very problem at the heart of the social. What makes this of interest to us, here and now, is that the modern conception of the individual self is only slightly younger than the self-portrait as an artform, both of which came into common parlance and practice towards the end of the Middle Ages.

5. I, Albrecht Dürer

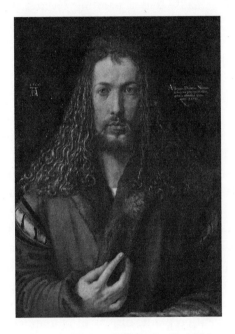

Albrecht Dürer, Self-Portrait, 1500.

The most famous artist to explore and visually conceptualise the self at this time was undoubtedly Albrecht Dürer, who painted some of the most notable self-portraits of the 1500s. Though there were self-portraits before his, no other artist produced so many. The art critic and historian John Berger went so far as to declare Dürer "the first painter to be obsessed by his own image".[1]

At the dawn of the sixteenth century, Dürer painted what remains one of his best-known works — a portrait of himself as an immensely handsome and notably Christ-like young man. "I, Albrecht Dürer of Nuremberg, painted myself thus, with undying colour, at the age of twenty-eight", a Latin inscription on the canvas reads. It is a painting layered with unsubtle symbolism and amusing strokes of self-aggrandisement. Not only does Dürer look like a now-classic (and notably European) depiction of Jesus Christ, his initials — a stylised "AD" — double up as both his signature and an allusion to the calendric label for those years following Christ's birth: "Anno Domini". Latin for "in the year of our lord", it is unclear who "our lord" is supposed to be — Jesus or Dürer himself.

Looking at this portrait today, we might expect Dürer's self-image to be deemed sacrilegious, and most modern appraisals of the painting often do mock it for the artist's exuberant pride in himself. It may have even reflected Dürer's hyperinflated sense of his own abilities as a master painter, as if he was on a par with God regarding the beauty of his artistic creations. But contemporary audiences seemed to agree with him. In the early 1500s, people flocked from far and wide to see Dürer's self-portrait. In fact, the painting proved so popular that, after his death, it went on public display in Nuremberg's town hall — the town in which Dürer was born, lived and eventually died. By that time, people were as obsessed with the man as they were with his image. Art historian James Hall notes that Dürer's likeness, and particularly his iconic curls, were so famous that, after his death, "his admirers exhumed his body to take casts of his face and hands, and cut lockets of hair".[2]

However, beyond these (somewhat macabre) tales of early celebrity, John Berger proposes another, far more interesting reading of the artist's self-obsessed oeuvre. He compares

Dürer's Christ-like image to an earlier self-portrait painted in 1498, in which the artist looks no less regal but perhaps a little more anxious, facing side-on rather than gazing defiantly outwards, like a young debutante nervously entering society for the first time.[3] Berger suggests that there is "perhaps a slight over-emphasis on his being dressed up", as if "the portrait half-confesses that Dürer is dressing up for a part, that he aspires to a new role". Having recently travelled to Italy to see the latest trends in Venetian painting, self-portraiture in particular, and having heard the latest ideas shared by Italy's art critics and theorists, Dürer no doubt "came to realise for the first time how independent-minded and socially honoured painters could be".[4]

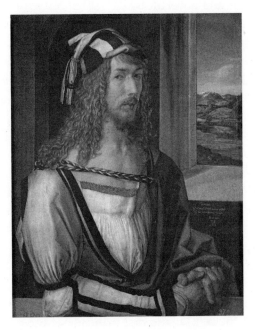

Albrecht Dürer, Self-Portrait, 1498.

Contrary to our modern interpretations of Dürer's pride, Berger wonders if the young artist wasn't so much a *prima donna* but instead the first person to depict a new kind of self. He argues that modern viewers give too much credence to their "many complacent assumptions of continuity between his time and ours"; we should instead be humbler and acknowledge that understanding "Dürer historically is not the same thing as recognising his own experience".[5] Indeed, to understand Dürer's experience in actuality is surely impossible for us today. That he saw himself as a new kind of European, a new kind of man, a new kind of self, is not hyperbole. Dürer was present at the start of a radical new era, when the philosophical concepts we now accept as the very foundations of modern consciousness were still new and novel ideas.

It took a while for these ideas to settle into a form that we might recognise today. René Descartes, for instance, was one of the first to ground this new kind of self within philosophy. In his influential *Discourse on Method*, an autobiographical treatise on how to "rightly conduct one's reason", which was written almost a century after Dürer's death, Descartes provided the new world with a now familiar methodology for separating truth from falsehood.[6] To do this, he stripped back everything that, he believed, could not be trusted in his perceptions of the world around him — that is, everything that was not immediately self-evident about the outside world. When all of this was discounted, Descartes was left with one thing — that is, the "thing" that thinks. "I noticed that, during the time I wanted thus to think that everything was false, it was necessary that I, who thought thus, be something".[7] *I think, therefore I am* was his resulting declaration, and with that he established the self "as the first principle of the philosophy I was seeking".[8]

In comparison to Dürer's own, Descartes' sense of self is (quite literally) reductive. For Dürer, however, there was little anxiety about whether his self-portraits were an entirely accurate depiction of the self at all. The artist certainly came to pride himself on his anatomical accuracy, but he hoped to provide beautiful representations of the human form above all else. As such, this did not preclude the use of his imagination. On the contrary, when Dürer looked at himself in the mirror, Berger insists he "was always fascinated by the possible selves he saw there".[9]

This is clear enough when we compare the two portraits discussed above, one from 1498 and the other from 1500. The changes in Dürer's appearance could be the result of his improving skill as a painter, but others argue that the later portrait is essentially a fabrication. It hardly even looks like Dürer anymore — the *real* Dürer, that is. As if overlaying a Christ-like filter over his own face, this is neither Dürer nor Jesus but some fictional figure in between.

Berger insists, with this in mind, that it could not have been the painter's intention to be blasphemous; he was a devout Roman Catholic, after all, even after Martin Luther instigated the Reformation in 1517. In creating a likeness somewhere between himself and Christ, the painting can instead be seen as aspirational rather than self-aggrandising. "The picture cannot be saying: 'I see myself as Christ'", Berger argues. "It must be saying: 'I aspire through the suffering I know to the imitation of Christ.'"[10] If Dürer was so self-obsessed, it seems — at first glance — to be as a true narcissist. He hoped, more than anything, to be transformed.

6. Self Sacrifice

Though one of the first, Dürer was far from the only artist at this time to see himself in this way. His beautiful self-portrait is exemplary of a growing trend across Europe, when artists were depicting themselves as notable members of society, rather than hired hands serving the whims of their rich and famous patrons. As a result, self-portraits took on an aura akin to contemporary headshots of famous actors and celebrities, and their grandiosity served a similar professional purpose as well. These paintings were often like all-in-one business cards or *curriculum vitae*, containing everything a curious patron might want to know about a jobbing artist looking for work. Primarily, they presented the viewer with both the artist and their skills, but they also occasionally advertised an individual's social circle, as well as their personal interests and possessions.

In Italy, where self-portraits were especially popular at that time, there developed a trend for artists to paint group portraits of themselves with various figures from high society. Less a depiction of a group identity, these paintings were made specifically to boost the social standing of the individual painter, who usually occupied a central panel whilst surrounded by studies of his — and it typically was "his" — famous friends. It was the beginning of a transitory period, where the social *subject*, as a member of a community shaped by that same community, was transformed into a social *self*, with a person's popularity and friendships being adopted as an individual virtue.

This aspirational sense of self remains prominent today, of course; it is arguably the defining feature of a *bourgeois* sense of self. Self-transformation and self-actualisation are tied to notions of social mobility and this was no different in Dürer's time. But then as now, not everyone moved between social classes with the required grace and gratitude, and the self-portrait was, for some, a mode of subversion and resistance as much as it was a medium for self-actualisation. Allegorical self-portraits soon became popular, and what began as a medium for self-aggrandisement or self-expression slipped into irony and irreverence, not to mention self-critique and self-deprecation.

No artist epitomises this self-critical tendency better than Caravaggio. Working almost a century after Dürer's rise to fame, he remains the most infamous provocateur of the Italian Renaissance. His depictions of the self are evidence enough of this fact. Though he produced self-portraits in which he looks very handsome indeed, he was not partial to depicting himself as one of the rich and famous, like so many of his contemporaries. All too familiar with the values and expectations of his patrons, particularly the Catholic Church, Caravaggio instead devised bold new ways to subvert them, challenging the power they wielded over the lower classes.

These subversions did not go unnoticed. Unlike Dürer's aspirational works, Caravaggio's paintings *were* deemed to be sacrilegious, and his various controversies are well-documented. They include supposedly hiring a sex worker to model as the Virgin Mary for a church commission, as well as depicting the dirty soles of saints' feet.[1] But more interesting than his controversies are his self-portraits, in which he

depicted himself in several surprising and even unflattering roles. Whereas Dürer hoped to be Christ reborn, Caravaggio saw himself as the devil incarnate. But his self-portraits were not always demonstrations of a kind of pantomime showmanship, playing the villain for shock-value and infamy; his unconventional selfies were often sincere and complex attempts at self-critique or moral condemnation, even when dripping with a scathing irreverence.

It is clear that Caravaggio lived a hard life, and as a result he routinely depicted his own precarity. But there is a certain defiance in his depictions nonetheless. He had known the effects of living under the cosh of power and privilege his whole life and his paintings did not shy away from this fact. His allegorical self-portraits, in particular, were less self-pitying and more like depictions of the collective experience of a particular class, making him "the first painter of life as experienced by the popolaccio, the people of the back-streets, les sans-culottes, the lumpenproletariat, the lower orders, those of the lower depths, the underworld".[2] Through his first-hand experiences, he could not help but include the squalor and realism of poverty in his holy tableaux. Though this may have scandalised the Church, he did not "depict the underworld *for others*", as Berger explains; his vision was instead one he shared with those from below.[3]

In this sense, Caravaggio is the anti-Dürer. Whereas the man from Nuremberg painted his readily expanding potential, Caravaggio often painted the oppression and foreclosed potential of his own social class. This is particularly apparent in the allegorical selfies he painted towards the end of his life, when those in power were becoming increasingly less tolerant of his defiant attitude.

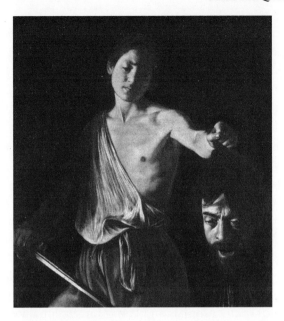

Caravaggio, David with the Head of Goliath, c. 1609-1610.

Take, for example, *David with the Head of Goliath*. In the very last years of his life, Caravaggio used his own likeness to paint the severed head of the giant, mouth agape and eyes bulging, with blood spurting from his ragged neck. In the original Bible tale, Goliath is a towering Philistine threatening the Israelites on the outskirts of Jerusalem. He is confident in his ability to squish all opponents who might try and challenge him, and so he goads the Israelites into sending forth a champion to duel him. A young shepherd, David, approaches the giant with a slingshot and some stones. To everyone's surprise, David manages to knock Goliath unconscious with his ranged attack, before quickly chopping off his head. It is a tale synonymous today with upset wins and underdogs bringing down well-established opponents.

Assuming this story held the same idiomatic associations as it does today, should we interpret Caravaggio's depiction of David's victory, with the painter casting himself as the dead giant, to be an expression of his own careerist insecurities? An exact date has not been established for the painting, but it is generally accepted that it was painted within the last five years of Caravaggio's life. (He died in 1610.) Was he afraid some hot new talent would knock him from his pedestal, eclipsing him as the Italian art world's new *enfant terrible*? Unfortunately, it seems that Caravaggio's fears for his own head were far more literal. Indeed, many of his later works take beheadings as their subject matter, and each seems to express either a fear for his life or painterly pleas for mercy.

Caravaggio was in exile for much of his final decade. His reputation for fighting, insolence and petty crime made him a target for both criminals and law enforcement alike. But his reputation was ruined utterly when, in 1606, he killed a man named Ranuccio Tomassoni. One version of the story goes that Caravaggio and Tomassoni had bet on a game of tennis and disagreed on the outcome. Another version of the tale suggests that Caravaggio was jealous of Tomassoni's relationship with Fillide Melandroni, a local courtesan who had modelled for Caravaggio on several occasions — most famously as Judith in yet another gory painting of an assassination, *Judith Beheading Holofernes*. (Papers released by the Vatican in 2002 seem to confirm this latter tale.[4]) Whatever the true source of their disagreement, the pair decided to settle their differences by having a duel. Caravaggio won that duel and attempted to castrate his opponent as an act of retribution. Tomassoni later died of his injuries.

It is believed that Caravaggio had not intended to kill his rival and the fallout from the botched duel was complex. The

painter's life was turned upside down; he went on the run, travelling the length and breadth of Italy, even spending time on the isles of Sicily and Malta. While in exile, he painted himself as Goliath, but this was not the only artwork to predict the painter's imminent demise. He also painted *Salome with the Head of John the Baptist*, a painting in which the severed head once again looks like Caravaggio himself. (Intriguingly, Salome also resembles Fillide Melandroni.) The painting was presented to Fra Alof de Wignacourt, the Grand Master of an order of Maltese knights, presumably as a gesture of goodwill. But despite having fled to Malta, the painter was later driven off the island, either because news of his crimes had reached the Maltese noblemen or because Caravaggio still couldn't behave himself and once again ended up on the wrong side of the law. No doubt already exhausted and tired of life as a fugitive, in repeatedly offering up his head on a painted platter, the artist longed for mercy. But he didn't get it.[5]

Though Caravaggio's circumstances are extreme, political exile was not an experience reserved for fugitives at that time. In fact, such an experience was common in Renaissance Italy. Back then, the country was divided up into a collection of city-states, each with its own governing body. Because of this, one could count oneself as an Italian but nonetheless live under a diverse range of political realities. As a result, the masses tended to vote with their feet. No longer simply subjects of a given monarch, fated to circumstance, the power under which you lived was contingent on where you lay your head. The free movement of people further inspired and emboldened the idea of the individual in this way, particularly among artists, who may have seen themselves as somewhat romantically in touch with some great cultural spirit, travelling from city to city and sailing above the political fray.

Nevertheless, the desirability of being one with power was hard to ignore. Like countless generic businesspeople today, who appear to us in ham-fisted YouTube ads, showing off their homes and boasting of ingenious methods for accumulating wealth and influence, it is never a case of just bettering yourself but "being like me" — being a supreme individual. There was, of course, little chance that the average person could ascend to the heights of an emergent bourgeoisie, at least prior to the Renaissance.

Whereas some figures, like the poet Dante, famously embraced this newfound freedom, others like Caravaggio remained ill at ease. His depiction of himself as Goliath is just one example. Less graphic but no less self-destructive, Caravaggio is also thought to have painted himself as Bacchus, the Roman god of wine and fertility, as well as madness and the festival, otherwise known in Greek mythology as Dionysus. Rather than being a jovial character, as one might expect, Caravaggio's *Young Sick Bacchus* wears a queasy grimace and green skin. He is holding a bunch of grapes, as if ready to keep eating, but resembles a drunk at a party who has already had one too many and should really start thinking about going home. Against his own better judgement, he is trying to keep up appearances. It is, in many respects, a subversion of Bacchus's character. Whereas Narcissus may be associated with a kind of self-intoxication, the drunken Bacchus is instead a figure of social abandon; those who follow him are freed from an otherwise suffocating self-consciousness. However, in Caravaggio's hands, this Dionysian spirit is less attractive. Inverting the narcissism of a self-portrait, Bacchus's detachment from the self is depicted as its own kind of sickness. Though care-free and hedonistic, and a glutton for pleasure, Bacchus is as fleshy and grotesque as any of Caravaggio's other allegorical self-portraits of murdered mythological monsters.

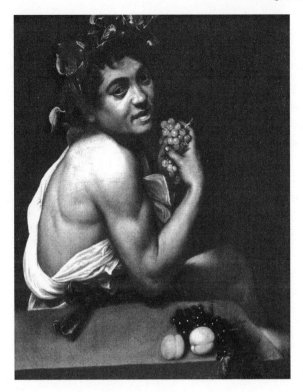

Caravaggio, Young Sick Bacchus, c. 1593-1594.

Each of these paintings seems to tell us something about Caravaggio's sense of his own position in Renaissance society. Rather than exercising the braggadocio of many of his more well-to-do peers, to paint himself as a vanquished giant or a sickly hedonist suggests he was painfully aware that the independent life of an artist wasn't all it was cracked up to be, even prior to his time spent as a fugitive from justice. Though none of these paintings can be labelled as "self-portraits" in a traditional sense, as allegorical paintings of the self they are arguably even more accurate depictions of Caravaggio's

self-understanding, in that they allude to an inner experience that the rest of the world was not privy to. Those elements that are most alike or relevant to Caravaggio himself are hidden, obscured or only symbolically alluded to. Though they may have been exploratory and self-reflective for the man himself, as viewers of his paintings we are only made more aware of our distance from him, the mythologised painter with a bad reputation. It is as if, despite the fact he is wearing a series of masks, Caravaggio's portrayals of others tell us something more compelling and less vainglorious about the person underneath than Dürer's more explicit self-portraits ever could.

7. Art's Primal Scene

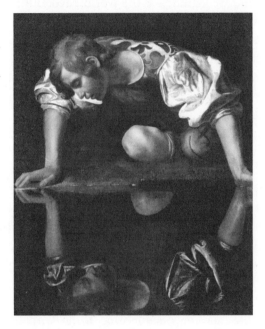

Caravaggio (conjectural), Narcissus, c. 1594–1596.

Among his diverse portfolio of mythological and religious figures, it is thought that Caravaggio also painted Narcissus. (Some scholars dispute its providence; it was first attributed to him as recently as the twentieth century.) Most likely painted in the early 1600s, even if we were certain that this painting was produced by the Italian Renaissance's chief generator of *causes célèbres*, it would remain unclear as to whether he used

himself as a model or someone else. Even so, regardless of its true authorship, as an unusual painting of Narcissus it still tells us a great deal about the time in which it was made.

The painting is eerily minimal, and a striking example of the *tenebroso* style.[1] Narcissus is enveloped in shadow and darkness, and we cannot see the world beyond him, only the kneeling figure and his gloomy reflection. Even the riverbank on which he sits seems dead and barren, as if the solitary hunter has become marooned on some terminal beach. If narcissism is a pathological imbalance within the relationship between self and world, Caravaggio's *Narcissus* has seemingly lost touch with reality altogether. This is readily apparent when we consider how the figure is presented to us. Bizarrely, our attention is drawn immediately to Narcissus's knee as the painting's centre point. But this framing is itself telling; compositionally, Narcissus and his reflection appear totally in orbit of themselves, constituting a whirlpool of the self.

Though Narcissus may be that quintessentially (if excessively) reflexive subject today, for Caravaggio this reflexivity may have had another purpose. As with his paintings of Goliath and Bacchus, with so little of the world around him on display, it is arguably the act of looking itself that is the focus of the painting. This may have something to do with how Italian artists and writers understood the myth of Narcissus during the Renaissance. For Leon Battista Alberti, for instance — an influential humanist and notable friend of Dürer's, whom he met when Alberti travelled to Nuremberg to give a lecture — Narcissus was deemed to be the very "inventor of painting".[2]

We might assume that this is a reference to the average artist's self-concern — the thrill of having one's work admired and loved is, of course, a euphoric and narcissistic high — but there is another interpretation available here.

It is as if, for Alberti, Narcissus's furious despair at his own impotence, his inability to capture and possess the reflection that has so captivated him, a reflection of his own nature no less, is an allegorical retelling of the experience that first drove humanity to paint in the first place. "As the painting is in fact the flower of all the arts, thus the whole tale of Narcissus perfectly adapts to the topic itself", he argues.[3] Narcissus's metamorphosis is, in this sense, nothing less than the primal scene of art history. After all, what is it to paint, Alberti asks, "if not to catch with art that surface of the spring?"[4] What is it to paint if not to try and capture a fleeting glimpse, a moment, a perspective that we may never be able to pull ourselves away from without the knowledge we could somehow commemorate or preserve it?

The emergence of culture, then, is Narcissus's metamorphosis in reverse; the product of our alienation from nature rather than society at large. As the flower is transformed into a transcendental object that we cannot know or possess outside our experience of it, we attempt to remake it by our own hand. (Though Narcissus is transformed into a flower, in Ovid's telling at least, we mustn't forget that, culturally speaking, the flower always came first.) That way, we hope to know nature itself as a font of creativity — not just as something to admire but as something *to be*; as something to become and to take part in.

This reading presupposes the philosophy of Immanuel Kant, one of the most famous critics of Cartesianism in the centuries that followed the Renaissance. In his *Critique of Pure Reason*, first published a century and a half after Descartes' *Discourse on Method*, Kant refutes Descartes' "material idealism", which he defines as a "theory that declares the existence of objects in space outside us either to be merely doubtful and

unprovable, or to be *false* and *impossible*".[5] For Kant, this is nonsense. Descartes may trust nothing but his own thoughts, but for Kant there is a clear (even essential) relationship between subject and object at play here. Indeed, without a subject there is no object to be perceived. However, although we can reasonably assume, *contra* Descartes, that the world exists without us, we still cannot think things "in-themselves". Everything available to thought must pass through the senses, in one way or another.[6] "Without sensibility no object would be given to us; and without understanding no object would be thought", Kant says. "Thoughts without content are empty; intuitions without concepts are blind".[7] This is true enough of paintings themselves. Objects, Kant observes, affect us — even those objects we create for ourselves. What is our experience of art, after all, if not the aesthetic experience of a subject and an object in an affective relation? And so, when we experience objects, we sense them, and these sensory experiences give rise to understanding, which, in turn, allows us to think more deeply about the objects before us. Kant thus argues that all "objects are *thought*" about, and from such thoughts "arise *concepts*".[8]

Placed within the context of art history, and art history's relationship to philosophies of the self, we might reframe Kant's challenge to Descartes as follows: though he was aware of himself — that is, though he experienced doubt and realised that the only thing he was certain of was that there is a *cogito*, that there is consciousness, that there is the thinking thing that he is in himself — Descartes' self-awareness was not, in actuality, self-contained. After all, he wrote it down. His abstract self only begins to take shape as he writes about and conceptualises — that is, when he *objectifies* — the "I" of his first-person philosophy.

Artists, of course, work in a similar way. When they can't paint and draw others or the world around them, many artists paint and draw themselves, considering the shapes and sensations that make up the human form as they attempt to depict the objective texture of being itself. Indeed, whereas Descartes makes thought superior and our experience of objects untrustworthy, Kant insists upon their unavoidable correlation to one another. For Kant, particularly in his aesthetics, it is through art and philosophy that thought is conceptualised; the objects of our concern are always already framed by language and culture. But this is not a one-way process; it is a feedback loop, like that experienced by Narcissus himself. Just as Alberti wrote of the birth of painting coming from our desire to capture "that surface of the spring", so too does philosophy often emerge from the dialectical relationship that entangles the subject in its attempts to conceptualise itself as an object of thought.

The art-historical timeline supports this reading. Contrary to Descartes' self-mythologising account that his conception of the self was innate to his own mind, we have already mentioned that artists began painting self-portraits about a century earlier. Self-portraits, then, as studies of our experience of the self, surely provided the foundation on which Descartes and others attempted to build a rational conceptualisation of *"the self"* as a philosophical concept. To reiterate Kant, it is from our thinking *about* objects that concepts arise. From here, we might argue that the generation of art — particularly at a time of diminished literacy, when visual culture better reflected the concerns of the masses — is *followed by* the generation of philosophy as a more refined intellectual pursuit, rather than the other way round.

The art historian Susanna Berger — of no relation to John — has recently made this same point in her 2017 book, *The Art of Philosophy*, in which she explores how the visual culture of the late Renaissance and early Enlightenment prefigured and helped spread the concepts that would come to define the era.[9] Paying particular attention to paintings of people, she argues that portraits both literal and allegorical were integral to the conceptualisation of many modern philosophical concepts, from the self to the nation-state, which were often not seen as static objectifications but shifting concepts in an active becoming. More recently, she has extended this argument to the likes of Caravaggio, including the painting of Narcissus often attributed to him.

Following Alberti's interpretation of Narcissus as the primal scene of art itself, Berger argues that Caravaggio's *Narcissus* is an example of what she calls a "meta-image". She suggests that, during the Renaissance, "such self-aware paintings could … thematize the potential fictiveness of visual experience" for the viewer, in the way that their content and structure echo the act of painting itself or, additionally, the very act of *looking at* a painting.[10] "In visualizing acts of observation", such meta-images "turned gallery visitors into representations on display, an effect that would have made the spectators' identification with Narcissus even closer".[11] This is to say that paintings like Caravaggio's *Narcissus* not only dramatize an artist's self-consciousness but raise that same consciousness in the viewer as well.

Caravaggio may have been aware of this. Just as he lampooned the habits and values of his patrons on various other occasions, perhaps his *Narcissus* was another knowing nod to Italian society's growing obsession with images of the self, as if he were using the image to say to its viewers: "This

is what you look like". Just as the Catholic church betrayed its own narcissism in commissioning grand representations of its own mythology, so too did other patrons of the arts get off on the very act of looking at representations of themselves or, indeed, any of those objects that they owned.

In his final years, Caravaggio played up to this narcissism even more explicitly, hoping that, in painting his head on a platter and sending it to someone who could influence his future, he could sate the desires of those who wanted his *actual* head on a spike. To "own" *a* Caravaggio was recognition from the artist that his patrons and persecutors could also "own" the man himself. This is contrary to Albrecht Dürer's intentions, painting his own innate power and potential; instead, Caravaggio hoped to paint and flatter the power of others, including their power over him, forcing the viewer to reckon with their own cultural impact and political influence.

Here, caught between Dürer and Caravaggio, we find the seeds of our contemporary predicament; we find that familiar tension between transformative and oppressive narcissisms. In fact, in Caravaggio's particular depictions of the self, following Susanna Berger's insistence that visual thinking often prefigured philosophical thinking at this time, we can see an attempt to grapple with the burgeoning political philosophy of bourgeois liberalism, as theorised most famously by John Locke.

Locke's political position was heavily influenced by Cartesian philosophy. Published a few decades after Descartes' *Discourse on Method*, Locke's *Essay Concerning Human Understanding* begins with the assertion that the "*Self* is that conscious thinking thing … which is sensible, or conscious of pleasure and pain, capable of happiness or misery, and so is concerned for it*self*, as far as that consciousness extends".[12]

But this Cartesian foundation nonetheless responds to certain political ideals, specifically a new conception of *individual* liberty and rights, making the self a first principle for politics as well as philosophy. But Locke's conception of the self was often dependent on an individual's social status. As a result, by Locke's measure, not every living thing was "conscious" of itself in the same way. It is for this reason that, although much of his work pays lip service to universal freedoms to be enjoyed by all individuals, this was not always true in practice, especially by today's standards.

Locke argues that the word "person" — his supposedly "forensic term" for the self — "belongs only to intelligent agents capable of a law".[13] But this is not the same sentiment as "I think, therefore I am". Locke instead positions the self as a reflexive being that thinks *in accordance with* reason. Rather than this self being a foundation upon which reasoning itself can take place, the cart is put before the horse. A person is not just *capable of* reason — they are fundamentally *reasonable*.

Some of Locke's resulting conclusions are relatively innocuous. Under his criteria, an animal is not a person, for example, because animals do not have laws. But neither, in Locke's view, are the supposedly uncivilised, whose rights do not warrant the same respect as "persons" from more "reasonable" societies. Though Locke does not argue this point explicitly, the proof is in the pudding. Indeed, this implicit suggestion was very influential, and particularly disastrous given Locke's political influence over the colonisation of North America — an influence that can be seen explicitly in historical studies of British imperial expansion and the Transatlantic Slave Trade, during which the emotional lives of slaves, in particular, transported like cattle to the New World and clearly experiencing trauma and grief, were instead

ignored, denounced or simply not perceived through the prism of liberalism's burgeoning ideology.

The political impact of Locke's "self" did not stop there, however. Soon enough, "the self" became a term for a kind of individual sovereignty, analogous to that of the nation-state (another relatively new concept). Self-knowledge was defined less by what we could be most sure of, as in Descartes' formulation, and more by what we can claim possession of — whether that be our own thoughts or, in Locke's extension, the land underneath our feet. In this context, Descartes' "I think, therefore I am" was soon extended into the realm of governance, empire and property rights, making "I own, therefore I am" a more accurate founding doctrine for the politics of classical liberalism, settler-colonialism and, a few centuries later, the consumerism of neoliberal capitalism.

Given the ever-peculiar experience of being a conscious subject, Cartesian doubt nonetheless remains the founding gesture of modern thought, as well as a frequent starting point for many students today who are beginning their journeys into philosophical thinking. As such, even in contemporary popular culture, Descartes' questioning of the existence of a mind-independent reality can be found everywhere, from Nineties Hollywood blockbuster *The Matrix* to "Therefore I Am", the 2020 hit single by pop star Billie Eilish. And yet, whilst we take this foundation for granted today, with the ideology of liberalism still pervasive (albeit adapted to what is now referred to as a *neo*liberal society), it was already clear to many in the Middle Ages and the early modern period that "the self" was not the best foundation for a new era of thought and commerce. It was, even at its conception, critiqued for the ways it constituted certain pernicious relations of power.

Caravaggio and Dürer, though they may appear on either side of this divide — one critical, the other affirming — nonetheless shared an unease with this situation. Caravaggio may have been more aware of these power relations simply because society had, in his time, already had a century to get accustomed to these new ideals. But towards the end of his life, Dürer expressed a number of reservations of his own as well.

8. Art in the Age of Individual Reproduction

Albrecht Dürer (conjectural), Printing Press, c. 1520.

In his final decade, Caravaggio's art became increasingly self-referential, as he feared for his own life more than anything else. But for Dürer, his art came full circle. Having previously embraced the new world of the individual, as the first artist to be obsessed by his own self-image, in later life he used the latest technologies to explore a dying sense of social self as well.

One of the ways Dürer did this was by making the printing press both a subject in his work and a tool for its mass reproduction, producing another form of "meta-image". Was it his goal to establish a vision, rather than a technical knowledge, of this new means of production in the minds of his patrons, who may not have understood how these new kinds of images were made? This would have been a smart move and marketing strategy for the budding entrepreneur. From photography to abstract expressionism to non-fungible tokens, one of the biggest obstacles to people's acceptance of new forms or styles of art is a lack of understanding regarding how they are made — or, indeed, a suspicion regarding who is using them and for what purpose. This would have been no less true for Dürer. An exquisite painter of portraits and still lifes, his woodcuts and engravings distinctly lacked the same level of detail and colour that audiences may have become accustomed to. In fact, many of his woodcuts, whilst expressing an unprecedented sense of immediacy, like an artist's sketch, nonetheless displayed a stylistic naïveté that was uncharacteristic of this master painter's better-known works. Are we to imagine him as an aesthetically revolutionary figure in his time, like Pablo Picasso or Jackson Pollock? How many art sceptics thought these two more modern artists were just shitty painters until they saw their expressivity in action, or came to understand the institutional restrictions placed upon expressivity that they were actively breaking down?

Dürer was, then, likely aware that the best way to win people over to a new form of art was simply to show them how it was made. But the social reception of Dürer's work with the printing press was nonetheless entangled with its ability to embolden his individual reputation. Whereas the masses may have previously seen singular works of art in particular contexts — in church, for instance — where the artist retained a certain anonymity, their identity of less importance and interest relative to the message being conveyed, the printing press brought the entire operation in-house and under the control of the individual. This was far more explicit for writers than artists, but both experienced the same effect on their individual personhood. "It is the press that disseminates the fame of a commentator or writer", art historian Reuben Wheeler writes; "it is the press which assists in creating the new conception of individual importance, by relying on the importance of the writer to ensure the success of each new printing".[1] This turned culture on its head. Whereas the one-off painting, conveying a collective mythology or shared history, is something that the viewer may have felt like they were an active participant in, at least to some degree, the printing press reversed this polarity.

No longer were the masses interacting with a singular work but a disseminated reproduction. This reproductive process, somewhat counter-intuitively, emphasised the individual over the audience themselves. This was even true compositionally. The grand frescoes that a church-going public may have been accustomed to — like that found in the Sistine Chapel, to reference a particularly grand example — were often sprawling works where time and space themselves were folded impossibly into an all-encompassing and omniscient perspective — like that of God himself. In this sense, the

scenes depicted far exceeded the frame of human perception. Biblical events appeared as such — not as snapshots taken from an individual viewpoint but as omniscient perspectives, depicting a multitude of events that all seem to be happening simultaneously, allowing the eye to trace an entire scene or narrative across space and time. But with the birth of the individual, painting began to show less rather than more, attempting to replicate human vision itself by emphasising a frontal perspective, as if the scene captured was a singular moment in time — a perspective we now take wholly for granted since the invention of photography. "This was something new in human development", Wheeler argues. It produced "the sense that through an individual is revealed a vision personal to him, which we can only admire but in which we can never participate".[2]

This argument, that culture accelerated the adoption of individualism, is known today as the "Burckhardt thesis" — named after the eighteenth-century Swiss historian, Jacob Burckhardt. In his history of *The Civilization of the Renaissance in Italy*, he explores the various conditions of the individual's emergence, most of which we have gestured towards already. Developments in politics, poetry and science all informed a new sense of self-understanding among the masses. This typically trickled down from those in power. Throughout the fourteenth and fifteenth centuries, wars were waged between despots, emboldened by their self-belief in their God-given right to rule. But this aggrandised sense of sovereignty was contagious, eventually spreading to their noblemen, then to their armies, and eventually to the masses themselves. No longer simply subjects of power, each individual's capacity for observation — perhaps encouraged by the meta-images of Caravaggio and others — was itself emboldened. As a result,

although Wheeler emphasises the fact that the viewer may have found themselves unable to participate in the visions offered to them by others, rather than feel excluded, many individuals gained further insight into their own personal perspectives on the world around them.

For most, this perspective was still social in its orientation. To demonstrate this, Burckhardt pays particular attention to a familiar figure: Leon Battista Alberti. First, he lists Alberti's numerous achievements, which are impressive even today. As a child, he was a gymnastic prodigy; as he grew older and less agile, however, he dedicated time to the study of civil and canonical law, physics and mathematics, and to the arts, as both a practitioner and a theorist. It seems like there was no area of expertise that he did not think was within his reach. But above all else, Burckhardt notes Alberti's Narcissus-like captivation with nature itself and man's place within it. "At the sight of noble trees and waving cornfields he shed tears; handsome and dignified old men he honoured as 'a delight of nature', and could never look at them enough".[3] Alberti's "narcissism", regarding not just his own potential but that of nature itself, was profound; "like all the great men of the Renaissance, he said, 'Men can do all things if they will'".[4] In Alberti, we see the Renaissance narcissist's attendance not only to his own fortune but to that of all mankind. The idea of the individual could not emerge without a sense of its social force. As Burckhardt later notes, "the development of personality is essentially involved in the recognition of it in oneself and in others".[5]

As another "great man of the Renaissance", it is perhaps for this same reason that Dürer's pivot from the social self to the individual was hardly clear cut. Instead, he oscillated between the two. He did not abandon painting in favour of the printing

press; rather, he explored both mediums simultaneously. More than anything else, this was because woodcuts and engravings allowed him to make more work more quickly, funding the production of more ambitious paintings. Whereas artists had previously relied on commissions from wealthy patrons, which may have taken a great deal of time to complete, the printing press made artists more independent. This was hugely freeing for Dürer in particular, vastly increasing his profile as an individual artist, and helping him to finance trips around the world, which led to encounters and experiences with people, places and objects that later provided the foundation for new work.

Raised up as an individual, Dürer took to sharing his vision with those he encountered on his travels. By the measure of any contemporary Instagram influencer, he was living the dream! And yet, whilst Dürer embraced his newfound fame as an individual, he still kept his social role as an artist in mind. The new work generated by his travels was not simply artistic and aesthetic, but related to a variety of interests. He travelled the whole of Europe in search of sights and experiences that would not be available to the everyman. In sharing these discoveries, applying his masterful skill as a draughtsman to render nature in all its splendour, he greatly enhanced our collective knowledge of the world around us. Indeed, in seeing the great cities of Europe, this knowledge likewise informed his studies of social organisation, particularly with regards to city planning. As a result, his fame and independence allowed him to contribute almost unthinkable amounts to society as a whole, in an array of subject areas that it would likely be impossible for any one person to influence today.

But this awareness of the benefits of individualism, alongside his growing understanding of Europe as a whole, increased

Dürer's sensitivity to the schisms that were appearing between the individual and society at large. He may have used the self-portraits of his youth to affirm a new European conception of the self, but his later woodcuts and etchings seemed at sea with the direction European society was heading in. In fact, as the supremacy of the individual was becoming culturally established, in part due to his own artistic influence, Dürer's work grew increasingly dark and melancholic, even pessimistic, with regards to this new conceptual understanding of the self and its place in the world.

9. Apocalypse Now

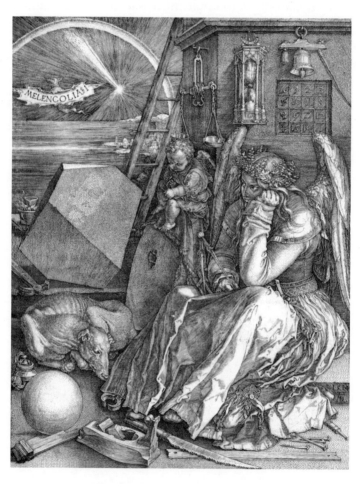

Albrecht Dürer, Melencolia I, 1514.

Dürer's most famous depiction of this new dark age is *Melencolia I*, an intricate engraving created in 1514. Today, it is one of the most discussed works of art ever made. Packed to bursting with symbolism, we see a winged Lady Melancholy, listless as the sun sets on her cluttered surroundings, which are impossibly littered with scientific instruments and books; animals and angels; buildings, bodies and geometric shapes. However, despite being surrounded by such curious objects, she rests her head on her hand, forlorn and world-weary, looking off into the distance, as if the entire world is at her disposal but nothing in it can hold her attention for long. The same is true of Dürer's hodgepodge references to various popular styles and artistic movements; as John Berger notes, the engraving is "incongruously and simultaneously Gothic, Renaissance and Baroque".[1] It seems to reflect both the multiplicitous aesthetics of a transitory age and Dürer's own transitory self.

Erwin Panofsky, a Dürer biographer, notes that the incongruity of Dürer's style was common to German art in general at that time. Indeed, in Panofsky's assessment, Germany was primed as a petri dish for the emergence of the individual. "Germans, so easily regimented in political and military life, were prone to extreme subjectivity and individualism in religion, in metaphysical thought and, above all, in art", he writes.[2] One result of this, however, was that "German art was never able to achieve that standardization, or harmonious synthesis of conflicting elements, which is the prerequisite of universally recognized styles".[3] But this is not to insult German culture; it was clearly still capable of exerting "an international influence by producing specific iconographical types and isolated works of art which were accepted and imitated, not as specimens of a collective

style but as personal 'inventions'"[4] — a situation that might seem familiar to us in our postmodern age of late-capitalist individualism, where movements of collective style in art are fleeting and inchoate, as if we have left such things behind in the twentieth century.

Still, we must remember John Berger's previous comment that, whilst his artworks may continue to speak to us, Dürer's experiences are not our own. His understanding of "melancholy", for instance, will have been very different to the one we hold today. Panofsky notes that his understanding of the term was likely informed by the then prevalent theory of the four humours — that is, the theory that there are four vital bodily fluids within the human body, the proportions of which correspond to our shifting emotional states.

The states to be balanced were named as follows: phlegmatic, choleric, sanguine and melancholic. Together, Panofsky explains, they neatly corresponded to "the four elements, the four winds (or directions of space), the four seasons, the four times of day, and the four phases of life".[5] Melancholy in particular, he continues, "was supposed to be coessential with earth and to be dry and cold; it was related to the rough Boreas, to autumn, evening, and an age of about sixty".[6] Rather than explicitly referring to a specific kind of depressive attitude, as it does today, melancholy was then a temperament more generally associated with endings, with winter, with things coming to a close. However, additionally, in being an "elderly" temperament in this regard, it was also associated with wisdom, even genius. Still, the melancholic person, afflicted with an excess of this particular humour, is likely to be "unfortunate and disagreeable"; "awkward, miserly, spiteful, greedy, malicious, cowardly, faithless, irreverent and drowsy"; "surly, sad, forgetful, lazy and sluggish".[7] We might

also consider how, in addition to this telling list of adjectives, to be melancholic is also to be narcissistic, in a negative sense. Panofsky adds that the melancholic also "shuns the company of his fellow-men and despises the opposite sex; and his only redeeming feature … is a certain inclination for solitary study".[8]

Though this theory of the four humours was disproved by science long ago, it seems clear that Dürer sensed society as a whole was becoming unbalanced in its own way. But nothing was yet set in stone. As the individual and the social went to war in all aspects of life, it makes sense that Dürer's theories of art would make reference to them both. Indeed, this seems to be his general impression of the unfolding age of reason; although studious, producing great advancements in science and culture, the inhabitants of this new world were increasingly isolated and misanthropic. This may, in part, have transformed him into something resembling an old man yelling at clouds. As a young man, living through the spring season of his life, Dürer felt excited about his position in society, as a new man in a new era, but in his winter years, having recognised the truly transitory nature of the period in which he was living, he also found himself disgruntled. Whereas he had previously been fascinated by himself, as a potential new subject in a new historical era, he was later much more aware that, as a transitional self, he was also one of the last subjects of an era now being eclipsed. As John Berger suggests, eventually, as "the *end* of history approached and as the Renaissance dream of Beauty … receded", so too did Dürer's capacity to make, respond to and even precipitate change as "the first, one-man, avant-garde".[9]

The contentious history of the printing press remains key to this growing imbalance and the fading of that brief flicker of

a newly empowering and empowered world that Dürer had once glimpsed. Outside its impact on art, many historians have written about how this new technology — whilst democratising and effectively creating popular culture as we know it today by increasing literacy and access to art among the masses — was also used by those in power to further embolden their political hegemony. (Our individualism, according to Burckhardt, is a direct product of despotism, after all.) This produced an acute contradiction, whereby the printing press, as a new medium for a newly social art, also helped spread the idea of the individual itself even further. The role of the printing press in the rise of Protestantism, in particular, helps put a finer point on these tensions and their impact on life at that time.

Following the publication of his *Ninety-Five Theses* in 1517, the German theologian and priest Martin Luther successfully orchestrated a split within the Roman Catholic Church, which he criticised for its political overreach and abuses of power. This included the Church's self-determined authority, as God's representatives on Earth, and its related ability to absolve the sins of wealthy donors in a kind of "cash for absolution" deal that Luther considered to be fundamentally corrupt. His acts of "protest" — most famously, the pinning of his theses to the doors of Catholic churches in Germany — later gave their name to the form of Protestant Christianity that developed in his wake. It also asserted the sanctity of the individual in matters of faith. Arguing that contrition before Christ could not be bought and adjudicated by an institution, instead coming from within, Luther asserted that everyone is responsible for their own repentance on an *individual* basis.

Luther's ideas were spread far and wide — again, thanks to the printing press. Though it would be historically inaccurate to

say he developed these ideas in isolation — others had argued similarly — his name (and, by extension, his theses) spread furthest thanks to his early adoption of this new technological innovation. As a result, his writings were turned into flyers and placards, and later into pamphlets that people could take away with them. But this came with its own set of problems. Whilst we could argue that Luther's protests were overall a contemporaneous force for good, challenging the deep-seated political and theological corruption of overpowered Catholic institutions, his Protestant ethic was unfortunately diluted and spread throughout both the upper and lower classes, providing the foundation for capitalist voluntarism and a specifically Protestant work ethic over the centuries that followed. Indeed, as the factory eventually overtook the church as that central hub around which communities were oriented, emphasising one's work towards an economic rather than spiritual salvation, Protestant individualism gave capitalists permission to relinquish responsibility towards their workers. If our salvation is our responsibility as individuals alone, it turns out that our social institutions will accept even *less* responsibility for social problems...

Dürer rejected the allure of Protestantism at that time, staying loyal to Catholicism, but this was not because he disagreed with Luther's individualist teachings. On the contrary, no man who had spent so much time painting his own aspirational image could be described as an anti-individualist. In fact, he greatly admired the heretical preacher. When Luther was eventually arrested for his heresy, Dürer praised him as a "pious man" in his journal. When Pope Leo X, a man "with his money against God", demanded Luther recant his theses, Dürer wrote down a prayer, hoping that Luther, "enlightened by the Holy Ghost, a follower of Christ and the true Christian faith", would not

be put to death.[10] "O Lord, give us then the new beautiful Jerusalem, which descendeth out of heaven", he continues, "whereof the Apocalypse writes; the holy, pure Gospel, which is not darkened by human teaching".[11] For Dürer, Luther was a saviour who had come to rescue the Church from an all-too-human corruption, preparing the masses for judgement day.

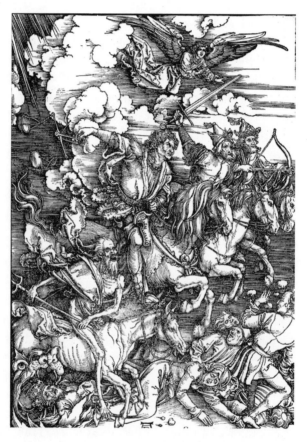

Albrecht Dürer, The Four Riders of the Apocalypse,
c. 1497–1498.

This mention of the Apocalypse may startle us today. Indeed, visions of the Apocalypse captivated Dürer — besides his own likeness, there is arguably no subject he depicted in his art more. But as Jane Campbell Hutchinson, another Dürer biographer, notes, his renderings of the Apocalypse are quite unlike "the contemporary art of more provincial artists such as Hieronymus Bosch", in that they were "neither pessimistic nor chiliastic in … tone".[12] Further describing Dürer's apocalyptic vistas, she continues:

> Although vengeance is wreaked upon the wicked in spectacular natural disasters on land and at sea, the monstrous is kept to an absolute minimum … while no effort is spared in depicting the "Wonder of Heaven", the splendor and majesty, power and dominion of God, and the honor done to the Blessed.[13]

This kind of representation is question-begging. The Apocalypse, like narcissism itself, is another word with deeply negative connotations today. But even by the measure of our contemporary understanding of the term, we can glimpse what made it so attractive to Dürer.

Contemporary post-apocalyptic dramas often present us with a world in which social institutions — even the state itself — have collapsed. Individual survivors, loyal to very few, roam the wastelands, utterly out for themselves, trusting nobody. Even in Dürer's time, the Apocalypse brought to mind visions of unthinkable horrors and the very end of the world as we know it. But the Apocalypse was also understood as a great unveiling, wherein the truth of this world is finally revealed, beyond all "human teaching". It was an event that would force us to finally look behind the curtain and see God in all his glory,

no longer obscured by petty human squabbles — a spectacle from which there was no turning back. The Apocalypse, then, is a kind of narcissistic transformation upscaled to the level of society as a whole, and Dürer's engravings emphasise this view of the Apocalypse as a *social* event that would transform the whole of humanity for the better. It was an event that would bring about the end of corrupt social institutions, apart from which people could be judged on their individual piety alone. Luther, Dürer believed, brought that reality closer to home.

But Dürer's vision was ultimately idealistic and conservative. His melancholy did not necessarily emerge from an awareness of a growing individualism among the clergy or the aristocracy, but an individualism that was disrupting the peasantry as a subordinated social class. This was not how Dürer had imagined things going. Nevertheless, he watched on, patient and pious, waiting for the grace of God. But it did not appear.

The world may have felt apocalyptic nonetheless. At that time, the German empire was stricken by famine, plague and syphilis. In 1524, just four years before Dürer's death, the country was also enthralled in a Peasants' War, as the peasantry mounted a (poorly) armed insurrection against the German aristocracy, their new sense of individualism leading to demands for a redistribution of wealth. Here the contradictions of the age boil over. Though Luther denounced the Church, corrupted by wealth, like many a fundamentalist Christian today his political allegiances remained quite complex, even contradictory. At first, he seemed sympathetic to the peasants' cause, but as the violence grew more fierce, he denounced both sides of the war as heathens against God. When the Church itself came under attack, Luther denounced the peasants' revolt outright. In an open letter addressing the

conflict, it is abundantly clear that Luther's revolutionary spirit was confined to matters of faith alone. "A serf can be a good Christian and enjoy Christian liberty, just as a prisoner or a sick man may be a Christian although he is not free", he writes. "This article would make all men equal and convert the spiritual kingdom of Christ into an external worldly one; but that is impossible, for a worldly realm cannot stand where there is no inequality; some must be free, others bound; some rulers, others subjects".[14]

How Dürer responded is unclear. His various biographers argue that he remained loyal to Luther, echoing this same conservative sentiment in his own writings. He was no Caravaggio, after all; Dürer was a member of an emerging bourgeoisie. But others have interpreted his artworks as

Albrecht Dürer, Bagpiper and Peasant Couple Dancing, 1514.

depicting the peasantry in a more generous light. In a scholarly article on his peasant engravings, Jürgen Müller notes that some historians see "the primary theme of such works as being mockery in the service of social differentiation (city-dwellers laughing at peasants)", whereas others have argued "that prints representing peasants partook in a humanist as well as a low-brow, humorous discourse".[15]

Müller himself takes the latter view, arguing Dürer's engravings were not works of mockery but instead challenged a prevailing orthodoxy in how life should be depicted. For Müller, his "peasant pictures mark the beginning of a new aesthetic potential in the visual arts — the potential for subversion".[16] Since culture "has always been determined by questions of hegemony", to depict peasants at all in Dürer's time goes wholly against the prejudices of Europe's expanding art scene, wherein "the depiction of Christian or mythological historical subjects is the noblest task of the painter, who achieves a certain status with his choice of topic".[17]

Jenny Farrell has argued something similar elsewhere. She highlights, in particular, a much later drawing Dürer made of a young black woman named "Catherine", sketched on one of his trips to the Netherlands. Farrell explains that Catherine was a servant to a Portuguese spice trader, who had changed her name following her presumed conversion to Christianity on arriving in Europe. (That she did so under colonial encouragement can be presumed but not proven.) Despite the fact she is a slave or servant, Catherine is depicted by Dürer with dignity. It is a beautiful and intricate portrait by any measure, and so it is easy to imagine that the care taken to render her likeness would have been unusual at a time when the trading of slaves was normalised in European society. It is, in this sense, a *humanising* depiction. Farrell writes:

Dürer's obvious interest here is in the individual person. His deep humanism infuses her portrait with the same dignity he affords the peasants he depicts. Dürer was the first German artist to capture the peasants' self-confidence that had been stirring since the late 15th century. He was the first to portray peasants as aesthetic subjects. Through Dürer, depictions of peasants appear in the revolutionary pamphlets of the time.[18]

If there is uncertainty and debate today regarding Dürer's political allegiances, including how the fallout of the Peasants' War may have blunted his empathy for the lower classes, perhaps that is to be expected. Even if his more conservative tendencies ultimately won out, his earlier sympathies were nonetheless uncommon for his time. If Dürer's mind changed here and there, this is no doubt because society itself was changing repeatedly and rapidly. But still, his apparent uncertainty represents an opportunity missed.

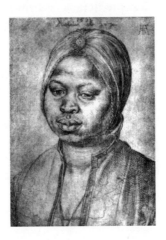

Albrecht Dürer, Portrait of an African woman, Catherine, 1521.

Unfortunately, as far as society at large was concerned, the Lutheran backlash was a nail in the coffin of the struggling peasants' movement. The social transformation that the peasants were demanding was supposed to come from above, from God, not from below. A bourgeois man at heart, Dürer's own sense of self-actualisation was also liberal in its essence; though he celebrates the potential for transformation, he decries the collective narcissism of subordinated groups in a contradictory manner that is still common amongst political commentators today. It is for this reason that Dürer's melancholia can still be read as a mournful response to the establishment of a new class consciousness. Unpredictably, the new age of individualism had provided the peasantry with a new perspective on their own circumstances. If it was true, as Luther proffered, that emancipation before God was down to the individual, then the peasantry became more aware of the other social obstacles that remained in its way. The solution for those in power was predictable: affirm the individual even further, so that all social relations are obscured in their totality.

10. Consciousness Deflated

The Peasants' War was ultimately unsuccessful. Friedrich Engels, later assessing this first emergence of a revolutionary class consciousness in Europe with a few centuries' hindsight, describes regrettably how, in its aftermath, the "rule of the honourables was almost everywhere re-established with new force, and the opposition of the middle-class remained broken for a long time".[1] Though the very fabric of German society had been called into question, the aristocracy nonetheless remained well-positioned to exploit the resulting chaos for its own longevity. "Old patrician routine thus dragged on", Engels observes, "hampering commerce and industry in every way, up to the French Revolution".[2]

Nevertheless, the Peasants' War still changed a great deal. It had almost razed German society to the ground, and although its new sense of individualism can be credited with the paradoxical production of a new class consciousness, the further exacerbation of individualism was also the central weapon used to undermine it, instigating the new age of liberal subservience that followed. Though this might make any change brought about by the Peasants' War seem negligible, it is nonetheless true that the relations of power that existed before its outbreak had to be completely redrawn. Indeed, pre-existing forms of social organisation had been, if not destroyed, at least heavily damaged, and so the peasants' failure allowed certain mechanisms of social control to be reconstructed with a new essence — just not for the better.

What should be emphasised is that, as all methods of social manipulation were fundamentally reimagined, the most significant outcome of the Peasants' War was the further maligning of the role of religion in society. In this sense, the Peasants' War had, in fact, constituted its own kind of Apocalypse, but rather than a new society based on the Protestant grace of God, as was the Lutheran ideal, a new and inchoately capitalist conception of an individualistic society instead took its place. Protestantism, then, in the words of Fredric Jameson, served as a kind of "vanishing mediator".[3] The slippage between Protestant and newly capitalist ideals was not a minor adaptation but rather a major shift disguised as a subtle formality. As Slavoj Žižek argues, drawing explicitly on Jameson's thesis, this opened "the way to the devaluation of religion" across society in general, allowing for the emergence of the "'normal' state of bourgeois society where religion is reduced to [a] 'means'", rather than a virtuous end in itself; it was reduced "to a medium enabling the subject to find new strength and perseverance in the economic fight for survival, like those techniques of 'self-experience' which put the encounter of our 'true Self' in the service of our 'fitness'".[4]

The remnants of a supposedly "Protestant" ethic were thus applied to every section of society, such that the importance of religion itself began to fade. The Church no longer held a privileged position as a major pillar of social organisation, instead taking on a relatively minor role in doctrines of self-improvement, as if going to church were reduced to a habit no different from eating well and exercising often, which are again not understood as ends in themselves but rather as means for maintaining the viability of a workforce. This gradual malignment has continued down the centuries, such that we now live in an increasingly secular society in which a growing

majority of people do not identify as religious at all. Of course, understood in the context of our contemporary biases, we are unlikely to mourn religion's dwindling relevance to all of our lives, but the church was nonetheless once an important place for the production of communal understanding — and, most importantly, as a place where a broader sense of transcendence and transformation could be actively imagined. Ultimately, the vanishing of the Protestant mediator has left us with a world in which forms of social gathering have been largely abandoned, allowing the individualistic world we now know to come to the fore.

This disappearance was not coupled with a convenient amnesia, however, with the explosive class consciousness that instigated the Peasants' War being immediately forgotten in its aftermath. Though those in power have done all they can to obscure it, over the centuries that followed this near-revolutionary moment, a new consciousness has continued to permeate all levels of society regardless, even if it has been made impotent. We might argue that this is, in part, why all that was lost through the maligning of religious communities later became a preoccupation for so many artists and writers, who may not have mourned institutionalised religion explicitly but nonetheless found themselves still desiring the kinds of communal understanding it made possible.

It is particularly significant that many philosophers in German society remained attuned to this growing secular tendency, such as Friedrich Nietzsche, who most famously declared that God is dead and we have killed him. But this cry is less a claim that we have lost our moral compass, as many loyal Christians still often argue in the face of our contemporary secularism, instead suggesting that we have lost our sense of perspective, such that we are, as Žižek argued,

overly concerned with the minutiae of our individual lives. The death of God, then, signifies the loss of our sense of infinitude, of our capacity to be so much more than we are, which Dürer expressed in his Christ-like self-portrait from 1500. Instead, in killing God, we have not only diminished religion but our own hopes for a heaven on Earth, or rather a world beyond the reductive drudgery of capitalist life.

The new methods of manipulation that emerged from this reduction of the social to the doctrines of individualism frustrated many artists too, including those among the middle classes, who may have found themselves free to explore their own interests and desires but nonetheless felt incapable of affecting the world around them as immediately and forcefully as they may have liked. As such, these manipulations deceptively restricted the freedoms supposedly afforded by individualism and its technological counterparts, the printing press in particular. One notable result of this was that art, like the new Protestant individual, was increasingly detached (at least politically speaking) from the social order and its material conditions, and so artworks were, at this time, first reduced to the status of a commodity. The reduced significance of the Church's role in society was perhaps the first step towards this new reality, since its malignment deprived art itself of an important social context. (We might think that the existence of contemporary art galleries accounts for this loss, but here art too is reduced the a "means". Indeed, the clinical nature of a white cube hardly inspires us in the same way that churches do, as more holistic spaces of spiritual transcendence, where every aspect of a building's architecture attempts to propel us into some spiritual beyond — something an artist like Mark Rothko, for instance, hoped to re-establish in a more secular twentieth century.[5])

Over the centuries that followed this adaptation, whilst some artists accepted the situation uncritically, many others clearly expressed their dissatisfaction with the apparent necessities of individualism. For example, briefly discussing the careers of two eighteenth-century painters, Joshua Reynolds and Thomas Gainsborough, Reuben Wheeler writes how many artists, faced as they were (and still are) with art's subservience to financial markets, "had two choices: to compromise with this development and produce a commodity art ... or to remain outside of society".[6] He continues:

For Reynolds the compromise provided wealth, social position and an assured reputation for a second rate talent; for Gainsborough wealth and comfort was assured, but the compromise robbed England of the chance of producing a very great artist besides a brilliant painter. Gainsborough could have been both but not in the material self-satisfied society of eighteenth-century England.[7]

Countless artists have since fallen along this same divide. With the social function of art now paradoxically dependent on the status of the individual, we have all found ourselves restricted to our individual pursuits, otherwise facing exclusion from society at large, whether that be due to increasingly limited opportunities for sustainable patronage, or in terms of our wider influence on society being limited more generally (unless we appeal to various cultural gatekeepers and their associated institutions). Art did continue to influence other areas of social life, of course, as it does today, largely in spite of the restrictions many artists face, but this level of influence was still only accessible to a lucky few, at least when compared to the broader social potentials that had previously been

demonstrated by the likes of Dürer. Artists instead struggle against their role as mere entertainers, offering pretty vistas or calming poems as a kind of palliative to the masses, with the possibility of more in-depth and transformative contributions to society being made increasingly difficult to actualise.

Though this may sound like a pessimistic perspective, who is not aware of the prevailing feeling among the general public today that art is not for them, instead being reduced to a leisure activity enjoyed by more privileged classes? But artists themselves are hardly unaware of this disconnection between the individual and broader society. Such frustrations were particularly palpable during the rise of Romanticism, which was an artistic movement clearly centred on the status of the secular individual who hopes to find transcendent experiences outside of religious doctrine. But the movement also demonstrated how the individual has now been consumed by a new sense of ennui, much like Dürer's Lady Melancholy. This may have been because the Romantics knew all too well that to have the sort of broad influence on human knowledge that Dürer enjoyed, far outside the confines of the art world, was now very much a thing of the past. Nostalgia prevailed. But with society effectively smothering them, rather than supporting them, they sought out inspiration in more exotic lands, as if giving up on the idea that they could transform their lives at home.[8]

However, this implicitly colonial mindset only further helped make the artistic individual all the more synonymous with the new industrialist, without any guarantee of influencing anything other than one's immediate social circle. For Wheeler, writing in the mid-twentieth century, there seems to have been little change since — or rather, this cultural disunity has repeatedly found new ways of reasserting itself,

despite (or because of) our ever more rapidly changing social environment. As a result, though still writing about post-Renaissance Europe, he notably speaks in the present tense:

> For the genuine creative artist there is little choice: to compromise is to sacrifice his particular vision which provides his *raison d'être*, so instead he becomes isolated, outside the main area of society, neglected and very often abused when not just left to struggle in poverty.[9]

The significance of this to our overall thesis is hopefully clear. Whereas Narcissus was once understood as the inventor of painting, his predicament instead becomes a fatal trap where dreams of transformation go to die.

This is certainly a reality that remains familiar to us today, beyond the superstar echelon of individual artists who now financially dominate the art world. Instead, whereas Dürer had previously embodied a new artistic vanguard, the experiences of artists over the centuries since more closely resemble those explored and expressed by Caravaggio, in that they have found themselves restricted by or otherwise at the mercy of external — that is, often socio-economic or more explicitly political — forces that are now understood as being beyond their control. Any sense of a community, artistic or otherwise, is compartmentalised within the culture industries at large. The role of art itself, like that of the Church that often housed it, has been painfully diminished.

Though we may view this as a still pessimistic but also defeatist acknowledgement, it is worth understanding as an observation that still needs addressing today. This is not simply to benefit those artists on the social fringes, but the very quality of social life experienced by everyone more generally.

For example, how many artists or athletes or entertainers, who dare to comment on socio-political issues, find themselves dismissed and told to focus on their "day jobs"? How often are television shows or video games derided today for getting too "political"? Any influence that art may have to the contrary is acquired *in spite of* the preferences of those in power and their hegemonic limiting of our cultural and social imaginations. *If you wanted to be a politician, you should have become a politician*, the retort often goes, as if politics has become an enclosed "industry" like any other, restricted to a private sphere and accessible only to those trained in its administration. As a result, art's role as a basis for social consciousness — that is, a self-consciousness of both one's self and social class — has repeatedly been attacked, its significance instead restricted to the immediate output of an individual's labours; artistic pursuits (in the broadest possible sense) must be constituted in apparent *opposition* to society, rather than alongside it in the obscured complexity of its relations.

As a result, Dürer's apocalyptic visions have now been inverted, with many politically conscious artists no longer decrying an emergent social order but instead the very cul-de-sac of the individual that sets them needlessly apart from their own communities. As such, in leftist discourses in particular, it is no longer the social order, generally speaking, that is to be torn away, in order to privilege the individual (as many a libertarian may argue), but rather, in a truly narcissistic fashion, the figure of the entrapped individual itself that has to be overcome.

11. The Return of the Gothic

The suggestion that what is required of us is an overcoming of the individual sounds like a more radical and abstract proposal than it is in actuality. In fact, it is a proposition we have wrestled with throughout the history of art and culture. And in order to understand the emergence and persistence of this cultural conflict between the individual and the social, we need look no further than the classics of Gothic literature produced in the nineteenth century, around the time of the Industrial Revolution, which remain deeply influential to this day and where the anxiety we all may feel towards this enclosing and limiting of our multiplicitous selves can still be found in abundance.

Robert Louis Stevenson's *Doctor Jekyll and Mr Hyde*, for example, famously tells the story of one man's struggles against two differing "personalities", incapable of a union. Emily Brontë's *Wuthering Heights* likewise dramatized the extremity of an interpersonal relationship that cannot be contained within the diluted Protestant ideals of Victorian society, such that the ghosts that haunt the West Yorkshire moors in Brontë's tale are not simply those of heartbroken individuals but the spectres of an ill-fated social relation. Relatedly, Mary Shelley's *Frankenstein* contends with the production of new monstrous subjectivities, with the monster at the heart of her story itself being an amalgamation of cadavers, brought (back) to life through the electrified machinations of new industry. Though he wants nothing more than to be loved and accepted,

the novel's monstrous and unnamed new subject is spurned at every turn. Whilst his creator is described by Shelley as a "modern Prometheus", the monster himself comes to resemble a modern Narcissus, disastrously alienated from the very society that produced him.

Each example — and there are countless others — is repeatedly retold and redramatised in contemporary pop culture, and each expresses, in its own way, a new melancholy regarding our (in)capacity to coexist with ourselves and others. Though the central anxiety at the core of each tale may be buried under various horrors, we can nonetheless argue that the tension between the individual and social remains implicit in each, as all artists and writers find themselves perpetually "cut off from the fundamental driving force of all art, which was", as Wheeler writes, "the expression by the individual for the community, of the community's need to establish a sense of the stability and order of things transcending the predicaments of ordinary material existence" — a material existence that was the direct, if diffuse, result of the failure of the Peasants' War all those centuries ago.[1]

It is no coincidence that this striving is found so often in the Gothic. Though it is a shape-shifting and transhistorical aesthetic mode, our history books nonetheless tell us it first took hold of our imaginations in those centuries immediately prior to the Renaissance. Following the rise of the individual, it has been renounced by many as a remnant of a more uncivilised age. The French playwright Molière, for instance, famously derided his home nation's "besotted taste of Gothic monuments" in his 1669 poem "La Gloire du Val-de-Grâce", echoing the fashionable opinions of his time, claiming France's Gothic façades depicted little more than "odious monsters of ignorant centuries" from which "the

torrents of barbarity spewed forth".[2] But in constituting the last great artistic movement of a more social age, prior to the individual's conceptual ascendence, the Gothic has persisted regardless, just as our desire for a pre-individual — that is, an altogether more social — age has also persisted. Indeed, the monsters that emerge from these "ignorant centuries" are often depicted as grotesque beings that rupture the false stability of the individual subject as we have since come to understand it. What we fear is the breakdown of an already false unity. But to will such a breakdown is also a desire that has nonetheless been taken up by many political radicals since.

This desire needn't be predicated on a reactionary striving for the past. Gothic imagery is central to the nineteenth-century writings of Karl Marx, of course — which often spoke of spectres, vampires and hobgoblins — and it has retained ever since, at its core, an attempt to overcome the limitations of individualism (and the occulted forces of capitalism more generally), both in the present and near-future — something that the inescapability of individualism's capture makes innately horrifying for us, in that it requires an awareness of socio-political forces that far exceed our individual agency.

Indeed, a tendency towards an explicitly "Gothic Marxism" has found increasing traction in recent years, particularly online. Jonathan Greenaway, on his popular blog *The Haunt*, argues that "we need a Gothic Marxism" today, which he defines as a mode of "analysis that would expose the occult economies of capitalism that keep hidden the ways in which capitalism operates and normalizes itself as well as understand this cultural proliferation of monsters for what they are" — that is, "not just a warning of what we think may happen, but a record of what is, in so many ways, already happening".[3]

One such thing that is already happening is the breakdown of the concept of the individual, the outer reaches of which have never be containable within the hegemonic cultures of liberalism and neoliberalism. Though "neoliberalism" is viewed by many as a contentious, overused and under-defined signifier today in political discourse, it nonetheless still speaks to the ways that liberalism has mutated in the postmodern era, mutating our senses of self in turn, all the while provoking in us a sense of horror and haunting when we cast our gaze over the spectral subjectivities that are not included in its limited conception of personhood.[4]

Though many may affirm this sense of horror, in that it allows us to more easily identify the disruptive potentials of those forms of life symbolically excluded from the status quo, it is also true that demons and mutants are invoked by those in power to disregard those on the fringes, again echoing the religious remnants of Protestantism's subsumption within the capitalist worldview. As Adam Kotsko argues in his 2018 book, *Neoliberalism's Demons*, which makes explicit use of Gothic imagery and Protestant Christianity's literal demonisation of anything that exceeds its bounds:

> Neoliberalism's appeal is its promise of freedom in the form of unfettered free choice. But that freedom is a trap: we have just enough freedom to be accountable for our failings, but not enough to create genuine change. If we choose rightly, we ratify our own exploitation. And if we choose wrongly, we are consigned to the outer darkness — and then demonized as the cause of social ills.[5]

We might recognise the "narcissist" as one such contemporary demon. But if such monsters continue to stalk us through

popular culture, both past and present — whether those established through Gothic literature, those depicted in the allegorical paintings of Caravaggio or in Dürer's visions of the Apocalypse — it is because they are not simply representations of the *causes* of social ills, but also of the outliers of an enclosed culture that refuses to make space for those who wish to live their lives differently. In this sense, as Greenaway continues in his treatise on Gothic Marxism:

> The monsters we see all around us in culture are an anxiety-laden response to real social practices and symbolic registers. Vampires, zombies, kidnappers and other monsters are an outworking of a particular set of social concerns — determined by economic and other material conditions ... [B]ut what needs to be made explicit is that whilst we have concrete monsters to fear, they reflect something far more diffuse — that wider, far more nebulous threat to human personhood and bodily integrity which emerges when one's own life is dependent upon selling your energy and labour on the market.[6]

With all this in mind, perhaps we can see how the persistence of the Gothic suggests not a desire to return to the barbarity of the Dark Ages, prior to the Renaissance, but rather a desire for a post-individualist (and even post-capitalist) society. Here lies the contradiction at the heart of a modern narcissism, after all. Though we are encouraged to embolden our singular senses of self, our subjectivities are nonetheless divided by the control mechanisms of the market and our society's disciplinary institutions in general.

We are all Narcissus, we are all monstrous, in that we are trapped between various ways of seeing and being seen. If we

are left with the feeling that we are stuck between a rock and a hard place, that is surely no accident. This is the very essence of our capture. But what is produced is a volatile stasis, and the more aware we become of its instability, perhaps the more aware we will become of the fact that something has clearly got to give.

12. The Rise of
the Photographic Self

Today, this defiant striving for the post-individual can be found explicitly in a medium like photography, which has always retained a certain Gothic tendency at its core, in being associated with spectres and hauntings since its very inception. It is towards this medium that we shall turn in this book's second part.

Photography is relevant here for a number of reasons, and not simply because it is the medium we now use most frequently to depict the self to ourselves and others. It is a medium that takes the chaos and confusion inaugurated by the printing press and exacerbates it to a previously unthinkable degree. As Walter Benjamin argued in his seminal essay on "The Work of Art in the Age of Mechanical Reproduction":

> For the first time in the process of pictorial reproduction, photography freed the hand of the most important artistic functions which henceforth devolved only upon the eye looking into a lens. Since the eye perceives more swiftly than the hand can draw, the process of pictorial reproduction was accelerated so enormously that it could keep pace with speech.[1]

It is this monstrous acceleration that terrifies and unnerves us so utterly, both in terms of its relation to our

ever-accelerating industriousness and our frayed capacity to observe and analyse its affects. If the aftermath of the Peasants' War saw the intensification of the disunity between the individual and social, by flattening and further obscuring the relations between the two, then the Industrial Revolution only made matters worse. But what both periods have in common is a series of tandem technological and cultural developments that have changed society in significant if subtle ways. Indeed, just as the social adaptations inaugurated by the printing press lingered over the trials and tribulations of social consciousness following the Renaissance, the social impact of photography continues to linger over our collective consciousness today.

This is all in spite of the fact that photography appears to be the medium of individualism *par excellence*, with the frontal perspective that Dürer understood as an innovation being made a fundamental part of its operation. But photography's deployment as both an individualised and innately social technology has, like that of the printing press, been far from compliant, uniform and linear. Even at the moment of its conception, some of photography's inventors and first practitioners resisted and actively fought against the medium being restricted to the ideals of a still-emerging capitalist world. They experienced — ahead of most other, more established mediums — the additional compromises and contingencies that photography produced within an increasingly industrial and industrious society.

The ways that these conditions were to impact our understanding of the self and power's relationship to it were readily apparent from the beginning. This came not from the reinforced supremacy of the individualist's point of view, but rather from the threat photography posed to our very conception of the individual self in a new era. Photography,

in this sense, can be seen as a horseman of a new apocalypse, establishing the long-desired death of the individual as such.

In the following section, we will explore the impact of photography on the individual in this regard at length. Though many of the problems explored above remain relevant to the present day, the problems introduced into society by photography are considerably more complex, constituting nothing short of a Copernican revolution with regards to our understanding of modern subjectivity. Indeed, though Dürer's sense of melancholy now seems foundational to our pessimistic understanding of the individual self and its potential as an agent of social change, something shifted with the invention of photography— as much for the better as for the worse.

This is because photography is a medium that alienates us in a way that painting does not. Though the centrality of the frontal perspective that defines the medium emboldens Suzanna Berger's theory of the "meta-image", which makes us more aware of our own capacities of observation than ever before, photography, despite its appeals to "realism", also exacerbates our sense of our own impotence and the subjective distance we feel from the objective world around us. But we turn towards it anyway, producing increasingly incalculable numbers of images for ourselves and others. It is as if, despite the fact that we have been traumatised by photography's role in the accelerated destitution of our subjectivities, the medium allows us to bind these traumas to the chaotic world it depicts. It concretises, at split-second intervals, our sense of self, whilst at the same time documenting its very dissolution.

The complex nature of our relationship to the medium in this regard cannot be understated, and we shall soon turn more emphatically towards contemporary philosophy than

we have thus far in an attempt to understand these apparent paradoxes. This is necessary if we are to further dismantle the idea of the individual that we so take for granted. Indeed, such a philosophical turn is essential if we are to effectively challenge the dominant understanding of the individual self and its social agency, which leads us to denounce the potentials of self-portraiture so persistently in the present.

Narcissism, or at least our more positive conception of it, remains relevant here. As in Freud's formulation, it is a product of a trauma we all experience, wherein we find our sense of self made destitute and unstable by the machinations of power. But through discussions of a number of photographers — principally Hippolyte Bayard, Lee Friedlander and Hervé Guibert — we will discover how this traumatic destitution nonetheless constitutes an innately Gothic wound, which must be more actively sutured and rebound by all of us. In binding our trauma to the political problems of our modern world in this way, we will discover new methods for self-fashioning that far exceed the limited potentials currently ascribed to the selfie as a symbol of all that is wrong with contemporary society.

In much the same way that the persistence of the Gothic offers us ways of exploring a kind of ruptured subjective position, death and melancholy will come to dominate our discussions even more, as death has long been deployed as a negative symbol of any post-individual unknown, giving form to the anxieties so many felt when first confronted with the relatively new medium of photography. But just as Dürer's apocalyptic visions were suggestive of a future unveiling, so too does photography's persistent relationship with death uncover new ways of thinking about the world and its myriad subjects also. The anxiety we feel when we consider our own

mortality is central to so many theories of photography in this way, but we should prepare ourselves, as many artists of the Renaissance did, to read in this death the possibility of a new life and a new kind of self-image — one which moves against the false consistency of the self that we understand the selfie as being the ultimate representation of.

Just as the settling of Renaissance tensions revealed the new concept of the individual to be full of holes, so too has photography's ubiquity further widened these gaps, even as it is proclaimed to be an important medium for establishing its more stable opposite, revealing new possibilities for us to affirm and explore, but only if we can further suspend our belief in liberalism's individualistic founding doctrines, which are as unstable now as they were at their inception.

We will uncover this instability through an analysis of one of the first photographic self-portraits ever made, before considering how this instability can tell us a great deal about the power relations that art, since Caravaggio, has often tried to manipulate and circumvent. As we consider how the medium has become more ubiquitous in the twentieth and twenty-first centuries, we will take as an injunction the work of Lee Friedlander, whose entire body of work explores the unsettling gap between the individual and social, illuminating the kind of purgatory we are all captured by but which we seldom notice. From here, we will see how certain photographers, particularly those who are members of marginalised social groups, and under the influence of anti-visual trends in French philosophy in the late twentieth century, took to renouncing the medium and the selves it depicts altogether. But rather than following them into a blind dead-end, we will make the case for photography as a temporal weapon in our capitalist age, which can interrupt the false consistency that is forced

upon us, making the case for other forms of life that can only be concretised through acts of self-reflection and mediation that we might otherwise denounce as "narcissistic".

As was the case for Dürer and Caravaggio, the selfie remains an intriguing and complex artform in this regard. To renounce it entirely, moralising against its now-trivial over-production, is to deny ourselves one of art history's most important modes of self-expression, as well as an important foundation for any kind of political consciousness no less. As such, its increased accessibility, thanks to photography, is not something to wholly berate. It makes the questions once asked only by a privileged few far more relevant to each of us, assisting us as we ask ourselves who exactly we want to be, and what kind of world we really want to live in.

Death

13. Death Becomes You

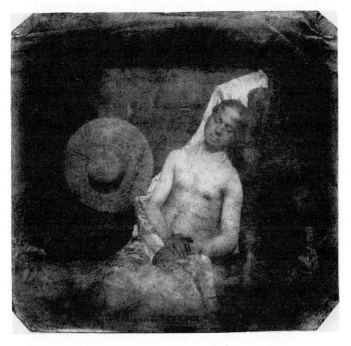

Hippolyte Bayard, Self Portrait as a Drowned Man, 1840.

In 1840, Hippolyte Bayard took a selfie. Using his own process of direct positive exposure, he titled the image *Self Portrait as a Drowned Man*. The picture is as described: we see Bayard himself, languishing in a voided room, partially wrapped in what looks like a burial shroud, his neck limp and his head cocked to one side, as if he has been found sleeping.

And yet, beyond the obvious signposting of its title, it is also unclear how we are supposed to understand the photograph before us. There is so much about its context that we do not know. Is it a document of an accident or a suicide? Is this a portrait of a man who, in the moment of his death, found peace with his odd fate? Or is this a man depicting himself violently as a piece of waterlogged detritus, abandoned and unclaimed, in an otherwise neutral environment? Is this a death met with serenity and dignity, or a macabre piece of melodrama?

Bayard could be a captain gone down with his ship, or a man dredged up from the depths and left to one side like any other inanimate object. But a sunhat sits incongruously on the wall behind him, suggesting another existence — perhaps a life of leisure interrupted or otherwise denied. Either way, the scene is quietly surreal, even dreamlike, with its quietude also making it an innately anxious and reverberating image. But the tension inherent to its unanswerable questions is oddly fitting for its subject and true context.

The story of Bayard's selfie begins a few years earlier, when he had hoped that a demonstration of his photographic prowess would astound the world. It had been two decades since Nicéphore Niépce had produced the first blurry images of a farmstead in eastern France, using a process of chemical engraving known as "heliography", and now the race was on to establish a technique that was consistent, portable and commercially viable. Bayard was confident that he had the magic recipe for success, and he hoped his particular photographic process would be an exciting new business venture for him. It is not hard to see why. His early experiments remain scientific marvels for the period,

as products of one of the most accomplished photographic processes yet devised.

Though we think of it as an ostensibly modern invention, it is worth noting that the techniques used to produce the optical phenomena that make photography possible have been well documented across millennia. Like how the human eye works, at least in principle, a small hole in the wall of a darkened room can produce an upside-down projection of the world outside. There are records of experiments that make use of these projections going back thousands of years, with the earliest recorded observations appearing in the *Mozi*, an ancient Chinese philosophical text dating back to around 400 BC.

In the nineteenth century, experiments with various chemical processes suggested that we might finally be able to "fix" these projections in place, making early photography a primarily scientific rather than artistic pursuit. Whilst some of the medium's principle inventors did dabble with painting and other creative endeavours, fame and fortune lay in state recognition and subsequent funding, and this was awarded on the basis of technological innovation and scientific advancement rather than constituting a new kind of state-sponsored artistic patronage. It seemed, at that time, like the medium's scientific benefits clearly outshone its creative potentials.

It is for this reason that Bayard's self-portrait was intended to be a demonstration of his chemical process, and it is an impressive one at that. But it is also, notably, a fiction; a constructed scene. Perfectly framed, here is a man with a painterly sensibility, working in a wholly new medium. The image also has a narrative, and an expressive and emotional character in being a solemn, even macabre self-portrait,

encapsulating a sense of drama and self-concern. As a result, alongside its status as a scientific marvel and a potential business opportunity, *Self Portrait as a Drowned Man* is one of the first photographic works of art ever made.

We might ask ourselves, with this in mind, if painting is the flower of all the arts, as it was for Alberti, then what is photography? It seems to function like so many other scientific advancements of the period, which finally made possible what human civilisation had previously only dreamed of: directly capturing that surface of the spring. But the drama of Bayard's image implicitly asks a more morose question: at what cost?

Photography's apparent fidelity to reality made many early viewers of the medium uneasy, encapsulating a number of innately Gothic concerns. Just as Doctor Frankenstein combined art and science to sculpt and electrify his monstrous amalgam of human cadavers, so does Bayard create a narcissistic and composite self-image somewhere between life and death, demonstrating not only an active sense of self but a passive acceptance of a perceived destiny. Here we might see Bayard as a photographic Caravaggio — and his self-portrait certainly echoes the *tenebroso* style. But whereas painterly self-portraits seemed to focus on what we might gain from or otherwise become as a result of our self-reflections, photography emphasises the darker side of Narcissus's tale. With Caravaggio's allegorical self-portraits, there is a sense of bargaining; in Bayard's, only the self-deprecating howl of alienated resignation.

In freezing the subject in place, in those moments immediately after his "demise", Bayard provided the world with an image that cemented photography's often disturbing and persistent associations with death. It is an image that

presages, for example, the *memento mori* photographs of the Victorian era, when the death of a loved one often occasioned the commissioning of a family portrait, with the recently deceased propped up in the centre of the frame. In the twentieth century, this usage understandably fell out of fashion, as Western society became increasingly squeamish about reminders of its own mortality. But photography itself played a vital role in this inadvertent emotional adaptation. Susan Sontag, in her seminal text *On Photography*, argues precisely this: "The effectiveness of photography's statement of loss depends on its steadily enlarging the familiar iconography of mystery, mortality, transience".[1] In other words, photography not only fixed the light of this world to the page but, paradoxically, the very transience of life itself. Following the emergence of this new way to document ourselves for posterity, we have never been more aware of our own finitude.

This "statement of loss" seems largely abstract and conceptual in the present, maybe even a little romantic and melodramatic, but photography's relationship to death was much harder to ignore in the earliest examples of studio portraiture. Exposure times for the earliest photographic processes could vary from ten to thirty minutes; fidgety and full of life, people were impossible to photograph accurately across any length of time. (This is most apparent in images of children, who, as anyone knows, hate nothing more than sitting still.) And so, at first, the medium only allowed us to document the shifting nature of our immediate surroundings. Eventually, photographs could be compared across months, years, even decades, highlighting the wear and tear that daily sightseeing could not comprehend. It illuminated, with new clarity, the "injuries of time", or so

argued another early photographic pioneer, Henry Fox Talbot.[2]

Though it would take some time for people to be documented effectively, photography soon came to catalogue time's injurious effects upon the human body also, even its metaphysical constitution. "Photographs show people being so irrefutably *there*", Sontag continues, "and at a specific age in their lives"; they "group together people and things which a moment later have already disbanded, changed, continued along the course of their independent destinies".[3] Soon enough, photography's beginnings documenting buildings and assisting with the observation of scientific truths seemed quaint. Photographs do not document a static truth at all, but rather fleeting glimpses of our world's constant becoming. In this sense, photography does not *preserve* time at all; the ways it might stall and interrupt the movement of our world are only illusionary, as we become increasingly aware of time's infinite duration, a process which is so central to life but which photography itself cannot capture, except at melancholic intervals. Early photography, then, captures what life can never be; it captures what is still and what has stopped. As soon as society realised this, Sontag concludes, photography became a new method for the production of an "inventory of mortality".[4]

Still, this is a romantic understanding of photography's relationship to death, conjured out of hindsight. In truth, photography's morbidity did not begin with its ability to photograph people as they are, if only for a moment, but rather in its initial failure to capture any singular moment whatsoever. Indeed, at a time when photography was only capable of recording things that were completely static, to photograph people was an eerie affair.

Louis Daguerre, Boulevard du Temple, Paris, c. 1838.

For example, Bayard's principal rival, Louis Daguerre, is said to have taken one of the first photographs of a person in the late 1830s, but he did so almost entirely by chance.[5] In a photograph looking down upon the Boulevard du Temple in Paris, a lone figure is seen resting against a water pump. Daguerre's image — the product of his own personally devised process; not a photograph, but a "daguerreotype" — required a ten-minute exposure time, and so, whilst the rest of Paris moved around him, this unknown figure stood still just long enough to be registered by the camera, making him appear alone on an otherwise empty street — a ghostly figure, half-captured, waiting and lurking on a street corner in an abandoned world. This sort of failure has haunted us ever since, revealing what Eugene Thacker has more recently called "the world-without-us".[6]

The "world-without-us" is Thacker's term for "the subtraction of the human from the world" — or perhaps, more accurately, the subtraction of an anthropocentric *point of view*.[7] Although we might associate such a concept with post-apocalyptic science-fiction today, it is a world that we have been made increasingly aware of, ratified by the ever-peculiar world of scientific fact, which now often relies on more inhuman forms of machinic vision to make its observations, with scientific evidence recorded with the sorts of cameras or imaging processes that can now see far beyond our visual spectrum, corroborating seemingly paradoxical observations of otherwise unobservable phenomena.

This was a process that was vastly accelerated by the invention of photography, and as science has continued to advance along these lines, it has become more and more necessary for us to understand that there are other ways of seeing this world than through our own two eyes. Indeed, photographs reveal just how limited our perspective can be — something that fascinates us as much as it may unsettle us.

If this was a vision of the world newly inaugurated by the rise of photography, it was achieved contrary to expectation; photographs of people were intended to be personal and sentimental rather than "impersonal and horrific".[8] But in trying to make some of the first portraits of people with a new medium, this was the experience lying in wait for many an unsuspecting photographer. For example, even though heads and bodies could be fixed in place with subtle scaffolding in studio settings — with such contraptions looking more like medieval torture devices than accessories for a new technology — a person's eyes were prone to rove free. As Daguerre had already demonstrated, anything that moves during a long exposure is unlikely to appear in the resulting photograph at

all, and so, despite how much encouragement a photographer might give their subject, no one could keep their eyes open long enough for a full ten-minute exposure to take place.

It was here that photographic portraiture first met its true nemesis: the blink. Its irresistible intrusions meant that many early portraits of people were glassy eyed, or appeared to show no eyes at all. Many studio owners even began recommending that those sitting for portraits closed their eyes instead, inexplicably believing that this helped people look relatively less deceased. Others began painting odd-looking googly eyes onto their photographic prints, thinking that to add artificial pupils and irises was better than accepting their eerie absence. Suffice it to say, until exposure times improved, making people — and, indeed, the world at large — look alive was a real challenge.

This led many of the people who first encountered photography, early on in its development, to be untrusting of this new technology. The nineteenth-century photographer Félix Nadar, in a memoir of his "photographic life", recalls how the French novelist and playwright Honoré de Balzac had a spiritual aversion to the medium, for instance. According to Balzac's inchoate theory of the human spirit, "each body in nature is composed of a series of specters, in infinitely superimposed layers, foliated into infinitesimal pellicules, in all directions in which the optic perceives the body", and photography appeared to possess the ungodly ability to "catch, detach, and retain, by fixing onto itself, one of the layers of the photographed body".[9]

We may be familiar with this superstition already: in popular culture, it is often questionably attributed to Native Americans, ridiculed for their belief that to have one's photograph taken is to have the camera steal part of one's soul. But this superstition was just as common among nineteenth-century Europe's

cultural elites, especially those interested in the contemporary fad of spiritualism. In this sense, photography was not the individualist's natural medium but a threat to their very constitution, and Western liberals were just as unnerved by it as those from supposedly less "civilised" corners of the globe.

At first glance, Bayard's self-portrait is a clear antecedent to this tendency — and it is possible that he may have photographed himself as a drowned man simply because a more active portrait was not possible. But *Self Portrait as a Drowned Man* does not, in fact, depict an artist confronting the limits of a new technology or his own mortality at all, but rather an individual mourning the assumed death of his own career. What Bayard feared most was not the experience of his own death, but his unceremonious ejection from the history books. In many ways, he was right to.

When we think about the principal inventors and innovators who first shaped the medium of photography, the first people to come to mind are likely those already mentioned in passing above: Nicéphore Niépce, Louis Daguerre and Henry Fox Talbot. Whereas Niépce captured the very first photographic image, the latter two innovators — from France and England respectively — improved the clarity, speed and mobility of early photographic equipment tenfold. There are, of course, many other lesser-known figures who invented their own processes or otherwise mastered early photographic techniques long before they were commercially viable. Among these names, as ever, are several pioneering women, such as Anna Atkins and Mary Dillwyn, who have only recently been subject to archival exhibitions and publications, celebrating their almost forgotten contributions to an otherwise socially privileged and patriarchal practice. But Bayard also felt he was at risk of becoming another name lost to popular history. He found

MATT COLQUHOUN

himself in direct competition with Monsieur Daguerre for funding and recognition, and it turned out that Daguerre was a ruthless industrialist and a force to be reckoned with.

The two men were public rivals, having independently developed competing chemical processes and photographic techniques. Bayard's process was, arguably, the better of the two. It appears that he also demonstrated it better, with a creative flourish and painterly eye; his early experiments include a gorgeous array of still lifes and flower arrangements. No doubt confident in himself and his invention, Bayard hoped to reveal his work to the French Academy of Sciences, so that he might acquire funding to develop his practice and claim his place in the annals of photographic history.

Nicholas H. Shepherd, daguerreotype of Abraham Lincoln, 1846 or 1847. Library of Congress / The White House Historical Association.

113

Unfortunately, Bayard was dissuaded from doing so by François Arago, a renowned member of the Academy who had been inducted at the age of just twenty-three for contributions to the field of analytic geometry. Perhaps it was this esteemed reputation that led Bayard to trust Arago, but he was wrong to do so. A friend of Daguerre's, Arago distracted Bayard so that his rival could pip him to the post, showing his photographic process to the Academy before Bayard could reveal his own. A further contributing factor to Daguerre's preferential treatment may have been that he was previously mentored by Niépce, who had sadly and suddenly died of a stroke some years earlier in 1833, and so Daguerre was favoured as the true inventor's understudy. But even Niépce's role in Daguerre's early success was initially downplayed. It appears Daguerre wanted all the credit for himself, and his was a desire that crossed borders; soon after revealing his invention to the Academy, he developed a rivalry with Henry Fox Talbot over in England as well.

Daguerre traded the rights to his invention with the French government in exchange for a lifetime pension. The daguerreotype became the first commercially available photographic technique. It was made "free" to the world — excluding England, of course, owing to Daguerre's rivalry with Talbot — and was a runaway success. Soon enough, portraits of many of the mid-nineteenth century's most famous people were produced using Daguerre's method — such as the image of Abraham Lincoln included here — until it was superseded by new and improved processes a few decades later.

Bayard's disappointment and frustration over his unjust marginalisation must have been considerable. Indeed, it was this incident that led to the making of his macabre self-portrait. The image heralded not an exit from life but instead

teased a sort of Rimbaldian exit from a *life-as-photographer*. In this sense, we might see it as an expression of his own frustration at the ruthless individualism now governing the medium's development. Daguerre was even called out by name in the "obituary" Bayard wrote to accompany his suicidal selfie, which reads as follows:

> The corpse which you see here is that of M. Bayard, inventor of the process that has just been shown to you. As far as I know this indefatigable experimenter has been occupied for about three years with his discovery. The Government, which has been only too generous to Monsieur Daguerre, has said it can do nothing for Monsieur Bayard, and the poor wretch has drowned himself. Oh the vagaries of human life...![10]

Predicting his own relegation to obscurity, Bayard has ironically found an enduring fame since, thanks to this bitterly expressive staging of his own demise. As a modern Narcissus, Bayard's *Self Portrait as a Drowned Man* remains, somewhat ironically, his best-known work. In a marvellous twist of fate, transforming himself into a new flower of the arts, pressed between photographic plates, Bayard preserved forever a subject that he believed was scheduled to disappear from history without a trace: himself.

14. Photographic Exits

The black comedy of Bayard's performative exit from history is poignant in light of the self-portrait's painterly beginnings and its contemporary ubiquity. Photographic expressions of self-concern are clearly not a new and postmodern affliction but were rather central to the birth of the medium.

But of course, Bayard's time is not ours. Photography may have since made the production of self-portraiture truly accessible to us all, but whereas Bayard's self-portrait was perhaps one photograph among dozens made in 1840, in the 2020s we are expected to take ~1.5 trillion photographs a year globally. Bayard's documentation of his own dissolution was an ingenious (if nonetheless inadvertent) way for him to ensure he would never be forgotten; today's self-portraits smother us in their apparently meaningless ubiquity. Bayard's attempt at an escape is juxtaposed against our total capture. His experience, once particular, is now universal. We find ourselves cast adrift on an ocean of images, rocked by the incessant machinations of symbolic exchange, wherein our everyday political reality, which derides the superficiality of so-called "identity politics", nonetheless encourages us to show up and (re)present ourselves regardless. But despite the fact that our selfies and Bayard's are products of two very different times and worlds, there remains a fundamental (dis)connection between the two — that is, a shared sense of the disconnection between the self and its images.

Surrounded by homogeneous representations of an otherwise insisted-upon individuality, we are today increasingly aware there is no *one* self to be. We become alienated from and tormented by ourselves, like Narcissus himself, all too aware that we can never fully embody or otherwise possess the manipulated reflections that confront us every day, whether they are self-made or foisted upon us. Photography continues to play a major role in this capture, but as a result, the medium is not simply an inventory of our mortality today, as Sontag claimed; it is, in a more specific sense, an inventory of our subjective instability.

As in Dürer's early self-explorations, photography depicts not *the* self but our various *selves* — the selves we are, have been and hope to be. As such, though this subjective indeterminacy may trouble us, there is nonetheless a sense of hope to be extracted from our strange predicament — that is, the realisation that our indeterminacy, in being so open-ended, is ripe with potential, illuminating our innate capacity for change and transformation.

Because of this, the contemporary ubiquity of photography means that the unpredictable becoming that threatened Bayard alone in 1840 now threatens us all of us in the twenty-first century, and it is a process that begins to forcefully undermine the post-Renaissance ideal of the individual, as well as the political restrictions this idea has been disastrously responsible for.

Bayard's self-portrait made this announcement in a tenor of defeat. A product of his wounded ego, he commemorates the moment photography enters wider society with a document of his own ego-death. The image is passed around — today, this original and fragile material object is made infinitely reproducible and invincible as a digital object on the Internet.

It has become, and will no doubt long remain, a *memento mori* for the once-new figure of the photographer, reminding us that our histories remain defined by the victors of so many battles — and the aftermaths of these battles often shape our collective understanding of the self in turn. But compared to the examples we have already explored, Bayard's self-portrait appears to be an inversion of Dürer's much grander aspirations. He becomes a modern Narcissus, wrestling with a new kind of self — the photographic self — and his awareness of it, which has in turn given form to a new and unstable vision of the world, entering paradoxically through an exit.

It is in this way that, in spite of itself, photography, that most personal of mediums, announces the emergence of a newly impersonal world to us — a world in which we feel ourselves at the mercy of forces beyond our control, where the individual self is insisted upon but is also, as a result, made generic and inconsequential. This is true enough when we consider photography's paradoxically alienating first-person perspective. Though we understand our own images as documents of things *we* have seen, photography is promiscuous; any image can easily be adopted as if it is something we have seen with our own eyes. The photographer, though they exert control over how the scene before them is presented, is displaced almost immediately. Photography becomes an indeterminate medium for an eerie subjectivity, with the individual photographer equal parts present and absent.

However, this process of authorial displacement is not unique to photography in our modern era; in fact, it has been discussed far more explicitly in relation to other mediums, equally transformed by the accelerative nature of modernity itself.

The literary theorist and semiotician Roland Barthes most famously wrote about this subjective indeterminacy with regards to writing and the modern novel, in ways we might see as equally apposite within photography's own development. "Writing is that neutral, composite, oblique space where the subject slips away", he argues; it represents "the negative where all identity is lost".[1] Though an author might take full ownership of a novel during its gestation — and perhaps not even then, if we consider more experimental and "automatic" engagements with writing — their control over any text is diminished as soon as they relinquish it from their grasp. This is the so-called "death of the author", and the photographer dies a death in much the same way, albeit — as Walter Benjamin argued — at a far more accelerated pace.

When a text (or image) is divorced from the moment in which it was produced, no longer "acting directly on reality but intransitively … finally outside of any function other than that of the very practice of the symbol itself", then a moment of "disconnection occurs", Barthes argues; "the voice loses its origin, the author enters into his own death".[2] For writing, this may be a relatively protracted and convoluted process; with photography, it is more direct in being almost instantaneous.

Barthes' argument remains somewhat contentious in the realm of literary criticism today. Though we are predisposed to take him at his word in our postmodern moment of fan-fiction and expanded cinematic universes, in which the death of the author has never felt more affirmed by the impersonal processes of cultural production, Michel Foucault, in an essay entitled "What Is an Author?", argues that the death of the author is not something newly inaugurated by modernity but is rather inherent to writing itself (and always has been).

For Foucault, writing is a medium that, like its visual cousins, has always had a very particular relationship to death. Beginning from the same starting point as Barthes — that is, from the sense of subjective indeterminacy produced by writing — he argues that:

> writing's relationship to death ... subverts an old tradition exemplified by the Greek epic, which was intended to perpetuate the immortality of the hero; if he was willing to die young, it was so that his life, consecrated and magnified by death, might pass into immortality; the narrative then redeemed this accepted death. In another way, this motivation ... was also the eluding of death: one spoke, telling stories into the early morning, in order to forestall death, to postpone the day of reckoning that would silence the narrator.[3]

Here we can see something of Bayard's intentions: in killing himself in photographic effigy, he inadvertently provided himself with a new kind of cultural immortality. Barthes suggests that this process is still ongoing and must be consciously entered into, since our insistence on an author's authorial *authority* only limits the possibilities of writing — it is necessary, then, that the author dies. But Foucault subtly adapts this argument: it is not *our* task to kill the author, but rather the writer who must be willing to accept their own death in order to become an author at all, dissolving their individual efforts into the social realm of cultural production.

An "author" is, after all, a relatively new concept that has only grown in stature following the tandem emergence of the individual and the printing press, signifying a kind of objectified subject in a constant battle with itself. But rather

than being "something designed to ward off death", as was the case in antiquity, Foucault argues that it is writing itself that kills the author, now under the influence of new technological processes; it is writing that must "now possess the right to kill, to be the author's murderer".[4] Following Bayard's example, photography makes this process of entering into death all the more explicit, as if we cannot photograph ourselves without entering into this same relation, this same sense that the self depicted is short-lived and dissolved immediately by the process of its own external representation.

Of course, this is not to suggest that this form of death is some aesthetic conspiracy that has crept up on writers and photographers from behind, as if on finishing a work they turn to it and whisper: "*Et tu, Brute*?" It has been welcomed by many, who meet such a "death" head on, actively working towards that final moment where the writer and artist is subsumed into what Foucault calls the "author function", which has always been constituted by a kind of symbolic death, in which the author is little more than a referent, or perhaps the foundation for a theory, hypothesis or narrative, which far exceeds the individual who first midwifed the work into the world.

In this sense, Foucault later argues that an "author" is always already "dead", rather than referring melancholically, as Barthes might have it, to a specific someone who will die. Dying, then, is not a process that an author consciously undertakes; it is rather the inevitable result of an impersonal (and notably social) process of becoming-author.

This is how the term "author" acquires its inherent function as a kind of "death" for Foucault: the author is not the same person who writes or creates; the word "author" is rather a term of categorisation that separates and alienates the creative

individual from their own endeavours. As such, all artists — particularly those who turn towards themselves and their own experiences — find themselves falling into a narcissistic predicament, facing off against themselves as both subject and object.

Many modernist writers explicitly affirmed this fall into indeterminacy at the start of the twentieth century, and both Foucault and Barthes, despite their subtle differences, nonetheless consider this same period of literary creation explicitly, wherein, they argue, this tension came newly to the fore. But whereas Barthes speaks of the poet Mallarmé, for instance, whose "entire poetics consists in suppressing the author in the interests of writing",[5] or Marcel Proust, whom he argues was "visibly concerned with the task of inexorably blurring, by an extreme subtilization, the relation between the writer and his characters",[6] Foucault suggests that each attempt is predicated not on the blurring of but rather the sacrificing of certain subjectivities, often in an attempt to acquire radically new ones.

With this in mind, to Barthes' list we might add a writer like Fernando Pessoa, who published widely under a series of "heteronyms", inventing not only characters for his books but the imaginary authors who might have penned them, who do not exist anywhere outside the space of writing, drawing further attention to the way that any authorial signifier is its own kind of fiction, whether the writer shares a name with their authorial counterpart or not; or Virginia Woolf, struggling against the mandatory individualism of the *Bildungsroman*, and patriarchy more generally, who embraced a new conception of the self in works like *Orlando* and *The Waves*, where writing walks a narcissistic tightrope between emancipatory and suicidal gestures. In the latter, more

hallucinatory work, she ponders: "How to describe the world seen without a self? There are no words".[7] But still she writes. It is a writing without origin, as Barthes calls it — "the author is never more than the instance writing, just as *I* is nothing other than the instance saying *I*".[8] But the result of this, for Foucault, once again twisting Barthes' argument slightly, is that "the mark of the writer is reduced to nothing more than the singularity of his absence; he must assume the role of the dead man in the game of writing".[9] To reiterate the subtle difference between their arguments: for Barthes, the author must die; for Foucault, the author is always-already dead.

Bayard is a notable early example of this more Foucauldian tendency within photography, given how he assumes the appearance of a dead man so literally, but others have explored this kind of death in more depth over the decades since. Gillian Wearing, for instance, is a far more recent example of a photographer whose depictions of the self are destabilised and fragmented in much the same way. Over the course of her career, she has produced dozens of eerie depictions of people, albeit whilst always using herself as a model. Whether producing portraits of famous people, family members or simply people she passes by on the street, Wearing frequently straddles the role of both photographer and subject, donning masks, prosthetics and copious amounts of make-up to transform and dissolve herself in equal measure.

Writing for *Aperture* magazine in early 2022, on the occasion of Wearing's first major US retrospective at the Guggenheim in New York, Kaelen Wilson-Goldie describes how it could take Wearing upwards of eight hours to produce a single masked photograph — "a long time to be looking at multiple reflections of herself disguised as someone else ... 'At the end of the day,' she recalls in an interview with herself (of

course) in the Guggenheim's accompanying catalogue, 'when I saw my own face, it seemed a little bit alien to me'".[10] Robert Enright, in an essay for *Border Crossings* magazine, suggests that this practice of self-transformation and self-dissolution, skirting the edges of a fractal self, "functions therapeutically in a healing arc that moves from the private to the public, from the individual to society".[11]

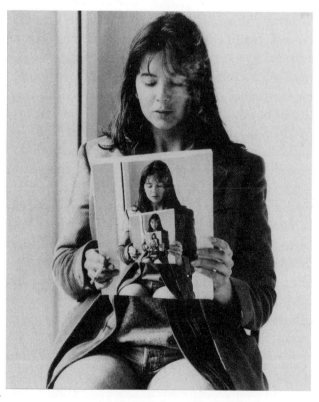

Gillian Wearing, Me: Me, 1991. © Gillian Wearing, courtesy Maureen Paley, London; Tanya Bonakdar Gallery, New York/Los Angeles; and Regen Projects, Los Angeles.

Between the pioneers of literary modernism and Wearing's contemporary photographic practice, there are innumerable examples of others who have explored these same themes and tensions. And of course, such questions of creation and authority, including the relationship between writer and author, spectator and photographer, are not explicitly modern concerns either. In fact, they are just as central to many of Ovid's tales of metamorphosis — that of Narcissus included.

Jeffrey Berman argues that Ovid's tale "dramatizes not only the cold, self-centred love that proves fatally imprisoning, but fundamental oppositions of human existence: reality/illusion, presence/absence, subject/object, unity/disunity, involvement/detachment".[12] And it was arguably photography that reintroduced the innate instability of narcissism, and its universal function within human experience, into the very heart of a modern(ist) subjectivity, inaugurating a new perspective on the world that called into question any clear and singular point of view — one in line with the expanding cultural supremacy of photography's promiscuous and indeterminate images, which we create as individuals but which also nonetheless reveal a series of impersonal worlds to us. It is, in this sense, the medium that changed everything.

With the invention of photography, the entangled tensions that had lain at the heart of any act of self-representation since the Renaissance were suddenly torn apart by their vastly accelerated production. The apparent authorial agency of the person who holds the pen or paintbrush was displaced and made both instant and distant by the mechanical autonomy of the camera — something even more applicable to the cameras we use today: black boxes with their own automated and internal functioning, triggered by little more than a button press. On the one hand, we might argue that photographers

thus have relatively little (physical) input within the process of production, compared to other mediums; on the other, we might see photography as the medium that actualised an illusory flattening of the relationship between human and machine. Indeed, if, as Foucault argues, the death of the author is foundational to the act of writing rather than a process to (over)come, it is photography that exacerbates and recontextualises this foundation and gives it the illusion of something new. In fact, it seems likely that many of the modern writers discussed by Barthes and Foucault, in experimenting with and playfully exacerbating the instability of the self, were influenced by photography's emergence for this very reason.

We have already noted Balzac's fascination with and spiritual distrust of the medium of photography; Barthes notably opens his essay on the death of the author with a passage from one of Balzac's stories. The same is true of Gustave Flaubert, whom Foucault mentions; his 1856 work, *Madame Bovary*, often described as the first modern novel, and a telling exploration of bourgeois narcissism to boot, features impersonal and even medically clinical descriptions of its characters and their bodies that appear quintessentially photographic in nature. The book's publication just a few decades after the invention of photography suggests that this was no coincidence. It is as if photography broke the mould of any prior conception of "realism" for many of the nineteenth century's literary innovators, as well as its visual artists, whose works were previously committed to representing things "as they are", but whom nonetheless stumbled over a newly exacerbated disunity between a passionate subjectivity and the impassionate objectivity of a newly visible world-without-us. Allowing us to see things as they are in a new way, photography further revealed the

materiality of this world to us, as well as the peculiar nihilism that lies behind any aesthetic realism.

With all of this in mind, we might understand the death of the author as constituting a loss of subjective power, as Bayard seemed to. What does it mean to know oneself and the world around you in a manner so impersonal? For Bayard at least, deeply affected by this new method of mechanical reproduction, and desiring public acknowledgement of his innovations within that same impersonal medium, the old adage "knowledge is power" suddenly refers less to the power of our own intellect than it does to our desire to *be known*.

Bayard believed he had been left powerless because he would not be recognised for his individual achievements, but his capacity to (re)produce his own image, and exert some sort of control over the narrative of his professional demise, was nonetheless an exercise of power in its own right. As a result, his self-portrait — and the innumerable examples by others that have followed it — start to potently evoke Caravaggio's attempts to wrestle with various structures of power, humanising himself in otherwise dehumanising moments of defeat, whilst at the same time killing himself in effigy in order to take ownership of his own sorry predicament.

But when we consider the sheer volume of selfies produced today, a number of other questions remain: if knowledge is power, and we want to be known, who or what do we hope will get to know us? What is the normative regime of looking that today restricts the selfie to a form of social administration, a way of expressing our unfreedom, rather than a way out of our restrictive subjectivities? Like Narcissus, we are trapped between a desire to know ourselves and a desire to know how others see us. But how are we to separate the two? Does such a separation matter? Just as Foucault asked, quoting Samuel

Beckett, "What difference does it make who is speaking?", we might ask ourselves today: "What difference does it make who is looking?"[13]

Here Bayard's example becomes even more interesting. In the moment he made his macabre self-portrait, it seemed to matter a great deal who was looking his way — and others did indeed take notice. In spite of the narrative he constructed around his own "demise", constituting a melodramatic prediction of his own irrelevance, he continued to make

Hippolyte Bayard, Madeleine, Paris, c. 1845.

photographic work, even innovating in areas of photographic printing. When faced with the problem of how best to capture both a photograph's primary subject and its background, he conceived of a kind of combination printing that allowed multiple exposures to be used so that the sky, for instance, could be accurately depicted rather than being over-exposed, lacking any detail — a technique many printmakers (and, in principle, even digital photographers) still use today.

A few years after his self-portrait was taken, having become known for this innovation in photographic printing regardless, Bayard was commissioned by the French government to photograph historically significant buildings and monuments to aid in various restoration projects. Ultimately, the death of one imagined career path allowed Bayard (and, eventually, France's architecture more generally) to be reborn, overcoming the injuries of time. Clearly, Bayard's career was far from over; his absence from the history books was far from a foregone conclusion. In truth, he contributed as much to society as a whole as any of his better-known contemporaries. It nonetheless remains ironic, all things considered, that he remains best-known for his sense of his own failure.

Relatively speaking, then, Bayard remained a man of some privilege. But this is already demonstrated well enough by his ability to exercise a right of reply in the face of that first apparent injustice. Unfortunately, this makes the dissention captured in *Self Portrait as a Drowned Man* an exception within the early history of photography rather than an example for others. Whereas the self-portraits of the Renaissance may have made viewers of art more aware of their own powers of observation, the invention of photography instead made this power all the more diffuse.

15. The Will to Know Power

"Power" is a surprisingly difficult word to define, particularly in English, because there are a multitude of senses in which this single word can be used. The French language, however, arguably makes any attempt at disambiguation a little easier, since it has two words for us to work with: *puissance* and *pouvoir*. (This is because French, unlike English, stays closer to its Latin roots, which are, respectively, *potentia* and *potestas*.) The former, crudely put, refers to our individual power to act — what I can do, what I am capable of, what is *within my power* — whereas the latter refers to a more relational sense of power — how someone or something has *power over* me, be that through an authority exercised by another individual, an institution or the broader structures of society at large. (Intriguingly, we might also note how *pouvoir* contains the verb *voir* — one of the most common verbs in the French language — meaning "to see".)

Many English translators of French philosophy opt for an simple, if potentially still confusing, solution to this problem: *puissance* is rendered as "power" and *pouvoir* as "Power". But we might otherwise translate these two words in another way — for instance, as *potential* and *possession*. Though still far from perfect — and admittedly the result of taking a few poetic liberties — when translated in this way, we can better appreciate how each form of power acts against or otherwise becomes entangled with its other: *potential* is projected outwards, beyond ourselves and the structures that

guide us; *possession* seeks to enclose that potential within some overarching structure or institution.

Michel Foucault, as well as offering a useful extension of Barthes' view of the death of the author, is also known for his analyses of these two forms of power and how they are utilised in the construction of what he calls a "disciplinary society". Such a society, Foucault argues, was first established through the development of a number of institutions that have manipulated relations of power to further divide society into insiders and outsiders, and this can be seen most obviously when we consider the development of the modern prison system.

Though Foucault does not discuss photography explicitly in his philosophy, the medium is clearly relevant to his analyses of our punitive institutions, which are so often concerned with the uses and abuses of the power of *observation*. In his seminal 1975 work, *Discipline and Punish*, for example, Foucault famously describes a series of telling developments in prison architecture, with Jeremy Bentham's circular prison design, known as a panopticon, chief amongst them, whereby prison cells are arranged in orbit of a central hub of observation, inducing "in the inmate a state of conscious and permanent visibility that assures the automatic functioning of power".[1]

What was most intriguing for Foucault was how the physical structure of a panopticon makes the power relation between prisoner and guard not just automatic but implicit. Whereas a guard would normally exert their power over a prisoner through an active observation, walking the wings and being physically present, a prisoner would come to rely on the autonomy they gained when a guard was not in their immediate vicinity. (We need only think of countless prison dramas, wherein escape tunnels are painstakingly excavated

the moment any rebellious prisoners are not directly captured under the eye of a roving guard; in many such dramas, it is also notable how easily and comically this form of power can be distracted.) But the invention of the panopticon changes this fleeting relationship into a more permanent, if passive and diffuse one.

Even if the panopticon's central guard tower is empty, in being subjected to and subjugated by the prison's architecture above all else, the prisoner will still continue to *feel* visible to the power that possesses them. Power, then, is ultimately detached from any single authoritative individual and is instead imposed on the prisoner by the prison environment itself. But as Foucault goes on to argue, this development within our disciplinary institutions has had a wide-ranging impact far beyond their bounds.

As power was made structurally passive in this way, power was also made more indeterminate, with *potential* and *possession* blending oddly together to constitute a new kind of superego, through which a prisoner is not so much *actively disciplined* as they are *passively controlled*. The desired result of this passive control is surely that the prisoner internalises this feeling of constant observation within themselves, so that, on their release, they continue to behave as if under constant surveillance.

The invention of photography exacerbated this superegoic function of observation even further, by paradoxically extending this sense of a surveilled enclosure into wider society. Expanding on Foucault's thesis, Gilles Deleuze makes this same argument more explicitly. As the twenty-first century loomed, he presciently argued that we were moving away from disciplinary societies, as Foucault had described them, and instead "towards control societies that no longer

operate by confining people", but instead "through continuous control and instant communication".[2]

To this end, following its invention and increasing accessibility, photography quickly became (and remains) a new and adaptive method of administration within this more controlling process, demonstrating how the explicit architecture of the panopticon was dissolved and made increasingly imperceptible throughout societies in the nineteenth and twentieth centuries, thereby making this kind of control both harder to define and hide from.

But photography does not only instigate this form of control through the proliferation of modes of passive observation alone; it is also used actively to establish new and "objective" forms of subject that we ourselves are told to look out for — a process fed by photography's surreptitious attachment to our desire to document and observe ourselves and others.

Foucault argues that this process of passive observation and active objectification was first instigated in the world outside the prison through the documentation and analysis of a newly constructed form of criminal — first through the work of sketch artists and later by photographers. In being given a determining image — for example, through mugshots and wanted posters — the abstract figure of "the criminal" is produced, caricatured and "designated as the enemy of all, whom it is in the interest of all to track down".[3] This formalised criminal, who is often gendered and racialised, is then disqualified "as a citizen and emerges, bearing within him as it were, a wild fragment of nature; he appears as a villain, a monster, a madman, perhaps, a sick and, before long, 'abnormal' individual".[4]

Clearly, then, this process of objectification is necessarily accompanied by a process of representation; it is necessary

that a criminal "appears" in a certain way. As Foucault continues, criminal prosecution is not simply about "the crime as a fact to be established according to common norms" — as in theft, which is at first an action without a specific subject, generically defined as someone taking something which does not, by law, belong to them — but also about "the criminal as an individual to be known according to specific criteria", forcing us to ask the question: how does one *recognise* a thief?[5] "The art of punishing, then, must rest on a whole technology of representation", Foucault argues, which photography's inventors inadvertently revolutionised.[6]

If this relationship between punishment and representation has since become more complicated, it has been a gradual process, unfolding over many decades. A creeping discrepancy has been produced as a result. We have steadily come to realise that, as much as we use photography to produce images of specific subjects, the individual lived experiences and realities of these same subjects often differ from their images considerably, leading to biases and other forms of discrimination and oppression. As a result, to be recognised as a particular subject is now as much something to be feared as it is to be desired. Indeed, although Bayard may have feared *a lack of* recognition, today the stakes of being recognised (or misrecognised) can be disastrous and even fatal for those who are truly marginalised.

However, this discrepancy was not immediately apparent to those who first made use of photography. This is because the *potentials* and *possessions* of the medium were, at its inception, far more clearly divided. As was the case with the new portraiture of the Renaissance, photography first illuminated the self for a particular socioeconomic class. Initially accessible only to a select few, it was the middle classes who began to observe and

understand themselves before anyone else in a new era, whilst also using the medium to affirm their pre-established views of other social classes; bourgeois subjectivity, for example, was more self-determined, whilst any representations of an underclass were forced upon them by those with more power. Just as Dürer, according to some scholars, may have portrayed European peasants only to ridicule them as society's fools, who were incapable of participating in his aspirational grandeur, transformed from a once-unseen social class into a newly visible set of abnormal individuals, "underclasses" of all varieties have often been observed by photographers in much the same way — that is, only to affirm their otherness. Photography — and visual media in general — continues to facilitate this administrative role of restricted representation today, with a "bourgeois" or middle-class gaze persisting as the default perspective in society, defining many of our supposedly universal ideals.

In this sense, the diffuse nature of today's universalised gaze functions in much the same way as Bentham's panopticon. We are always already possessed by structures of observation and representation that control us in ways we find increasingly difficult to describe, precisely because they are so integral to how we understand ourselves and others. Subjectivity, in this sense, does not simply refer to a personal sense of self, but rather to our awareness of the ways we are specifically *subjectivised* and *subjugated* by our surroundings, making it difficult to think of ourselves outside of our social institutions, or at least with a desired critical distance. (Narcissus's original predicament comes to mind here once again.)

Demonstrating how this capture is made to feel so all-encompassing, Foucault explicitly highlights how the idealised forms of each of our social institutions informs and borrows

disciplinary structures and principles from all the others. Alongside the prison, he adds the hospital, the factory, the school and the family as further modes of confinement that produce specific subjects, despite the fact these same subjects are said to escape society's general functioning. Alongside the prisoner, these subjects include the patient, the worker, the student and the child, all of whom lose their subjective indeterminacy in being captured by an overarching institution, despite this indeterminacy also being, at the same time, oddly affirmed. It is here that something key is lost: our full capacity for self-transformation.

Consider how the child, for instance, is viewed socially as an incomplete subject, or a subject *in the making* — just as the prisoner is a subject to be *reformed*; the patient a subject to be *healed, mended* or *cured*; the student a subject to be *educated*. Echoing the inadvertent effects of Protestantism, whilst each subject's individual agency is tacitly affirmed, it is nonetheless significantly reduced, so that these particular forms of subject are nonetheless deemed to be incapable of (or otherwise disqualified from) possessing a more general sense of autonomy by those who wield a more institutional power over them.

This tandem affirmation and disavowal are important, however. Though this relation appears to constitute a contradiction, it instead represents the internal motor of power's functioning today. As Deleuze once argued, with regards to the subjectivity of the working class:

Contradiction is not the weapon of the proletariat but, rather, the manner in which the bourgeoisie defends and preserves itself, the shadow behind which it maintains its claim to decide what the problems are.[7]

Society's disciplinary methods of subjectivation are thus intentionally constituted by a kind of feedback loop — one in which we are left with just enough wiggle room to develop new forms of subjectivity, but at a *controlled* pace that keeps any subordinated subject on a leash, ready to be (re)captured should they wander too far.

Ultimately, any subject's inherent instability is denied; we fix and make static the kinds of subjectivity that we might otherwise understand as being in an active state of becoming. It is within this paradoxical state of capture that each form of power — our possession and our potential — comes to reflect back on the other.

Photography plays a key role in this power relation today, making this feedback loop appear even more inescapable. As we look at ourselves and at each other, with a camera found in every pocket, our sense of our photographic *possession* is obscured by our sense of our own photographic *potential*. We ourselves become part of an observational infrastructure as our desire to look at and engage with the world around us is made paranoid, and so we become just as concerned with our ability to identify *others* as specific subjects as we are hopeful that *we ourselves* will be recognised as any kind of subject whatsoever, always looking for validation from elsewhere. We want to both observe and be observed; to see and be seen.

But who feels that they ever truly acquire the kind of subjective reassurance that these processes of observation otherwise promise to us? Don't we instead feel that the idealised, symbolic (and ultimately ideological) subjects that crowd around us are impossible to self-actualise, like phantasms projected from an inaccessible "perfect" life? Alternatively, perhaps we innately understand how the reality of *who we are* is quietly discounted from an idealised social

order? No one really fits in as they are told they should, but we must strive to fit in regardless. Here the discrepancies of power come even further to the fore. We all want to be seen, to be recognised, so that our sense of self is validated from without, even though we may understand that the mechanisms of social administration at our disposal fundamentally limit the kinds of subject we believe it is possible for us to be.

But we do not have to accept this predicament blindly. In fact, it is through identifying the strangeness of our particular enclosures that we may become more attuned to the cracks in their walls.

Deleuze argues that, as a result of these contradictory exercises of power (and their inability to fully contain the subjects they produce), we have been experiencing "a generalized crisis in relation to all the environments of enclosure".[8] Indeed, since these words were first written at the end of the twentieth century, our awareness of our capture and the stifling of our freedom to be who we choose has grown steadily apace, leading many to question the apparent necessity of fixed subjectivities and their enclosures altogether, so that our deference to certain kinds of institutions and subject positions — ranging broadly from monarchy to the prison-industrial complex to gendered pronouns — has begun to wane. So it is, Deleuze continues, that "everyone knows that these institutions are in more or less terminal decline".[9]

Still, some institutions remain stubbornly fixed, such as prisons — and are therefore subjected to increasingly vocal demands for reform or abolition, in being seen as increasingly unfit for purpose in their oppressive unmalleability. Because of this, we are repeatedly struck by the ways that these institutions persist in spite of their own inefficacies. But this failure to fail is nonetheless integral to how control asserts itself. William

S. Burroughs, whom Deleuze draws on explicitly in his own description of control, argues that control "needs opposition or acquiescence" in order to function, which is to say that control necessarily responds to the allowances it makes for certain forms of resistance. "All control systems try to make control as tight as possible", Burroughs writes, "but at the same time, if they succeeded completely, there would be nothing left to control".[10] Control is not a prison cell but a long leash, and it is precisely the tension found in this relation that allows control to persist and adapt. But this does not make the very expression of opposition impotent in and of itself.

In political discourses, we have a tendency to be overly pessimistic when faced with such a dilemma. There is no outside to this world of control, we are told, and even if there were, every critique we might produce to get to this imaginary outside is always-already co-opted by the powers that be.

So, what is to be done?

"It is not a case of worrying or hoping for the best, but of finding new weapons", Deleuze argues.[11] But what does this process of finding new weapons look like, exactly? It is certainly not a process that can take place through an *absence* of dissention. The suggestion that all dissention is impotent is an *effect* of control, rather than some "realist" position to be taken seriously. We have to think outside the box, outside the cage, off the leash. This is the last thing that our capitalist control societies want from us, of course, as their institutions do all they can to maintain a limited and illusory sense of progress. But the fact remains: we do not have to live and think according to capitalism's given norms.

Nevertheless, control is still very effective at limiting our language, our thinking, our ways of seeing, using its platforms of instant communication to restrict both our freedom of

expression and the construction of other spaces of possibility. It is for this reason that capitalism's "quest for 'universals of communication' ought to make us shudder", Deleuze says.[12] The task left to us, then, is to create new modes of expression. Just as the efficacy of dissenting speech may be undermined as a result of a totalising "communicative capitalism", this only means that it is essential we do not depend on genericised forms of expression to express our discontent.

For Deleuze, what we must do is "hijack speech" as an act of creation in itself. "Creating has always been something different from communicating", he says.[13] It was Burroughs, once again, who best demonstrated the difference between the two, as a writer who ultimately despised control's corruption of language in the twentieth century. His famous cut-ups, for example, became a way of intervening within his own productive process, adding a further layer of creative hijacking to already sanctioned forms of linguistic expression, using his unpublished texts as an archive from which to conjure new and recombinant works. In approaching his own writing in this way, Burroughs interrupts an initial mode of expression with another, more unconscious one, where he is not so much speaking again as he is undermining the initial act of communication that the active self inaugurates.

Perhaps this is the sort of practice Deleuze is referring to when he argues that the "key thing may be to create vacuoles of noncommunication, circuit breakers, so we can elude control", wherein meaning is not predetermined and easily co-opted but requires a new mode of thinking in order to be understood.[14] Our task, then, is not to simply communicate our predicament through the restricted modes of expression that are handed down to us, but to create new modes of representation and expression all together. More specifically, we can observe how

it is in our various attempts to *communicate* our senses of self that we remain trapped, as if we buy into the suggestion that we are stable beings in a stable society, but we can also use the tools at our disposal to *create* new selves altogether.

If we cannot yet visualise an endpoint, a radically unfamiliar goal for these acts of creation, we might, at the very least, visualise new starting points, precisely by picking up new weapons with which to attack and undermine control from within. It is worth affirming the ways in which our images can also function as weapons in this regard — our understandings of *visual* language are no less as controlled as our various forms of speech. Indeed, though they often stifle and restrict our sense of becoming, images can nonetheless still be used to hijack the hegemonic narratives attached to any subjectivity's projected development — as Gillian Wearing has repeatedly demonstrated. Rather than simply communicating our senses of self, we can get creative. We can look for and explore new forms with which to express and represent ourselves altogether today.

We may be familiar with a number of now canonical artists, working in other mediums, who have done this successfully. From Pablo Picasso to Francis Bacon, many painters throughout the twentieth century, influenced by the cross-cultural innovations of modernism, have found themselves freed from the expectations of realism by the invention of photography, exploding the human form and transforming portraits of our various selves into abstract figures of pure affect and instability. In light of this, however, photography is struck in negative and appears to be our enemy.

The problem with photography's general usage today is arguably that each image created comes to represent a kind of reified object made impotent in its temporal fixing.

We are haunted by photographs as static and externalised representations of ourselves and, more specifically, of our memories, transforming what is remembered subjectively within the mind into a series of diffuse and static symbols that ultimately prove useful to the restrictive administration of life by society's apparatuses of capture.

Captured by bureaucratic systems of control in this way, Deleuze and his occasional writing partner, Félix Guattari, argue that each fixed representation of a "memory blocks desire, makes mere carbon copies of it, fixes it within strata, cuts it off from all its connections", and it is this fixing of memory and of desire in place that we must strive to escape from.[15] Turning to photography explicitly, they argue that, in response, we must unblock "the impasse that is specific to the photo and [invent] a way out of this impasse, putting it into connection with a whole underground network, and all the ways out from this network". The problem, then, they continue, isn't one "of liberty but of escape".[16]

What is interesting about this argument is that the pair do not advocate for a total disavowal of any popular artistic medium. They suggest that we must instead understand their broader potentials, reconnecting them to networks of experience that are otherwise obscured by relations of power. From here, we can begin to understand photography as a medium that we are more than capable of turning against itself, but this is only possible if we are able to more clearly distinguish between photography's potentials and possessions.

16. Gazing Back at the Gaze

Just as English only has one word for two types of "power", the invention of the self-portrait and its role in conceptualising the individual more generally (by giving rise to the singular perspective in art) has likewise left us with only one "image" or "perspective" with which to represent these two forms of power in our visual languages as well. Is it any wonder, at least in conversations around the narcissism of the self-portrait, that we routinely renounce our capacity to look altogether, or otherwise confuse one form of power for the other? But just because we struggle to represent our potentials and our possessions does not mean that the cleft between the two is wholly invisible to us.

Photography, as we have already seen, can twist our perspectives in interesting ways. Indeed, the self-portrait, at its best, can create fractal representations of power, with each form facing off against the other. Like two mirrors turned inwardly together, the gaze of the alienated individual meets the gaze of the socially embedded self, and the myriad eyes that make up each gaze are locked together, just as they were for Narcissus, who both saw his potential for the first time and, in the process, gained painful knowledge of a version of himself that had long been possessed by others.

Read negatively, we can mourn Narcissus for his decision to destroy his own image in response to this kind of capture; read more positively, we find Narcissus activating his potential, escaping the trap placed between seeing and being seen

through an active self-transformation. In much the same way, whilst we might despair at the ways this kind of narcissistic capture fuels and entraps us within our own self-concern, our awareness of this fact can also inspire us to attack the gazes that surround and torment us.

Consider Laura Mulvey's famous conception of "the male gaze" (which can easily be extended and considered alongside the complimentary gazes of heteronormativity, whiteness, the bourgeoisie, et al). In her 1989 essay, "Visual Pleasure and Narrative Cinema", Mulvey demonstrates how the power of the spectacle in the visual arts is split along (nonetheless blurred) lines that are very similar to those previously discussed, which are found between a more general sense of our potentials and possessions. "In a world ordered by sexual imbalance, pleasure in looking has been split between active/ male and passive/female", she writes.[1] Men look; women are looked at.

But the finer point for Mulvey is that these expectations of activity and passivity are nonetheless socially formulated. The male gaze is not innate to visual media or even to individual men in themselves, but is instead diffusely emboldened by complex relations of power that are "reinforced by pre-existing patterns of fascination already at work within the individual subject and the social formations that have moulded him".[2] The male gaze, then, is the impersonal, controlling and pre-existing gaze of a misogynistic socius, which emboldens the potential of the male individual and makes possible a woman's patriarchal possession; it is both constituted and internalised by men in equal measure, with the male gaze persisting perhaps only because it is socially habitual.

This is not to diminish the impact of the male gaze on women's potentials, but in acknowledging it as a socially

constructed habit we can perhaps more easily intervene within its modes of operation, even using visual media, like photography, as a weapon wielded against the kinds of gaze it is otherwise used to normalise. "There is no way in which we can produce an alternative out of the blue", Mulvey goes on to write, "but we can begin to make a break by examining patriarchy with the tools it provides", using them to create alternatives to our reductive habits of visual production and consumption.[3] And it is true that many women have used self-portraiture to gaze back at the male gaze in this way, challenging its possession of women's individual subjectivities, often by parodying the male gaze itself or by using art as a way to break apart and multiply the restricted subject under consideration.

The same approach is just as applicable to the individual more broadly today, who might use photography to examine and break apart a structural individualism altogether. One way of actualising this may be to further challenge the dichotomous premise on which both senses of power are tacitly understood. Since Mulvey's conception of the male gaze has gained widespread appreciation and entered popular discourse, there are many others who have further challenged our more general understandings of what constitutes activity and passivity, and the ways in which a limited understanding of the two terms is used to maintain unjust hierarchies.

Jacques Rancière, for instance, in his 2008 book *The Emancipated Spectator*, explicitly addresses how our general understanding of activity/passivity has obscured the innate power of the spectator in all of us. Inverting Mulvey's analysis of the male gaze, Rancière argues that, in our consumption of art in particular, we all too readily accept that there is a necessary hierarchy between acting and spectating. But to be a

spectator should not be considered a wholly negative position, since it is the normal situation for the vast majority of us. It is necessary, then, that the hierarchical delineation between actor and spectator is itself undermined.

Rancière does this by discussing how certain unjust hierarchies are taken for granted in common relations of knowledge exchange — for example, the hierarchy that exists between a pupil and their schoolmaster — which he quickly transposes onto a reading of theatre.

In theatre studies, the spectator is often seen to be in an inherently negative position for two reasons:

> First, viewing is the opposite of knowing: the spectator is held before an appearance in a state of ignorance about the process of production of this appearance and about the reality it conceals. Second, it is the opposite of acting: the spectator remains immobile in her seat, passive. To be a spectator is to be separated from both the capacity to know and the power to act.[4]

Rancière's argument runs counter to the work of many popular theorists of the theatre in this regard, such as Bertolt Brecht and Antonin Artaud, as well as other more explicit theorists of "the spectacle", such as Guy Debord. In these works, the nature of the spectacle itself is challenged — with "the spectacle" here understood, following Debord, as a kind of "*separate pseudo-world* that can only be looked at", which is produced by modern life's tendency to reduce everything "directly lived ... into a representation".[5]

It is supposedly only by drawing attention to the permeability of this divide that the spectator is allowed to become an actor, thereby transforming the theatre into a place "where the

passive audience of spectators must be transformed into its opposite: the active body of a community enacting its living principle".[6] This establishes the social function of theatre as a "purifying ritual in which a community is put in possession of its own energies ... reversing its effects and expiating its sins by restoring to spectators ownership of their consciousness and their activity".[7]

So far, so good... But the problem for Rancière is that the distance between actor and spectator is not, in fact, overcome when we are made aware of our spectating position. It is instead only exacerbated, creating what Artaud affirms as a "Theater of Cruelty"— a kind of negative theatre that attempts to cajole the spectator into becoming its opposite. But surely this only intensifies the very paradox of theatre? After all, Rancière asks, what is a theatre *without* spectators? No such thing can exist, as this would not only nullify the position of the spectator but that of the actor also. Instead, those audience members who are newly activated and forced to participate in the spectacle before them are only made all the more aware of how they remain different to the performers in front of them. Is it not, then, precisely "the desire to abolish the distance [between actor and spectator] that creates it?"[8]

Rather than affirming this incomplete passage from passivity to activity, thereby internalising control's slippery demands for both opposition and acquiescence, Rancière suggests we should instead question how the relationship between these two positions is structured. Why not view actors as passive instead, for instance, given the ways they are tethered to scripts and predetermined stage directions? "Why identify gaze and passivity, unless on the presupposition that to view means to take pleasure in images and appearances while ignoring the truth behind the image and the reality

outside the theatre?"[9] To attempt to transform every spectator into an actor, then, only serves to undermine how spectating can itself be an active process.

For Rancière, we should all instead see ourselves as *active spectators*. In this way, we can pay more attention to the initiatory event that allows a vanguard to self-activate in the first place. The point is not to overtly privilege the spectator or denounce the power of actors themselves, but rather to undermine the hierarchy that is so often seen as necessary to the functioning of theatre as a whole. Indeed, it is less important that we focus on the one-way transmission of potential to others — the transformation of a spectator *into* an actor — than it is to focus on the very emergence of potential in its first instance, which is accessible to all, regardless of whether we appear onstage or off. As Rancière continues:

Emancipation begins when we challenge the opposition between viewing and acting; when we understand that the self-evident facts that structure the relations between saying, seeing and doing themselves belong to the structure of domination and subjection. It begins when we understand that viewing is also an action that confirms or transforms this distribution of positions. The spectator also acts, like the pupil or scholar. She observes, selects, compares, interprets. She links what she sees to a host of other things that she has seen on other stages, in other kinds of place. She composes her own poem with the elements of the poem before her. She participates in the performance by refashioning it in her own way — by drawing back, for example, from the vital energy that it is supposed to transmit in order to make it a pure image and associate this image with a story which

she has read or dreamt, experienced or invented. They are thus both distant spectators and active interpreters of the spectacle offered to them.[10]

This is the relation to be affirmed, Rancière argues, against "the logic of the stultifying pedagogue, the logic of straight, uniform transmission".[11] To proceed otherwise is to trap communication in a linear and ultimately hierarchical process of cause and effect.

We have already seen how this deterministically impotent logic of transmission is established in the age of photography and social media. To return to the "first" selfie taken in our postmodern era — that of Britney Spears and Paris Hilton, discussed in this book's introduction — the pair's detractors denounce their attempts to create their own image as the activation of nothing but a pathological narcissism. But whereas previously the two women felt like Echo, wandering the wooded pseudo-world of the spectacle without a voice of their own, they instead transformed themselves into Narcissus, re-appropriating, in Rancière's words, the "relationship to self lost in the process of separation" between actor and spectator.[12]

In this sense, when we denounce the act of self-perception that inaugurates the women's photographic action, we do so on the presumption of their ignorance, which was highlighted misogynistically and *ad nauseum* by many of those who first replied to Hilton's tweet. But this is to unfairly presume that the two women had no active awareness, at that time, of the reality of their situation, as if the control exerted over their images by others was not abjectly known to them. Viewed in this way, Hilton and Spears come to clearly represent the paradox under consideration: showing the importance

of Rancière and Mulvey's critiques from the other side, they are denounced as passive actors incapable of an active spectatorship. They are there to be looked at; they cannot look at or for themselves.

Still, it is nonetheless true that the Hilton-Spears selfie is contained by the spectacle, even as an attempted intervention within it. If we are cynical about the taking of selfies as an empowering act today, perhaps this is why. To truly act means that we apparently cannot and should not look at all, even at ourselves, and so to reclaim ownership of one's likeness within the context of the spectacle is nonetheless to remain trapped *within* the spectacle; it is less an escape than an attempt to grasp at a malformed sense of liberty. But if we find something aspirational in this attempt at appearing on their own terms regardless, perhaps it is because we understand that the pair are wrestling with a now familiar problem that troubles us all: the fraught relationship between the individual and the social.

Hilton and Spears nonetheless represent an extreme example of such an intervention, given the fact that their individuality is otherwise wholly denied. Indeed, in *The Society of the Spectacle*, Debord skewers this predicament with an acute ferocity that we can read today with Hilton and Spears explicitly in mind:

> The agent of the spectacle who is put on stage as a star is the opposite of an individual; he is as clearly the enemy of his own individuality as of the individuality of others. Entering the spectacle as a model to be identified with, he renounces all autonomous qualities in order to identify himself with the general law of obedience to the flow of things.[13]

It is for this reason, Debord continues, that the "admirable

people who personify the system are well known for not being what they seem; they attain greatness by stooping below the reality of the most insignificant individual life, and everyone knows it".[14] But our contemporary age of postmodern celebrity introduces a new tension within Debord's analysis. Today we do not necessarily see our stars as enemies of individuality, since many hardly seem content identifying with any "general law of obedience" whatsoever; instead, the likes of Hilton and Spears appear as quasi-individuals who have made attempts to reaffirm their capacity for self-expression as a way to challenge the obedience expected of them.

In this sense, Hilton and Spears come to symbolise the emergence of the broader refusal of a totalising spectacle; many more celebrities have followed in their stead.[15] Though they hardly serve as examples to the rest of us, they nonetheless illuminate, albeit in negative, the sorts of emancipatory activities that may not be broadly accessible to them but are to us — specifically, what Rancière calls "the refusal of mediation", or the opening out of what Deleuze refers to as "vacuoles of noncommunication".

It is precisely this refusal that Britney Spears came to desire most explicitly — a desire expressed by the shaving off of all her hair. Despite being unsuccessful, we can nonetheless understand her actions as the expression of a desire to return to the anonymised masses — the realm of the spectator proper, which we so often take for granted and which Rancière frames as a positive position against the prevailing assumption that to spectate without being part of the spectacle is to remain inert.

Spears thus functions as a warning to the fame-hungry, who may not realise the extent to which their own capacity for self-expression — seen as a path to fame, fortune and self-actualisation — can be paradoxically restricted once their

public representations are controlled by the media. As such, though we identify the average celebrity's preoccupation with their self-image as narcissistic, we once again fail to consider the catch-22 at the heart of Ovid's original tale: the ways in which public notoriety traps those who have it in a painfully paradoxical capture of individualised non-individuality.[16]

Of course, the suggestion here is not that we should sympathise more with celebrities; it is rather that we should understand how this capture is not something they are subjected to alone. Postmodern celebrity is only an extreme example of a capture that affects more and more of us in the age of social media, as we are encouraged to stabilise and monetise certain forms of self in order to access the various side hustles that are open to the figure of the "Influencer", which are made attractive in a generalised state of economic precarity, even as such activities depend more and more on the maintenance of so-called "para-social" relations, which humiliate the social proper.

Such a situation demonstrates the importance of Rancière's challenge to the ways we are encouraged to give up our position of spectatorship. Indeed, to become an actor, in the more limited sense previously discussed, is arguably to give up our anonymity and relinquish the power it otherwise provides. For Rancière, this power consists of our potential to both associate and dissociate with the spectacle before us — something that is not afforded to everyone. We must instead acknowledge the latent potentials of spectatorship in general. As Rancière argues:

We do not have to transform spectators into actors, and ignoramuses into scholars. We have to recognise the knowledge at work in the ignoramus and the activity

peculiar to the spectator. Every spectator is already an actor in her story; every actor, every man of action, is the spectator of the same story.[17]

This is surely the same potential found in photography's social ubiquity and accessibility. Though so much of our knowledge of the modern world is transmitted to us through images, we are all aware of our own capacity to produce images for ourselves; to dissociate from the images we receive and instead produce our own.

This capacity is nonetheless often obscured from view by visual media itself. Social media platforms like Instagram clearly rely on a myopic sense of self-observation, and so further instil in us various normative modes of looking at ourselves and the world around us. However, though many may blame social media for a variety of social ills, it is nonetheless true, as was the case following the invention of the printing press, that this technological revolution has likewise produced new forms of social consciousness, giving us myriad images of resistance, and further illuminating our place in the world and our indeterminate positioning between technologies of self and power.

Rather than understanding the innovations of online visual culture as wholly new to us, then, we can easily draw on more historical examples to demonstrate how such technologies have long since emboldened power in two directions.

The political theorist Jodi Dean, in her 2010 book *Blog Theory* — which deals explicitly with the indeterminate potentials of and our new possession by social media — highlights how such a paradoxical situation, wherein power rests on a kind of two-way (rather than one-way) transmission, is not unprecedented, even recently.

To do this, Dean discusses the tandem rise of television and second-wave feminism. Together, these tandem innovations in technology and thought each "made the personal political, erasing the fragile and imaginary boundaries between public and private" life.[18] As such, damning television as the one-way transmitter of control is to focus on only one example of the kinds of activation it has made possible.

Consider how, on the one hand, television projected our political leaders directly into our homes for the first time, whereas we might have previously entertained the illusion of their separation from domestic life; on the other hand, this arguably also instigated second-wave feminism's projection of women's subjective experiences far outside of the domestic sphere. Here we find a prime example of our indeterminacy, caught between forms of power, each feeding back on the other, whereby a tandem penetration into other forms of enclosure has proven too seductive for either side to resist, emboldened by the latest technological advances and their impact on subjectivity.

Throughout the twentieth century, and now in the twenty-first, photography has played a continuous and vital role in giving each of these developments an image — television is, after all, a further technological innovation within the photographic process. But in the early 2010s, Dean seems far from optimistic about the potentials to be found within the similarly productive feedback loop that constitutes our social media age. Indeed, she seems to argue that things have gone too far:

> The networked interactions of communicative capitalism do not provide symbolic identities, sites from which we see ourselves as loci of collective action. Rather, they

provide opportunities for new ways for me to imagine myself, a variety of lifestyles that I can try and try on. This variety and mutability makes my imaginary identity extremely vulnerable — the frames of reference that give it meaning and value are forever shifting; the others who can rupture it appear at any moment and their successes, their achievements, their capacities to enjoy call mine into question: *I could have had more; I could have really enjoyed.*[19]

This is an analysis that seems particularly prescient when we consider platforms like Facebook, Instagram and TikTok, which are driven by their capacity to show us how the other half live. In restricting our self-knowledge to its association with the normative self-representations of others, we enter a space of ubiquitous envy. A depressive narcissism comes to dominate in this "reflexive loop of drive", wherein we gaze at the other as someone we ourselves want to (or otherwise should) be. Any meaningful self-transformation is made almost unthinkable in such an environment, in which the spectator is persistently encouraged to transform themselves into a participant, an actor, in an ultimately rigged game.[20] But in echoing Rancière's argument that the emancipated spectator is one who can dissociate themselves from a given spectacle, Dean wonders, "What would happen if we just stopped?"[21] She suggests, rather than contorting ourselves to fit into prescribed modes of participation and identification, that we instead unburden ourselves from "the obligations of being this or that, of being bound by choices or words or expectations of meaning", and instead declare ourselves "whatever beings", who are capable of flowing "into and through community without presupposition".[22]

This notion of "whatever being" is borrowed by Dean from the Italian theorist Giorgio Agamben, which she relates to her teenage daughter's tendency to respond to various questions and propositions with a quintessentially adolescent and indeterminate "*whatever*". Here she identifies a certain radicality in teenage indifference, comparing this state of "*whatever*" to Agamben's affirmation of our world's very indeterminacy, in that to be "whatever" is to be "neither particular nor general, neither individual nor generic".[23] But against the average adult's cynical perception of a teenage aversion to authority, Dean and Agamben both insist that this indeterminacy must not be mistaken for apathy, but rather the affirmation of an *in-difference*, in which difference itself is held in tension — which, as Agamben insists, allows a sense of self to reject its restriction by and to any number of social categories, albeit without being deemed wholly outside of the social order.

"Whatever being", then, Agamben explains, is "thus freed from the false dilemma that obliges knowledge to choose between the ineffability of the individual and the intelligibility of the universal".[24] It is, again, the indeterminate resolution of a narcissistic capture, which defies the static frenzy of a subject caught by society's many gazes, and instead, like certain flowers, rhizomatically takes root — reorientating the subject-as-object "towards its own taking-place".[25] For Dean, this allows whatever-beings to affirm "a loss of meaning, difference, and individuality that turns this loss into their condition of belonging"[26] — something that is, again, seen as quintessential to the relatively new social category of the "teenager".[27]

We can learn a great deal from our youth in this way. Against the negative solidarity encouraged by our social institutions,

which renders teenagers as incomplete subjects to be brought to heel, it is still possible for us to affirm a positive sense of solidarity that is of our own making, lingering at the very edges of the radically new and unsettled, as is often the case with youth cultures the world over. Though we believe that such a pop-cultural vanguardism is inaccessible to us as adults, this is arguably a further product of control's hardening of the lines of subjectivity. Socially speaking, we tend to view "adults", in the abstract, as fully formed beings who have shed the indeterminacy of youth. But as any adult will tell you, you never shake the feeling that you are eighteen forever. It is only a crushing sense of social responsibility and the cruelty of your aging reflection in a mirror that tell you otherwise.

In much the same way, in Dean's book, it remains uncertain whether this notion of "whatever being" is positive or negative, naïve or radical. Indeed, in its very indeterminacy, the uncomfortable fact of the matter is precisely that "whatever being" is neither — it makes any becoming a more explicit site of possessive struggle and potential emancipation, which is always necessarily in a state of irresolution. In this way, Dean challenges the static values and meanings upon which an authoritative social order is predicated. But whereas she seems to suggest that this indeterminacy gives rise to its own impotence in the age of social media, this is only if we continue to uphold the dichotomy of activity and passivity that Rancière expressly denounces. If we take whatever being's eerie constitution as it "appears" to us — that is, as not quite present and not quite absent — we can begin to affirm the emancipated spectator's innately spectral qualities.

Considered etymologically, we might note how a "spectre" is an image that appears to us, and a "spectator" is someone who looks at images. But in accepting Rancière's provocation,

does an active spectator, in this regard, not also transform the anonymised spectre of the spectator into another image of haunted and permeable subjectivity?

There are countless examples of this kind of spectrality to be found in popular culture — for instance, in horror films that depict the paranormal. In affirming the emancipated spectator's relation to the paranormal even further, what unnerves us more than the spectral haunting of a poltergeist, that most *active* of spectres, which continues to affect its environment after its apparent death — that is, the "dead" subject's posthumous denial of their own passivity, their exclusion from society proper?

Attached to the framework we have already established, we can begin to understand "whatever being" as a kind of activated spectre or apparition in much the same way — the spectator as a figure of living death; the spectator as a defiant form of subjectivity that continues to effect the world despite its own indeterminacy. This makes the spectral spectator another kind of "vanishing mediator", which retains the possibility that any of our vanquished subjectivities, like our teenage senses of self, and their political potentials, may have another life after their social death also.

Photography continues to play an important role here. Though we cannot deny that the medium makes certain types of subject more visible to power, to *possession*, with its once-new modes of administration having been further developed and universalised, photography, and its various technological adaptations and outputs, have nonetheless exacerbated this analogous sense of a life after death, allowing us to further weaken the hardened divide between doing and knowing, spectating and acting, individuality and sociality.

Whereas Roland Barthes — in so many of his works, but particularly his writings on photography, such as 1980's *Camera Lucida* — sees this cheating of death as just another cause for solemnity, others have instead understood this spectrality as an emancipation from capture. Indeed, photography's associations with death are acutely overbearing in this regard, as if the only response to the past's persistence within the present was a kind of mourning. By instead expanding beyond this mournful relation, making it something more hauntologically positive, photography further reveals to us how our potentials may linger on in their very indeterminacy, as if ideologically dormant or denied rather than wholly deceased. And so, rather than understanding the spectre as an active remembering only to be passively observed, as if what haunts us cannot be reintegrated into any present reality, we might instead affirm such lingering presences as the persistent hallucinations of other ways of being.

It is here that we can return again to Narcissus's seasonal transformation. Though it may appear like Narcissus kills himself, he instead fundamentally transforms his mode of existence into something radically other, which we nonetheless struggle to recognise as such from a more myopic perspective. Photography emboldens this same kind of movement, and this transformation from determinate subject into "whatever being" has been repeatedly explored and replicated by many photographers, from early examples of spirit photography to more explicitly political representations of marginalised ways of living. In this way, it is through the medium of photography that our flirting with the destruction of the gaze and its capture of one's own image becomes a way of working towards the ultimately positive indeterminacy of Narcissus's

now-familiar ordeal. Our photographs are not inventories of our own mortality, in this regard, but rather inventories of our suppressed potentials. As Rancière argues in his discussion of theatre:

> Projected images can be conjoined with living bodies or substituted for them. However, as long as spectators are assembled in the theatrical space, it is as if the living, communitarian essence of theatre were preserved and one could avoid the question: what exactly occurs among theatre spectators that cannot happen elsewhere? What is more interactive, more communitarian, about these spectators than a mass of individuals watching the same television show at the same hour?[28]

Rancière's comparative reference to television, like Dean's, is again pertinent here. Indeed, faced as we are with a (relatively) new world of technological capture by social media, which is so often viewed pessimistically, it may help us to answer Rancière's various questions by returning to Dean's particular consideration of television and second-wave feminism, and consider how some spectators have elucidated the indeterminacy of their own subjectivities, affirming visual media's complicated role in emancipating other spectators in the twentieth century.

17. Parodying the Gaze

Lee Friedlander, Philadelphia, 1961.

It just so happens that the wan reflected light from home television boxes casts an unearthly pull over the quotidian objects and accoutrements we all live with. This electronic pallor etiolates our bed boards and pincushions, our mute scratch pads and our inglorious pillboxes. It is a half-light we never notice, as though we were dumb struck by those very luminous screens we profess to disdain.[1]

These words were written by the great American photographer Walker Evans to accompany *The Little Screens*, a series of photographs made by another American great, Lee Friedlander. Published in the February edition of *Harper's*

Bazaar magazine in 1963, the photo-essay covers just four short pages and appears wholly incongruous in the context of a women's fashion magazine. Rather than partaking in the setting of trends, seducing the reader with artfully advertised clothes and modern conveniences, Friedlander, with a little conceptual assistance from Evans, instead constructs a series of meta-images that may have given the casual reader pause for thought.

The photographs are jarring, even today. In a recent essay discussing the series, the writer and art critic Saul Anton notes how they appear, at first, "to parody the viewer's gaze".[2] But as we try to make sense of what is in front of us, in these otherwise mundane scenes, we find that the faces leering outwards into various domestic settings are utterly decontextualised. As the camera gazes impersonally at the television screen before it, with the broadcast figures gazing just as impersonally back at us, we are ultimately left with a stark sense of indeterminacy, where the only subjects that we can be sure are truly present are ourselves. As a result, though the "return of our gaze initially promises meaning and sense", the photographs arrest "the movement of semiosis".[3] The one-way transmission of information is interrupted by a photographic stop-gap. Nevertheless, it is in such a strange and indeterminate space that the emancipation of the spectator can truly begin.

As we look at these images, we soon become aware that "the link between perception and understanding" we normally expect to encounter has been fragmented and broken down, forcing us, as Anton argues, to impose upon each photograph "a sense — or, possibly, a non-sense — that arises not from the elements of the image but rather from somewhere outside it".[4] This interruption produces a series of semiotic gaps in the syntax of visual language — breaks that are arguably

always present, but which are generally glossed over by the unconscious mind.

We will already be aware of how other artforms play with our unconscious filtering processes in other ways, drawing our attention to them when we least expect it. A film or theatre production might make attempts to break the so-called "fourth wall", for instance, by having a character on screen or stage break the illusion of their enclosed reality to suddenly address us, the spectator, directly — perhaps with a glance or non sequitur that shatters the expectations provided by dramatic convention. But what is most notable about *The Little Screens* is that Friedlander inverts this more familiar process, visualising the very act of looking by breaking the fourth wall from the other direction.

It is as if, by including the domestic setting that the unconscious otherwise blocks out when we are watching television, the previously invisible (or otherwise unconscious) gap between the individual and the social is where our attention eventually falls.

With this parodic gaze in mind, the initial publication of *The Little Screens* in a women's fashion magazine may begin to make more sense to us, in that it may have been Friedlander's intention to encourage the reader to more readily question the advertising messages presented to them on other pages. But to assume that any reader of *Harper's Bazaar* magazine is *not* already aware (in some capacity) of the returning gaze of the screen (or the magazine itself) would be ungenerous; Friedlander simply draws our attention to what the supposedly ignorant spectator already intuitively knows. Indeed, all readers of fashion magazines, especially today, are no doubt aware of how these otherwise static pages enact various processes of libidinal engineering, making us identify,

in one way or another, with their contents. But when looking at Friedlander's *Little Screens*, we are invited, against the usual conventions of fashion photography, to consider the two-way transmission of power more acutely.

Television enters one way, whilst subjectivity exits its domestic capture through the new social space that this same medium has opened up. As a result, we are presented with a scene otherwise hidden from us: the transitory space where forms of power meet.

For this reason and others, Lee Friedlander should today be considered the great photographer of our subjective indeterminacy. Throughout his career, he has often made the tensions innate to visual media the subject of his photographs, placing himself incongruously between them.

By way of another example, from the 1960s to the present day, Friedlander has contributed hundreds of images to an open-ended and continuously developing project, which he has exhibited various versions of, all under the title *America By Car*. The photographs depict scenes both iconic and mundane, captured across America's fifty states. In every single one, the scene is somehow obstructed by the architecture of his vehicular mode of transportation. Skylines or various vistas of Americana are shot through windscreens and side windows, or otherwise reflected in rear-view and side mirrors. Though an intrusion we will all be subtly aware of when we attempt to take photographs through car windows ourselves, our attention is once again trained on the gaps or intrusions in our visual field that our compositional habits would otherwise have us filter out, transforming the car itself into a core element of the photograph's composition.

In this way, the car, as a ubiquitous symbol of American sprawl and life, both complements and interrupts the

photographs, as if we are not seeing Friedlander's point of view but the free-floating perspective of the car itself as a tool of mediation, which is here presented to us with a new clarity, as a tandem signifier of both our freedom of movement and our tethering to post-Fordist capitalism.

Even more evocative of our subjective indeterminacy are Friedlander's self-portraits, which were the works that first introduced him to the American art world. In his debut photobook, simply titled *Self Portrait*, Friedlander problematises the relationship we have with photography and, indeed, our own selves. Like Bayard, he begins his photographic career with his own symbolic death, entering fully into the indeterminacy that lingers between a

Lee Friedlander, Montana, 2008.

socialised visual language and his own individual point of view, with the body itself becoming an oddly impersonal mode of transportation that lingers on the edges of our field of vision.

This early body of work comes to demonstrate how, although our images may distinctly capture a singular viewpoint, the ubiquity and accessibility of the medium of photography transforms all photographs into images that we might otherwise imagine ourselves taking part in. But such a process can also alienate the photographer from their own images. Friedlander nevertheless keeps this tension firmly in play, refusing to ignore it, even when photographing far more mundane scenes of contemporary life. Instead, he intervenes within and deconstructs this flattening of our powers of observation and our agency.

In a short introduction written for the publication of *Self Portrait*, Friedlander recalls the experience that drove

Lee Friedlander, Buffalo, New York, 1968.

him to make these images in the first place. "They began as straight portraits but soon I was finding myself at times in the landscape of my own photographs", he writes — here referencing his inclusion as a shadow or reflection, which we might otherwise deem to be a compositional *faux pas*.[5] (It is also worth noting that, although he refers to his images as "portraits", Friedlander uses the word not only to describe images of people but his desire to capture an essential American "character" or "gaze", whether he or others are explicitly present in the images or not, as if emphasising the fact that there is always some sort of subject present, whether in front of the camera or behind it.) Friedlander thus begins to haunt his own photographs, as a spectre both present and absent, hovering over the shoulder of the camera held in front of him, which might even appear to have more agency than he. "I might call myself an intruder", he adds.[6]

These self-portraits, then, though they may have started as unconscious depictions of the self, soon come to document Friedlander's *distance* from himself as a photographer, and indeed, as a minor American subject traversing the populous nation-state as a whole. Rather than presenting us with his explicit point of view, we become more aware of the ways that Friedlander is nonetheless alienated from the world around him — *because* he is a photographer, rather than in spite of this fact.

There is a narcissistic quality to this distancing, as if re-inaugurating Alberti's declaration that the myth of Narcissus is the primal scene of art history. As in our newly problematised conception of the term, to become narcissistic is to recognise one's self-image as something that we cannot necessarily possess in any meaningful

or actionable way. And yet, whilst we might consider photography our best chance of capturing that surface of the spring, Friedlander exacerbates our continued separation from the world around us, even affirming his strained encounters with the self as the key to his own photographic impulses.

Concluding his short introduction to *Self Portrait*, Friedlander writes: "I suspect it is for one's self-interest that one looks at one's surroundings and one's self. This search is personally born and is indeed my reason and motive for making photographs".[7] However, the camera soon becomes an insufficient mediator in this process. It is "not merely a reflecting pool and the photographs are not exactly the mirror, mirror on the wall that speaks with a twisted tongue".[8] He continues:

> Witness is borne and puzzles come together at the photographic moment which is very simple and complete. The mind-finger presses the release on the silly machine and it stops time and holds what its jaws can encompass and what light will stain. That moment when the landscape speaks to the observer.[9]

However, though Friedlander is speaking here to the innate distance between the photographing self and its subject, there are some photographs in which Friedlander clearly recognises his own body as an impersonalised landscape that has spoken to him. In these images, he renders his own body as an intruding object. He becomes, as Anton argues, "an accidental figure [who] marks less the mastery of the visual field by the gaze than its accidental subjugation to a process that exceeds it".[10]

Lee Friedlander, self-portrait, date unknown.

One photograph in particular makes this explicit within this early body of work, appearing at the mid-point of Friedlander's photographic sequence in *Self Portrait*. Having perhaps become accustomed to the rhythm of the series, showing us intrusion after intrusion, the photographer suddenly appears before us, unobscured, sat in an armchair in the corner of a room.

Languishing beneath a tall lamp, in a photograph very reminiscent of Bayard's *Self Portrait of a Drowned Man*, we see Friedlander sitting in his underwear, with the harsh light of the lamp casting unflattering shadows across his torso, contrasting dark patches of body hair around his nipples and belly button. His expression is gormless; his hair askew. We might assume he has just gotten out of bed and placed himself before the camera unceremoniously, but the image also betrays a strange melancholy, as if it were another hastily arranged *memento mori*. Perhaps the self-portraits have

taken their toll, chipping away at the metaphysical crowd of spectres that Balzac believed constituted the photographed body. What appears before us is a near-empty sleeve, which may have once contained a fuller version of the self under consideration.

A similar (if even more harrowing) effect is achieved in a much more recent self-portrait, in which a now-elderly Friedlander lies in a hospital bed, surrounded by medical equipment — one impersonal machine connected by wires and tubing to other impersonal machines. His eyes are almost closed and his mouth agape; he is posed in such a way that we might assume he is unconscious, except for the fact that his arm is outstretched to hold the camera, another impersonal machine that sees but is unseen.

Rembrandt, Self-Portrait at the Age of 63, 1669.

In an afterword written for the second edition of Friedlander's *Self Portrait*, the curator and critic John Szarkowski compares this impersonal and unsentimental approach to that exercised by the Dutch artist Rembrandt.

If Dürer was the first artist to be obsessed with their own image, Rembrandt was undoubtedly the second. Over the course of his lifetime, he produced dozens of self-portraits, at a time when the ideal selves of the Renaissance were already beginning to unravel.

In the pictures painted early on in his life, he appears as vainglorious or aspirational as Dürer may have been. As Szarkowski notes, from the age of around thirty onwards, Rembrandt "proposes for our attention a persona that is clearly very important but not very interesting".[11] But thirty years later still, as Rembrandt enters old age, something changes in his self-depictions — he "gives us not a personage but a thing, a used tool, a thing as unimportant and as interesting as a well-used butchers' table, or an old work glove, or a pair of shoes precariously resoled one last time".[12]

This final image conjured by Szarkowski brings to mind the work of Vincent van Gogh, who repeatedly painted battered old shoes during the 1870s and 1880s. But whereas Van Gogh's paintings betray a certain nostalgia, evoking the past life of the spent object depicted, now rendered inert without a soul to fill them, Rembrandt problematises the agency of the person before us instead. Indeed, Rembrandt's self-portraits seem to invert Van Gogh's perspective: it is one thing for an artist to depict a personal object, but quite another to depict oneself as an *impersonal subject*.

Friedlander is clearly not dissimilar to the Old Master in this regard. Whereas the latter, according to Szarkowski, was interested in "impersonal things, such as the color,

shape, and weight of the object he describes; and the way his body occupies its space and accepts the light that falls on it; and the surprising way in which a human head, clearly seen, can resemble so closely patches of paint on a canvas",[13] Friedlander has tellingly described his preferred subject matter as "people and people-things".[14] But this sense of impersonality is not the preserve of master painters and photographic giants alone. Whereas Rembrandt and Friedlander seem acutely aware of the surreal experience produced by looking at one's own likeness so repetitively, affirming self-alienation for their art, others have acknowledged the peculiarity of such an experience in other contexts too.

Vincent van Gogh, Shoes, 1886.

Consider the innumerable self-portraits of Kim Kardashian, particularly those found in her 2015 photobook, *Selfish*, which outdoes both Friedlander's and Rembrandt's life-works in its accelerated production and scope. At a jaw-dropping and door-stopping 448 pages, the book contains everything from previously private nudes to public Instagram posts. But rather than being a monument to Kardashian's celebrity, the relentless repetition of the self produces a kind of subjective split. We are struck by the parallax view provided of two modes of existence: Kim Kardashian and Kim Kardashian™; the individual and its opposite. Like Hilton and Spears before her, Kardashian's own awareness of this fact has often been overlooked, her ignorance assumed. But to find evidence of such an awareness, we need only turn to the book's title, which plays on her narcissistic reputation to suggest something more self-discerning: Kardashian's is only a self-*ish*; hers is only a self, *sort of*.

With this in mind, the book soon begins to refer less to Kardashian's lack of consideration for others, and instead to the general ambiguity that defines modern celebrity and its fraught sense of an objectified subjectivity. In light of this, Kardashian's photobook becomes a perversely enjoyable document of an oddly cyclonic process: self-empowerment through self-objectification and self-commodification. Through the book's unprecedented repetitions, Kardashian soon begins to *embody* the process of self-dissolution that is exemplified by the de-individualising processes of the spectacle. No value judgement is presented to us, however. Kardashian instead seems to affirm her own "whatever being". Within the milieu of super-public representation, we watch as the self itself dissolves into the ether of social media and public perception more generally.

The same is true of Friedlander's self-portraits as well, albeit in a way that is less enclosed within celebrity culture. As Saul Anton writes, the repetitive nature of Friedlander's projects "calls upon the viewer-reader to move back and forth across repetitions, rhymes and echoes between individual images. The photographs are fragments, part-images that bleed and spill into one another without ever resolving into a work".[15] The impact on Friedlander himself is deeply affecting — although it is perhaps what makes Kardashian's book such a sorry document for some. Fragmented by its very repetitiousness, these partial images of an unfolding existence, of an unstable self in the process of both becoming and unbecoming, never quite resolves into a life-work, in being so innately porous and unfinished; in being *whatever*.

That we see this kind of self-representation as wholly negative is no doubt because of associations we have already discussed. Photographic series, as static representations of a far more fluid process — as Anton suggests — "takes the form and figure of the photographer as an agent of death".[16] Anton is here referring to a different modality of death than that described by the likes of Barthes and Sontag, however. Many of these critics are often concerned with singular photographs, through which we become more conscious of and begin to mourn their *finality* — that is, their *un*repetitive nature. But in repeating this more formal finality regardless, we find that photographs are able to exist alongside each other not indifferently rather than in a more conscious and fraught *in-difference*.

This is precisely what many of the artists and celebrities so far discussed affirm to the contrary of much melancholic photographic theory: it is precisely the lack of finality in Friedlander's work, or in Kardashian's fashionable self-

representations, that makes their fixation on their fragmented subjectivities more *productive*. (Here, Friedlander's work and Kardashian's may divert considerably, given their very different functions and contexts, but this is perhaps only a matter of taste — both find themselves oddly at home in fashion magazines, after all.) And as Anton notes, it is precisely the unresolved nature of their self-representations that holds open our own ability, as viewer-readers, to intervene in their interstitial nature, as we find the subjects of each photograph (and even ourselves) caught somewhere between real life and photographic death.

For Anton, it is the interstitial nature of the work that allows Friedlander's *The Little Screens*, in particular, to open "our relation and link to the external world, to others, even though, at the same time, these images also place us behind the screen"— that of the television, the windshield or the camera itself — "where we remain trapped, either as photographers or subjects, looking at one another across a living room or a bedroom", or from the backseat of a car or from the other side of a street — a disconnection that nonetheless promises us some sort of "communion" in the liminal space that is alluded to in-between the images.[17]

This is precisely how the agency of death remains seductive to the photographer in all of us. If not our actual deaths, we observe how we nonetheless seek out the ego-death that comes from our immersion in the power of the social that photography alludes to in its very insufficiency — that is, its inability, contrary to our own desires, to capture and *preserve* life in the moment it is being lived. Though we may enjoy the engagement with the present that photography, as a practice, makes possible for us, photographs themselves are nonetheless always viewed retrospectively. It is this temporal slippage,

and our repetitive engagement with it, that constitutes the "death drive" of the photographer — a process first described by Sigmund Freud. And it is fitting that, in Freud's original formulation, the death drive is expressed, narcissistically, through the "*turning round of an instinct upon the subject's own self*".[18]

18. The Beyond-Death Drive

In a later elucidation of his conception of the death drive, Freud explains how he was first struck by the compulsion to repeat that is central to our conservative nature — the ways in which we repeat things in order to process our experiences and keep ourselves alive. But Freud soon came to realise that we are not always compelled to do things in our own self-interest, such as through the "pleasure principle", which is constituted by an "instinct to preserve the living substance and to join it into ever larger unities".[1] He later noticed, in his numerous case studies, how this impulse towards self-preservation can be transformed into its opposite. Faced with this complication in his psychoanalytic theory, Freud added the "death drive" to his symptomatic armature of human neuroses — a drive he saw as fundamentally opposed to the consolidatory process of a "repetition compulsion". Where the death drive differs is that it repeats instead "to break down" the conglomerate units we otherwise strive for, "restor[ing] them to their primordial inorganic state".[2]

This process can be seen within narcissism itself, as we have come to understand it through psychoanalysis. Narcissus's death drive, even in Ovid's early telling of the tale, is presented as an attempt to break down the individual self and return it to a more primordial, pre-social order. This fits with Freud's earlier conception of narcissism and its relationship to both human consciousness and unconsciousness. But just as power itself flows in two directions, so does our self-concern. Indeed, as

Freud later went on to argue, although it appears — following Descartes — that "there is nothing of which we are more certain than the feeling of our self, of our own ego", which is "autonomous and unitary", and which we project outwards into the world, we also find that "the ego is continued inwards, without any sharp delimitation, into an unconscious mental entity which we designate as the id and for which it serves as a kind of façade".[3]

This is to say — contrary to idealistic conceptions of the self, wherein we appear to be clichéd masters of our fate and captains of our soul — that even when we focus our attention inwards, narcissistically, we find that the ego soon gives way to an awareness of its more unconscious — and therefore more impersonal — machinations. It is precisely in interrogating our sense of self, then, that it can be broken down, both inwardly and outwardly. In so doing, and before too long, "the boundary lines between the ego and the external world become uncertain" — or may, at the very least, appear to be "drawn incorrectly".[4]

The task of the narcissist, then, positively conceived, is to redraw these boundary lines. This process may manifest as self-deception and self-aggrandisement, at its worst, but when self-concern is necessitated from without, it can just as readily manifest as an attempt to change the world that threatens the self in the first instance. Such narcissistic expressions can be inherently creative, in that they require the self to construct and reconstruct itself at will, against the circumstances in which it may find itself — a creative undertaking that, of course, remains fraught and far easier described than actualised. One way of doing this, however, is arguably through an affirmation of the death drive itself, giving way to a more substantial process that does not retreat from "death" but passes through it.

Bayard's self-portrait remains a case in point, falling somewhere between a resentful self-aggrandisement and a painful self-fashioning. Though he believed he had been cheated out of a pension and a considerable amount of kudos, in faking his "death" and penning his own obituary, we can nonetheless imagine him having fun as he takes leave from his aspirations to be mediated and seen by those with the power to improve his lot — something he was ultimately denied. This is to say that, although his self-portrait depicts a death, it is nonetheless a product of creation and play. It is, then, an image of *another* death: death as protest, as joke, as affirmation. And it is a form of protest that is no less accessible to those who exist under a very real threat to their lives. Through the dark humour of his voided self-image, Bayard's "selfie" constitutes a wounding of the subject that is not *literally* fatal, but which is nonetheless *critical* of the circumstances that have undermined the life that Bayard hoped to live.

Death is not the end for Bayard. His death in effigy instead prefigures a reclaiming of the ego. Trampled by cronyism, in "death" he rises again. He frames photography as a way to reconfigure the self, even prefigure *new* selves. As such, contrary to the desires of photography's more lauded innovators, who sought to fix our self-images in place, we instead discover, through all the figures discussed so far, how unfixed our "selves" really are and can further become. Thankfully, there is joy to be found in this discovery, and a renewed sense of agency too.

Indeed, what sounds like a nihilistic perspective on the medium of photography, in its unwavering preoccupation with death, is perhaps more worthy of celebration than our culturally accepted melancholy allows for. This photographic nihilism offers up more opportunities than the mournful

shroud placed over the medium by the likes of Barthes and Sontag. It is a brand of nihilism that is not "an existential quandary but a speculative opportunity", or so Ray Brassier might argue, following his 2007 book *Nihil Unbound*. For Brassier, this is nihilism not as

> a pathological exacerbation of subjectivism, which annuls the world and reduces reality to a correlate of the absolute ego, but on the contrary, the unavoidable corollary of the realist conviction that there is a mind-independent reality, which, despite the presumptions of human narcissism, is indifferent to our existence and oblivious to our "values" and "meanings", which we would drape over it in order to make it more hospitable.[5]

To be dead, then, is not to be inert or to lack agency, particularly symbolically; it is to remove oneself from and begin to question a prevailing social order that runs counter to our desires. To welcome death, as Foucault argued, is to enter into a process that photography has continually actualised and undermined in equal measure. But the negativity of such a nihilism will no doubt make us uncomfortable, as the fates of marginalised people still cast a long shadow over this sense of affirmation. This does not undermine our argument, however. It is a form of affirmation that is perhaps no more affecting than when the all too real death of a particular group or subject is truly at stake.

19. The Height or Interruption

Rembrandt, Self-Portrait, 1630.

A Rembrandt comes in through the letterbox. Aged just twenty-four, he has a furrowed brow and, though he looks out at us, it is as if we are not really there. Head and shoulders framed, with the body at a slight angle, the young artist appears as though in a bathroom mirror, considering his own face sternly, unobserved by anyone but himself. The original

oil painting, anointed on copper in 1630, is currently housed in the Nationalmuseum in Stockholm, and it is from the Swedish capital that the photographer and writer Hervé Guibert has been sent a small postcard reproduction.

A few months later, this first Rembrandt is joined by another. One of the artist's earliest self-portraits, painted just a year earlier in 1629, he nonetheless appears much younger. But whereas the later self-portrait is "questioning, somewhat contracted by anxiety", Guibert describes this new arrival as being "like an explosion".[1] Rembrandt seems to have startled himself, Guibert observes, "looking like a wild dog, actually more like an idiot … surprised (as if the painter had shouted to himself, saying, Hey you, let's see what you look like!)"[2] This one arrives from the Alte Pinakothek in Munich. Guibert is pleased; he feels this is the start of a collection.

Rembrandt, Self-Portrait, 1659.

Soon enough, another Rembrandt comes through the door, presumably sent by the same friend but this time postmarked from the USA. This Rembrandt is different. Here the artist is much older, his face emotionless, as if he "had wanted to paint himself as a mass of flesh, like a carcass of beef hung by its feet".[3] Which Rembrandt miniature is now in Guibert's possession is unclear; perhaps it is the one held at the National Gallery of Art in Washington, D.C., painted in 1659.

Inspired, Guibert sets out to complete this burgeoning collection of Rembrandt selfies, unaware that the artist "had painted nearly fifty of them".[4] (Current estimates suggest the true number is closer to ninety.) He steals another postcard from a friend and later buys a fifth from the gift shop at the Louvre, likely the one produced in 1639, still in its collection.

Putting the postcards on display, Guibert positions the five reproductions together on a shelf and gazes at them. After arranging them in chronological order, he is struck by this serendipitous assortment of faces. He describes how, "from this juxtaposition, from these abrupt passages", he began to learn "something about my own existence".[5]

The postcard collection continues to grow; friends visiting New York bring back another three. But when placing them beside the others, Guibert finds that the spell has been broken. "Not only was I disappointed in these self-portraits, I violently rejected them", he writes.[6] "The first five self-portraits I had collected by accident formed a kind of perfect sequence, compact and not interchangeable; mentally, I had already framed them".[7] This initial Rembrandt, acquired in five fragments — four sections from youth and one from his mottled old age — formed a perfect prism through which Guibert was able to newly see himself. "I identified with him", he continues:

I would have wanted my own self-portraits to be like that, and in choosing these, I also chose my own. I tore up almost all the pictures in which I appeared and through this pictorial absence, just as through my rejection of the three Rembrandt self-portraits that I didn't like, I located my own self-portrait, I defined a posthumous image.[8]

Through his affinity with Rembrandt, Guibert now finds himself newly depicted in the objects that surround him, extending an experience of subjective abstraction into a radical new objecthood. But what is striking about Guibert's tale is not his identification with Rembrandt's self-portraits in and of themselves; it is rather his identification with their very multiplicity.

Time and self are out of joint here. Guibert is, of course, not Rembrandt. But perhaps that is because, in these images, Rembrandt is not Rembrandt either, and the artist has been removed one step further from himself — or perhaps a great many steps further — in now being presented to Guibert in the form of five photographic reproductions, many centuries after his death. Filtered through the enormous gap between himself and the Dutch painter, who already views himself impersonally, Guibert no longer sees himself as himself also. It is as if he hopes to take on a new, transhistorical self, like that explored by Virginia Woolf in her novel *Orlando* — the shadow side of an enforced individuality, constructed through restrictive social norms. In so doing, he loses himself in this fractal representation of atemporal non-selves, becoming alongside the objects in his possession. He makes himself hidden, emancipating himself from the gaze of both self and other.

In the end, what Guibert finally attains is not only a "posthumous image" but his own "ghost image". In his 1981

book of that name, in which he tells of his serendipitous encounters with Rembrandt's self-portraits, Guibert embarks on an impossible search for precisely this kind of photographic phantom — images he may have hoped to take, but which ultimately eluded him, for one reason or another. Through a conscious awareness of all that escapes the photographic process, he comes to realise that "the act of photographing [obliterates] all memory of the emotion, for photography envelops things and causes forgetfulness", and so a returning photograph is never anything more than "an estranged object that would bear my name and that I could take credit for, but that would always remain foreign to me (like a once familiar object to an amnesiac)".[9] Better, then, to affirm these absent images, these memories of a would-be mediation denied.

Death inevitably lingers over each ghost image all the same, but Guibert uses their ultimate absence from life to routinely contradict and overcome his nascent photographic melancholy, instead documenting the moments that each ghost image subsumes him through his writing, the moments in which any actual image is obliterated by the very *vitality* of a photographic life, which cannot be contained by the inertness of photography itself. But Guibert does not always mourn his photographic ghosts; he rather finds his inability to take the "right" photograph innately life-affirming. He thus emancipates himself as a spectator, through an explicit acknowledgement of all the similarly spectral images he has not taken.

Recognising the various ways in which life could refuse its own mediation, Guibert soon affirmed this same refusal for himself also. Indeed, when Guibert announced his "posthumous image", in choosing his Rembrandts, it is true and far from hyperbole that he went on to destroy all images

of himself that were then in his possession. But this self-destructive gesture was not simply provoked by a sudden enthusiasm for art history.

In 1988, Guibert discovered that he was HIV-positive. Like so many gay men who contracted the virus at that time, he found himself embroiled in an escalating social crisis and struggled to come to terms with what was still then considered to be a death sentence. But Guibert became morbidly fascinated with his own illness and the impact it was having on his body.

As a photographer and proud gay man, he watched all too closely as the face that stared back at him in mirrors and photographs became sickly and frail, and his declining health clearly came as a shock to him. Prior to his diagnosis, embracing the stereotypes that have long led to the pathologisation of homosexuality as innately narcissistic, Guibert cherished his own body as he would that of a lover, and so he often took portraits of himself. But his diagnosis changed everything.

Once aware of his seropositivity and the impact it was having on his body, Guibert was the first to acknowledge that his fading beauty was a tragic waste. Already feeling somewhat excised from society for his sexuality, he soon found his fractured sense of self compounded by HIV/AIDS, uncovering a further narcissistic kernel at the heart of his entangled experiences of ill-health and social exclusion. But Guibert did not renounce himself entirely, mourning the man he once was. Instead, he turned towards himself anew, albeit through that very renouncement of his own photographic representation. Indeed, rather than give into resentment regarding his impending death, he found himself totally reborn and, in the process, became one of France's most famous writers, chronicling the early years of the AIDS epidemic.

Guibert's account of his diagnosis and the new life he was forced to live as a result scandalized France when it was first published in 1990, under the title *A l'ami qui ne m'a pas sauvé la vie* (*To The Friend Who Did Not Save My Life*). But not only did Guibert write frankly about his own battle with HIV/AIDS, he also wrote about his friends' struggles also — in particular, those of Michel Foucault.

By the time Guibert's book was published, Foucault had been dead for six years, but his cause of death was still not public knowledge at that time. Though Guibert pseudonymised Foucault under the name "Muzil" — likely a fitting reference to Robert Musil, author of the unfinished modernist masterpiece exploring one man's grappling with an indeterminate subjectivity, *The Man Without Qualities* — it did not take long for readers to identify the man in Guibert's text.

Some saw Guibert's implicit disclosure as a betrayal of trust and an invasion of the philosopher's much-desired privacy, but it is nonetheless hard to imagine how Guibert could have told his story without making reference to Foucault — a man who was his friend, mentor, muse and so much more.

Foucault's influence on Guibert was indeed stark. He recounts in the book how he was first introduced to the philosophy of the ancient Stoics by Foucault, for instance, after Foucault took the *Enchiridion of Epictetus* "from his library shelf a few months before his death to give to me", suggesting it "might comfort and calm me".[10] It is not hard to see why.

The Stoics were important to a number of philosophers writing in the late twentieth century, particularly Foucault and Deleuze. Against their recent appropriation by capitalist ideology, folding a popular understanding of the Stoics' quintessential resolve into the Protestant work-ethic, Foucault

was instead inspired by how the Stoics, beyond any deference to social norms and the impersonal forces of the market, believed in the necessity of establishing a sense of one's own power. Indeed, contrary to how the Stoics are often understood today, they were not simply a group of philosophical pedants and apparatchiks, but rather, buoyed by a sense of what in the world was outside of their control, a group of philosophers who questioned power in all its guises and sought to discover what, if anything, was actually *within their own power*.

Eliding any Protestant-capitalist interpretation of their views, for Foucault and Deleuze this enquiry into the efficacy of one's own agency was affirmed from an explicitly subordinated position. The intention — particularly for Foucault, who hoped to develop an ethics of pleasure that rejected the moralising gaze of heteronormative society — was to develop a sense of moral freedom that did not conform to any oppressive sense of proper action, thought or reason.

This is particularly evident in Deleuze's reading of the Stoics as well. As Ryan J. Johnson writes, Deleuze's image of the Stoic was precisely that of a "philosophical pervert".[11] Colloquially speaking, we might understand a "pervert" as someone who engages in criminally sexual practices or who has an interest in particular sexual fetishes that are morally objected to. In psychoanalysis, however, the term is understood more complexly. For Freud, "perversion" referred to any sexual behaviour outside of heterosexual norms (particularly homosexuality, although not exclusively); Jacques Lacan later developed a more nuanced and less explicitly sexualised definition of the term. "What is perversion?" he asks in his first seminar:

It is not simply an aberration in relation to social criteria,

an anomaly contrary to good morals, although this register is not absent, nor is it an atypicality according to natural criteria, namely that it more or less derogates from the reproductive finality of the sexual union. It is something else in its very structure.[12]

It is this structural perversion that each of these figures affirmed. As philosophical perverts themselves, Johnson argues, they cherished Stoicism's most important and innately heretical operation: its commitment to "radically contesting the validity of that which is".[13]

This same sense of perversion, along with its pejorative connotations, was just as central to Foucault's philosophy; he wrote and taught at length on society's penchant for labelling (and thereby controlling) certain subjects as "abnormals", primarily in the administration of different sexualities and their associated identities.[14] Though restricting himself to a historical understanding of "abnormality" in his lectures, it is clear, with the benefit of hindsight, that Foucault's interest in the legal classification and control of aberrant identities was personally relevant to him as a seropositive homosexual man, and so Foucault affirmed his own "abnormality" in both his public and private lives, hoping to constitute an ethics of the (homosexual) self that was necessarily outside of contemporary society's moral standards. He turned to the Stoics explicitly in order to achieve this.

The Stoics were of further interest for the ways they asserted their own defiant potential in the face of any impending death, whether natural or otherwise, often alluding to the importance of going out on one's own terms — something that was particularly relevant to Foucault's diagnosis and to Deleuze's struggles as a sufferer of recurring respiratory issues.[15] Indeed,

such a stance becomes all the more pertinent when faced with the realities of disease and terminal diagnoses — and particularly those afflictions that are deemed to be moral punishments by a bigoted society. But we might remember that Foucault, in particular, did not make any foreknowledge of his death public. Instead, this defiance was asserted implicitly through the act of writing itself.

Writing, for Foucault, was a kind of confession, but in writing only for the sake of oneself — that is, not so much in isolation, but rather in order to provide an account of oneself to others — he found a space for pursuing a narcissistic transformation into another form of life, newly able to assimilate the tensions that made up his social existence. This is what Foucault took from the *Enchiridion of Epictetus* most explicitly. In an essay entitled "Self Writing", he argues that, for Epictetus, "writing appears regularly associated with 'meditation,' with that exercise of thought on itself that reactivates what it knows, calls to mind a principle, a rule, or an example, reflects on them, assimilates them, and in this manner prepares itself to face reality".[16] In this sense, then, it is precisely through writing (about) the event of one's wounding that one may be able to overcome it in reality.

Guibert was also a compulsively confessional writer and photographer in this same Epictetian mode. The products of this compulsion — his published books, diaries and photographs — allow us to experience the withering of his own subjectivity alongside him, as well as the construction of an altogether new subjectivity and mode of living. His journal, in particular, is a consciously narcissistic exercise in this regard, with each entry, like each photograph previously made, allowing him to attain "a posthumous impression" of

himself, even whilst alive, enabling him to better think the reality of his own morbidity.

"I pass myself off, as I begin to type this journal", Guibert declares, "as the researcher of myself", and it is a mode of research undertaken no less compulsively than any other.[17] Like life itself, the production of the journal is self-sustaining. "Only death will put a full stop to this journal", he writes.[18]

Though unillustrated, the fragmented entries of the journal appear like photographs to us, like ghost images, and those that describe Guibert's appearance are among the most affecting. They record glances that seem to weigh heavy on his mind, despite their fleeting nature. ("I look at myself in the mirror, what a sad face".[19] "In the mirror today saw myself blue".[20]) But over time, this distant and depressive concern transforms into a Rembrandt-like impersonality, as Guibert begins to consider himself daily, with his seemingly denied photographic compulsions feeding into a morbid self-concern. "The eyelid is the first thing to grow old", he notes one day, no doubt after that daily encounter with his own reflection; "one doesn't realize it because one looks at oneself with open eyes".[21]

It is notably Narcissus himself who reconnects Guibert to his fascination with a photographic gaze, one step removed from his own. "First visit to the painting museum", he writes in one entry, "reconciliation with the flesh (Caravaggio's *Narcissus*)".[22] But developing in tandem, it is his photographic and writerly practices that become the only true way to see himself without the restrictions of an embodied vision, in that both mediums take one's "gaze" and place it outside the self, through some version of the "author function". "Only in a photograph do I see how thin I have become, not in the mirror", he muses.[23]

As the years pass by without fanfare or celebration, as if the time of Guibert's journal was an uninterrupted and purgatorial expanse, this process of self-research becomes more and more pronounced. At first, he seems to hate himself for it, and suicidal ideation lingers narcissistically on the surface. "I can no longer stand to consider myself as an object of study", he confesses, continuing anyway.[24] "I felt death approaching in the mirror, gazing back at me from my own reflection, long before it had truly arrived to stay".[25] He later writes: "It impresses me that I'm still alive, and perhaps so close to death: to continue to see, to look at faces, which in turn see me, like an appearance which must seem firm, but which finds itself so advanced in dissolution".[26] What is he to do? "Get out of life? Hibernate in the middle of spring?"[27] No. Instead, with his body's deterioration already accelerating, with each photograph and each journal entry only marking the dwindling time he has left, Guibert's production of innumerable ghost images becomes a new life-work — a work of posthumous transformation enacted in his lifetime.

Affirming himself as a new Narcissus, terrorised by his own fading likeness, Guibert eventually attempts to conjure "the strength to transform in oneself the regret of the image that escaped me into something more intense than the image".[28] In abstaining from a photographic meditation on his own self, he realises that he, as a photographer and as the subject of his own self-portraits, can create a passage outwards from an increasingly medicalised awareness of himself as a PLA (a Person Living with AIDS), whose life is now structured by rituals of needle puncture and other invasive treatments. ("The whole body besieged, the once fortressed place invaded".[29]) But Guibert comes to realise that it is the shaping of a self through medical administration that bothers him the most. "Destroy

my life, or destroy its organization?"[30] AIDS is already taking care of the former, but it is up to him to destroy the latter. He begins to take pleasure in "destroying one's body", with the destruction of his self-portraits becoming a first step on the way to throwing off the image that torments him.[31] "(It is by renouncing that one advances?)", he asks himself in a telling aside.[32]

Though his journal is intensely self-concerned, Guibert never loses sight of the communal repercussions of his diagnosis. He is equally tormented by the "idea that I may die from the illness transmitted by the other, by his kiss, by his embrace".[33] But in also labouring under the knowledge that he may transmit the virus in turn, that he may be another's fatal encounter, he comes to feel more and more like Narcissus, tormented by society's increasing hostility to the gay community and his internalisation of its various enclosures, which paradoxically accost him every time he steps outside and experiences the other's gaze.

In one particularly affecting scene, he writes:

As soon as I leave the hotel room, I have the impression that my person, and not only my body, not only because of the heat, is damaged by the outside, gnawed upon it, that it is corroding, like a rare fume that had been contained in the room, and that, from out of this reclusion, multiplied, reinforced itself, and finds itself suddenly dissolved in contact with foreign bodies, gazes. So I sit down in the café breeze to augment this impression (the gaze of one's self is the only way to resist that corrosion).[34]

It is interesting that, at this juncture, it is the gaze of one's self that becomes a shield against the gaze of the other, particularly

for a seropositive gay man who documents in his journal, at intervals, his deep fantasies of lust, where fucking happens in the instance of a stolen glance. But later, the gaze of one's self is not a shield but an abject default, as the world withers away around the AIDS-ridden body. A desired immunity from violence gives way to a violent auto-immunity, perhaps even an internalised homophobia. The irony is devastating. Still, as gay communities began to wrestle with this most abjectly tragic of ironies, it was out of the question to wholly renounce a love given to and received from the self and its other. Indeed, as Guibert found himself increasingly alienated by his own appearance, he realised he had to love his own self as if it were that of another, if he was to have any life to live at all.

As the virus continues to strain the self's relations with power and with the other, a transformative narcissism becomes the only option. Guibert comes to understand himself as a protagonist in a story that he is actively constructing, as in Foucault's treatise on "Self Writing". He others himself in order to think himself more clearly. He engages in a practice of self-questioning, as if engaged with an ontological auto-immunity that mirrors the effects of the virus he has contracted. As Judith Butler has argued, such a self-questioning always

involves putting oneself at risk, imperiling the very possibility of being recognized by others, since to question the norms of recognition that govern what I might be, to ask what they leave out, what they might be compelled to accommodate, is, in relation to the present regime, to risk unrecognizability as a subject or at least to become an occasion for posing the questions of who one is (or can be) and whether or not one is recognizable.[35]

In response to this experience of alienation, Guibert affirms his diagnosis as its own form of protracted ego-death. The body he mourns is only the "ideal body (my dreams design it)"; it is "a body that refuses itself, then concedes, half consenting half grumbling, a body that lets itself go, inert, suddenly offered".[36] In the end, having passed through the various stages of grief, Guibert experiences not a breakdown but a breakthrough, a narcissistic transformation. Seeing the soon-to-be dead man in the mirror before him, he adopts this image as his own and is freed by it. "I will have had to become accustomed to this emaciated face the mirror shows me each time as no longer belonging to me, but already to my corpse", he writes, "and I have had, *the height or interruption of narcissism*, to succeed in loving it".[37]

20. New Complicities, New Tenderness, New Solidarities

What Guibert constructs, at the height or interruption of his narcissism, is his posthumous image, previously described, which we might otherwise think of as the impossible image of an impersonal and *historical* self. In being read historically, the self becomes something past, something that we are not, but it is against this reified image that we can begin to take better account of our future selves.

Reflecting on this same historical sense of self in Foucault's writings, Deleuze argues that the power of Foucault's work lies in his desire to enact much the same principle, which is enabled precisely through his Stoicism. History itself is understood by Foucault as that prevailing structure that sets out our course forward, often contrary to our own wills and desires. It is in this way that Foucault's perverted philosophy of history, according to Deleuze, "circumscribes us and sets limits, [but] doesn't determine what we are"; rather, if it determines anything, it is "what we're in the process of differing from; it doesn't fix our identity, but disperses it into our essential otherness".[1] Indeed, when Foucault concerns himself with history, historical periods, historical figures and movements — like the Greeks and Christians, for instance, as in his final and unfinished work, his multi-volume *History of Sexuality* — Deleuze argues that Foucault is trying "to find out in what way we're not Greeks, not Christians, but becoming

something else".[2] In this sense, history, Deleuze continues, "is what separates us from ourselves and what we have to go through and beyond in order to think what we are".[3] When Foucault concerns himself with processes of "subjectification" in this way, "it's stupid to see this as a return to the subject" as some fixed historical concept that persists, unchanging, in the present; "it's to do with establishing new ways of existing or, as Nietzsche put it, inventing new possibilities of life".[4]

So far, we have already been attempting something similar for ourselves, in considering the history of the self-portrait not to tell us what we are or what our selfies represent, but instead what we are not and how we differ from our artistic self-representations in reality. After all, each of the figures discussed here, with a few exceptions, is also an historical figure, long dead. Their times are not ours. But in considering how they differentiated themselves from their own societies' recent pasts, finding themselves caught within the narcissistic feedback loop of subjective experience and society's various processes of assignation and subjugation, they each made efforts, in Deleuze's words, to *elude the present*, affirming their "whatever being" or their becoming-something-else. It is for this reason that a consideration of their narcissisms may prove productive: we might better understand how we can do the same.

Such a process is increasingly necessary today. So many of the injustices that are now discussed in our public discourse are innately concerned with nothing less than the future of humanity, or perhaps less drastically, the new subjectivities that are needed for there to be any future whatsoever. Like Dürer, we may understand ourselves not as the first subjects of a new era, but as the last subjects of an old one. We find ourselves on the precipice of an essential change.

In our contemporary political discourse, this process is understood negatively. The recent intensification of cultural critiques of a systemic racism, for instance, is often framed as the erasure of some previously secured sense of hierarchy between subjects, albeit inverted so that it is the powerful, rather than the powerless, who both run scared and run from any recognition of their more privileged social standing. To return to the example of the Black Lives Matter movement and its opponents, discussed in this book's introduction, we might consider how, in response to the demand for transformation that comes from below, it is the supposed genocide of the white race that emboldens racism in our present for so many. But this does not refer to any actual act of social murder, as is arguably experienced by the oppressed; rather, it is the elimination of a once-dominant subject position that causes certain people to lash out. Transformation is not welcomed but feared. The "death" of a given subject position is made violent and absolute rather than necessary and transitory. A negative narcissism goes to war with a more positive reading of its affects.

The same is true with regards to the climate crisis, which demands that we radically rethink our relationship to other humans, other species and the world as a whole. Conservative politics in general makes few qualms about its opposition to this process in every instance. The world itself is seen as less important than the stability of a particular ideological position. What should be conserved is clear, if nonetheless paradoxical: it is the world and its environment, which is always changing and even necessitates change. But "climate change" itself is downplayed in such an argument — in the sense that change is seen as inherent to nature itself, and so we needn't respond to our changing world in any meaningful way,

because humanity has always been what it is and need not adapt accordingly when challenged by present contingencies. But against this denialism, we ourselves are made somehow distinct from nature; we are understood as static subjects who simply need to weather what is outside of our control. This negative Stoicism traps us in a paradox, where change is accepted in all instances except for ourselves, and so what is conserved instead, more often than not, is a particular kind of subjectivity that is, ironically and disastrously, no longer fit to maintain any social or even planetary equilibrium.

Though seemingly convoluted, the overarching point is simple: if maintaining the planet is our goal, against all assertions to the contrary, we must necessarily change how we see ourselves and our actions, as both individuals and societies, and this requires a shift in our very subjectivity — something we are right to not take lightly, precisely because the stakes of doing so are so stark. But such a change is no less necessary, and indeed, it is arguably already under way. But our political discourses are instead defined by a resistance to new ways of doing things or expressing ourselves, whether in relation to the coming climate catastrophe or in less cataclysmic examples, such as the suggestion we should make minor adaptations to our gendered language — with the latter, in particular, occupying the attentions of popular media so disproportionately in recent years. The underlying political significance of these examples is seen by those in power as the hysterical demands of a societal fashion-flux — simply new trends that will soon disappear as we return to some universal and transhistorically static subjectivity. But as we have already seen, no such subjectivity exists. History only functions through the active renunciation of what has come before, and so it is essential to question power

in its appeals to a stasis that is otherwise fundamentally illusionary.

Foucault himself made this same point, in writing that "I have tried to get out from the philosophy of the subject, through a genealogy of the modern subject as a historical and cultural reality — which means as something that can eventually change".[5] He instead "wished to study those forms of understanding which the subject creates about himself".[6] In so doing, reiterating his own brand of Stoicism, he "became more and more aware that in all societies" there are

> techniques that permit individuals to effect, by their own means, a certain number of operations on their bodies, their own souls, their own thoughts, their own conduct, and this in a manner so as to transform themselves, modify themselves, and to attain a certain state of perfection, happiness, purity, supernatural power.[7]

Perhaps there is no subject more curious about these techniques than the subject who knows and acknowledges — whether through ill health, societal persecution or both — that they are somehow deemed to be imperfect, unhappy, impure or all too ordinary in their power.

The result of this reorientation, for Foucault, was the discovery of "a set of truth obligations: discovering the truth, being enlightened by truth, telling the truth", all with the aim of considering anew "the constitution of, or the transformation of, the self".[8] We see this process at work already in a variety of social justice movements, which so narcissistically demand change. But again, we are more than capable of understanding this narcissism positively. Against a conservative politics that renounces social justice movements as enabling various

assaults on a received sense of "history" — as in the toppling of statues that many see as symbolic of white supremacy — Foucault emphasises that our self-questioning enables the very movement of history as such. "The more we discover the truth about ourselves, the more we must renounce ourselves; and the more we renounce ourselves, the more we need to bring to light the reality of ourselves".[9]

Though often negatively constituted, the truth that Guibert felt he had to contend with remains poignant here, in that he was forced to contend with the truth of his destiny as a PLA. Eventually, he was going to die — that fact was sadly immutable. But this truth nonetheless occasioned its own form of enlightenment. Indeed, any future death is a truth that we may all feel the pressure of today, in knowing that our planet is doomed unless we address our social comportment with regards to our environment. But in rehearsing this demise in particular, through symbolic images of a future death — for example, through the act of a "die-in", occasionally performed by climate activists, in which protestors lie down *en masse* in order to prefigure the spectacle of mass death that is to come — we come to understand such a truth as one that we *must* accept in order for us to act differently.

Analogously speaking, in affirming the truth of his diagnosis, Guibert was more readily prepared to contend with it. In writing it down, meditating on it, he was more capable of transforming himself in response to it. But at the same time, he did not disappear into himself; he was still able to retain a communal orientation. Though his writing may at times (understandably) fall back on self-pity, he also makes a commitment to representing himself frankly and impersonally to others, perhaps so that, in the future, no one else may have to share in his experiences — or alternatively, so that they

may use his self-representations as something to push against for themselves, accelerating their own capacity for self-transformation in light of his example. His AIDS memoirs become a record of the work required to become something other, and in confessing his truth, he provides himself as an image to be torn down.

In this sense, Guibert's transformation is not only personal but decidedly *impersonal*, and so he recounts the drama of this impersonalisation in the hope that it will affect a social self-understanding in turn. "To the friend who did not save my life" is, after all, a mournful and reflective title that pointedly addresses not only an individual — a friend whose biomedical work was directed towards finding a cure — but the Big Other who also has the power to save him. It is also, on the one hand, an accusatory and self-pitying title, but at the same time, it is a title that addresses itself as a posthumous work, as a ghost image or narrative, as if, in giving such a frank account of himself that will outlive that same self *to* the friend — that is, both pre-emptively and from beyond the grave — he centres anew an ethical relation that is not denied but intensified by his death. He becomes aware that, in his account of a transformative death, in the various ways he self-subsumes into the "author function", he may still encourage a transformative change in others. What was too late for Guibert may one day manifest itself for other PLAs and a wider LGBTQ+ community, if only they take heed of his experiences.

Beyond the specificities of the AIDS epidemic, this act of self-transformation is increasingly available to us all through various artistic mediums, with photography arguably being the most readily accessible medium there is. We can use it to determine not only the subjects that we are, but the subjects

we are in the process of becoming. If Guibert continues to affect us today, it is in the ways that his meditations on the self continuously affirm how we are always changing and adapting to the things that happen to us, contrary to any ideological position that insists we stay the same.

To this end, it is notable that Guibert's writings — particularly his AIDS memoirs — have had something of a resurgence during the coronavirus pandemic. The English translation of *To the Friend* was serendipitously reissued by Semiotext(e) in 2020, just as Covid was tightening its grip on the world, occasioning a number of reflections on the work's standing in a new age of plague in the US literary press. Drawing somewhat uncomfortable parallels between the AIDS epidemic and Covid-19, Andrew Durbin, who also introduced the new Semiotext(e) edition of Guibert's memoir, writes for the *New York Review of Books* about how disease is always "conspiratorial, never egalitarian, always crawling along social fissures".[10] Though any disease may not affect or put everyone at risk in the same way, we all have a duty to respond to it collectively. (We might understand narcissism has yet another social "disease" in this same regard.)

Julian Lucas, writing in the *New Yorker*, similarly notes how the AIDS virus functioned specifically as Guibert's "muse" in this way, allowing him to newly attend to the social tensions of queer life in twentieth-century Europe. He suggests, with the coronavirus in mind, that we might still learn something from Guibert's approach to the AIDS virus and the overbearing presence of mass death in our societies today. Our apparent incapacity to think of death as a social relation, rather than an abdication of the social altogether, makes this readily apparent. "Inextricable from

the malfeasance that has made the United States uniquely vulnerable to Covid-19 is a widespread failure to imagine one's own mortality — and a tendency to project it onto others, whose deaths are deemed unfortunate inevitabilities", Lucas writes. He continues:

> At the core of this callousness is the misconception that acknowledging death is antithetical to "really living." But it isn't the dying who are truly deathly. Guibert, who faced down AIDS with such irreverence, achieved an almost indestructible vitality in the duel.[11]

The AIDS epidemic and the coronavirus pandemic of course differ from each other significantly, but we can nonetheless see in these reappraisals of Guibert's work an attempt to recover an ethics of infection and transmission — not only within the literally "viral" transmission of a disease, but also the virality of power that manifests through art, memes and other modes of communication. In this we can see an attempt to rethink "death", whether real or symbolic, in the face of all that threatens us. But against the melancholy and pessimism that such threats encourage, we can also see, in the AIDS narratives of the Eighties and Nineties in particular, a new vitality that redoubles our ethical concerns and attempts to think communal risk otherwise.

Drawing on a particularly potent example from Guibert's memoir, both Durbin and Lucas are struck by the same comment made by Foucault/Muzil. Having returned from a recent trip to San Francisco, Foucault regales Guibert with tales of cruising in the city's baths and saunas. "Those places must be wholly deserted now because of AIDS", Guibert assumes. "Don't be silly", Muzil replies,

it's the opposite: the baths have been so popular, and now they're fantastic. This danger lurking everywhere has created new complicities, new tenderness, new solidarities. Before, no one ever said a word; now we talk to one another. We all know exactly why we're there.[12]

Though the coronavirus pandemic seems quite distinct to this, in that it is not negatively associated with a particularly marginalised section of society and its specific modes of (sexual) relation, we might nonetheless find a similar affirmation of new complicities, new tenderness, new solidarities in its aftermath.

So many of our communal spaces were forced to close once the coronavirus took hold, but as we return to pubs, clubs and other hangouts, perhaps we are also newly aware of their importance, contrary to the fact that they were seen by many governments as inessential spaces of communal gathering. This is not to suggest that their closures were unnecessary, but rather to acknowledge that many of these spaces were nonetheless denied financial support so that they might survive the effects of quarantine policies — a travesty when we consider how important such spaces are to so many of our subcultures. Indeed, though the virus affected everyone, marginalised peoples were arguably more affected by its restrictions in this way. (All emphasis was placed on a return to work, rather than a return to community.) But it is also true that, in some circumstances at least, these communities were more prepared to capitalise on the pandemic's inherent questioning of social norms and habits than others. For those communities that did survive the pandemic, their efforts to maintain their own survival have been necessarily redoubled, precisely because of the self-concern the pandemic exacerbated.

Though it may seem to operate at some distance from these more recent concerns, the philosophy of Gilles Deleuze goes to great lengths to affirm this very point. Demonstrating his Stoicism most explicitly, he insists that we must

> become worthy of the things that happen to us, and thus to will and release the event, to become the offspring of one's own events, and thereby be reborn, to have one more birth, and to break with one's carnal birth — to become the offspring of one's events and not of one's actions, for the action is itself produced by the offspring of the event.[13]

This kind of willing of an event, broadly speaking, has direct implications for how we think of ourselves as selves. In responding to the things that happen to us in this way, which are so often beyond our control, we begin a process of self-making that is framed as an innately ethical concern. If we cannot take the event back and return to the past, we must ask ourselves: who or what do we want to become in response to it?

Judith Butler again gives a particularly lucid account of the stakes of such a question in her 2005 book, *Giving an Account of Oneself*. There she argues that "what relation the self will take to itself, how it will craft itself in response to an injunction, how it will form itself, and what labor it will perform upon itself is a challenge, if not an open question".[14] This challenge is not self-contained within the enclosure of the individual, but must necessarily respond to the social relations that tether us to others.

The questions such a challenge may provoke — particularly in the context of the coronavirus pandemic — are, on the one hand, innately (bio)political, and thus make demands on systems of governance and power. But on the other hand, as

we have already seen, such questions of power do not follow a path of one-way transmission. In choosing how we ourselves want to live, we can collectively challenge (if not directly change) the ideological frameworks that contain us. Our potential flows outwards through the channels of oppression and communication that power makes newly visible to us. It is in this way, Butler continues, that such an injunctive event, like the pandemic,

> compels the act of self-making or self-crafting, which means that it does not act unilaterally or deterministically upon the subject. It sets the stage for the subject's self-crafting, which always takes place in relation to an imposed set of norms. The norm does not produce the subject as its necessary effect, nor is the subject fully free to disregard the norm that inaugurates its reflexivity; one invariably struggles with conditions of one's own life that one could not have chosen. If there is an operation of agency or, indeed, freedom in this struggle, it takes place in the context of an enabling and limiting field of constraint. This ethical agency is neither fully determined nor radically free. Its struggle or primary dilemma is to be produced by a world, even as one must produce oneself in some way. In this struggle with the unchosen conditions of one's life, a struggle — an agency — is also made possible, paradoxically, by the persistence of this primary condition of unfreedom.[15]

What figure reflects this dilemma of ethical agency, "neither fully determined nor radically free", better than Narcissus — the patron saint of our peculiar capture.

The political implications of this sentiment cannot be overstated, especially when they emerge from marginalised

communities, like the LGBTQ+ community, or individuals, such as Guibert. Steven Bruhm, focussing on the innately political nature of queer subjectivities in particular, argues that "politically dangerous desires" might be "desires precisely because they are politically dangerous".[16] If we denounce these desires as narcissistic, it is perhaps only because we know, deep down, that "Narcissus is he who changes".[17] Ultimately, Bruhm concludes: "If there is a 'use' for Narcissus, it is in his dangers. Narcissus, who is said to aspire to what is the same, is continually destroying the political safety promised by sameness".[18] But even if we are not homosexual, Narcissus can still remain an important figure for the rest of us.

The use of Narcissus, then, as a figure of quasi-freedom and capture, comes from the fact that he arrests the normative functioning of a shallow individualism, which attempts to keep the two-way transmission of power hidden, instead focussing on an individual's voluntaristic agency outside of any social relation. Any subjectivity, which might otherwise constitute an adaptive and ever-changing entity, is hardened and made opaque. But when we become more aware of these confines and the ways they are affected and rattled by crises of capitalism, we begin to see gaps in our individualistic armour. It is in this way that our sense of their opacity can be useful to us. As Butler argues, "it is precisely by virtue of the subject's opacity to itself that it incurs and sustains some of its most important ethical bonds".[19] Newly aware of how we are shaped and controlled from without, we are soon able to return to what matters to us more explicitly, emancipating ourselves, in newly considering how we might enact what little agency we have to affect change, and there may be no agency more important for us to actualise than choosing how to live our lives and die our deaths.

Processes of self-writing or self-photographing are one way that we can enact this principle. They are not repugnant acts of self-concern by default, but may be taken up as ethical practices, which are not wholly concerned with the self *for itself* alone but with the self caught in relation to itself and others. What is further notable about Guibert's response to his changing self is that, despite being initially captured by morbid reminiscences of his former health and beauty, he soon starts to draw the weak and shaky lines of a new and elusive likeness. He draws his own picture, or at times even affirms his inability to do so, constructing his own ghost image instead, fully aware that the self he is becoming (or will become after his death) is inaccessible and opaque to him. Nevertheless, he sketches its contours for us regardless, and makes implicit demands on our ethical relationship to him. As a result, it is a process of self-fashioning that not only makes his own experience more weatherable, but which also illuminates its complexity to and for others. Like Narcissus, he succeeds only when he comes to haunt himself — when he starts to write as if he were already dead.[20] But his transformation is only complete when he comes to haunt *us* also; when we ourselves return to the scene of his death to find only an intoxicating flower on a shifting shoreline.

Have not all the artists discussed so far sought out a similar transformation, with each being deeply affected by an event that resonates throughout their lives, hoping to be reborn in a manner of their own choosing? And is our relationship to each of them, as often canonical figures from a gradually mainstreamed art history, not also constituted by the fact we feel the echoes of their explorations in our own struggles with ourselves? In each instance, did their subjective rebirths not necessitate the construction of a new image — an image that

we may come to realise, thanks to their efforts, we have also (perhaps unconsciously) been striving for?

From Dürer's encounters with Italian art and the printing press to Caravaggio's botched duel with Tomassoni and his brushes with power in its aftermath, from Bayard's rejection by the French academy to Friedlander's first encounters with his shadow, each event constitutes a wounding of a sort — or, at the very least, a kind of rupture or injunction — in which the self is punctured and infected by impersonal forces, made newly aware of its place in history. But whereas all of these figures — with the exception of Friedlander — either deny or fight the event, eventually finding themselves subsumed in melancholy as they reach the end of their individual lives, there is perhaps no better photographic example of an event willed than that of Guibert himself, who made an attempt to release the event of his wounding through the literal destruction of his own image, allowing him to shed a deteriorating self in order to adopt a new one.

The truth to be affirmed is that we, as subjects, change all the time. In truth, the self is one of the most erratic and unstable concepts in all of the various philosophies that are available to us. From the few historical examples we have discussed, it is evident that art — and the medium of photography, in particular, in our modern era — is able to illuminate this kind of conjuncture for us. Against the general uses and pre-determined applications thrust upon it by capitalism, photography remains an important tool in shifting our perspectives on the world around us in this way. With regards to our constricted understanding of the selfie, we can begin to understand it less as a signifier of our static being and instead as a marker of our increasingly indeterminate and essential becoming.

Transformation

21. Narcissism Today

We have produced only a series of snapshots within what is undoubtedly a long and complex history of self-representation. And yet, despite all of this, today the selfie is regarded by many as an explicitly late-capitalist malady. Even academic books on the subject will treat the selfie as a new phenomenon. In many respects, as we have already discussed, it *is* new. But too often what we denounce as symptoms of postmodern pathologies are in fact aspects of self-portraiture that have been innate to this form of self-representation since the Renaissance. Of course, this sense of longevity is hardly going to make us feel better, and so perhaps we attack the selfie so vehemently because we believe it to be an impotent form of self-expression, which is ultimately incapable of solving the problems it symbolises. This pessimism is understandable, but it also exacerbates the necessity of ascertaining what it is about the selfie that is exclusive to our present epoch. Without such a qualification, our impotence will be assured, our solutions over-simplified, based on false dichotomies or foundations, stained by the mark of a popular moralism.

But in allowing ourselves to come to a better understanding of the history of the self and its representations, we may instead find solace in the few centuries' worth of dissenting examples at our disposal, comparing them to the more contemporary responses we have produced to our predicament. Indeed, against a prevailing pessimism that suggests otherwise, it should now be readily apparent to us that so many artists and

photographers have precisely engaged with — even actively questioned and attacked — this same narcissistic tension between the individual and the social. There is nothing to stop us from extending such critiques into the present.

It is nonetheless true, however, that the arrival of social media stretches the self and its representations across a new set of material conditions, changing our relationship to the self as such. But so many of the selfie's contemporary critics seem unable to illuminate what these conditions actually are. If the selfie *is* different from prior forms of self-expression — and we have already argued that it is, in our discussion of the Hilton-Spears selfie — then we must account for this difference without giving in to a cultural amnesia. But perhaps this is a problem borne of the selfie itself. It is not that the selfie actively *produces* something new; it is rather through the false newness asserted by a static capitalism that it is used to *obscure* the kinds of alternative self we have long been striving for.

It is for this reason that, whilst the likes of Dürer and Bayard produced representations of both emergent and fading selves, the problem today seems to be that our selfies document little more than an uneasy stasis. Of course, this is not a result of their repetitive production alone. The repetitive selfies of Friedlander and Rembrandt, for example, do well to place the self in tension with itself. In more generic examples of the selfie, however, we find only a false consistency, a unitary self repeated. It is what Roland Barthes might call a "humiliated repetition" of the self, making the selfie just another "bastard form of mass culture", wherein "content, ideological schema, the blurring of contradictions ... are repeated, but the superficial forms are varied: always new books, new programs, new films, news items, but always the

same meaning".[1] We can easily add our selfies to such a list. Though the faces, occasions and locations depicted in them may change, the self depicted, the self signified, supposedly stays the same. But Barthes' comment is worth paying greater attention to here, as this is clearly not a problem unique to the selfie as such, but rather a problem with postmodern culture in general. And so, blaming our selfies for our discontent with postmodernity is just another way of blaming ourselves, rather than the material conditions that have captured the self and its concerns so absolutely.

It is this limiting of the self-portrait's potentials that is arguably exacerbated anew in our current moment, but such limitations can still be overcome. We can do this by leaving social media behind, perhaps, or by affirming the ways that social media expands and accelerates the fragmentation of the self in (properly) new ways. Indeed, the point to be affirmed is that, whilst the selfie may intensify a sense of capture we have long wrestled with, its social-media context also exacerbates our potential to escape it. Our prevaricating over the influence of selfies on our lives surely demonstrates, in this regard, that we are more suspicious of capitalist individualism than ever before. But just as we still uselessly condemn the hypnotic glow of our screens — moving from televisions to smart phones — whilst paying little mind to the more emancipatory political projects these same technologies have helped promote, we continue to ignore the ways that the selfie has projected our subjective power out into the social sphere in new and provocative ways as well.

Still, we are no doubt aware of the enormity of the task ahead of us. In attempting to disentangle our potential from our possession, we may be struck by how the selfie is not simply a form of representation adopted by individuals themselves but

by communicative capitalism as a whole. Indeed, the horror of the selfie's ubiquity is that it vicariously provides capitalism itself with a human face, which gazes back at us from the disturbed surface of the spring, feeding our enduring sense of alienation. But this sense of alienation can also be useful to us. We must pay more attention to the uncanny valley it reveals — the reasons *why* modern selfies horrify us — rather than condemn the very existence of the selfie-form outright.

When swiping left and right on a dating app like Tinder, for example, we are often disturbed by the sheer abundance of near-identical people we find there — that is, people who *appear* identical only thanks to a certain regime of looking; they all replicate the same angles, filters and face-tuning apps, as well as the same methods and modes of composition, in presenting themselves to potential love-interests according to the app's restrictive economy of symbolic exchange. But this tells us less about the people under consideration than it does about the homogenisation of (representations of) the self by capitalism overall. What we show of ourselves on our dating profiles is, of course, only what we *think* other people want to see of us, influenced by capitalist standards of beauty, which likewise mirror the normative modes of living that the system inherently values and validates.

In this sense, the fact that online dating — as a relatively recent development in how we communicate — feels like browsing an Ikea catalogue is an indictment of capitalism rather than of ourselves as such. It demonstrates an acute lack of imagination with regards to capitalism's mechanisms of control and capture, as the system presumes that a model that works for buying furniture is just as suitable when looking for love. This is a ridiculous situation to find ourselves in, in so many ways, but in being represented to us through the form of

the human face, rather than more clearly identifiable structures of exchange, we tend to criticise the people that appear before us more readily than the system that normalises such methods of representation. The moral panic of narcissism remains a perfect example of this blind spot — we pour scorn on the player but ignore the totalising nature of the ultimately rigged game, which we can only escape by transforming ourselves. We should instead, then, become more aware of the ways that desire is wholly subordinated to capitalist regimes of looking.

But selfies still remain useful to us in this regard. Our generalised suspicion of their ubiquity provides us with an obvious starting point for any contemporary critique of communicative capitalism, especially if we hope to denaturalise any of its normative regimes of seeing. We can do this by emancipating ourselves as spectators. For example, no one who participates in dating apps or other ocular-centric social media platforms like Instagram is ignorant of the fact that a profile is not a person, and so we are all more than capable of understanding the selfie not as an accurate depiction of a self to be denounced, but rather as a mode of capture with intentionally limited horizons. The open secret of our era is that the true multiplicity of the self, the warts-and-all person we are in the privacy of our own homes, is incompatible with the ideals of a communicative and representational capitalism. The ubiquity of the selfie, then, is not a problem in and of itself; it is a useful measure for sketching the boundaries of our contemporary unfreedom. Considering this for even a moment, we realise that the very task of our online lives — and the unacknowledged truth of social media — is that we have only truly rediscovered the social proper when we allow ourselves to see all the things that control has hidden from view.

22. Escaping the Face

So what is to be done? Having read about Guibert's account of his apparent disillusion with self-portraiture, we might assume the only course of action is for us to do away with photographing ourselves altogether. This was certainly the overbearing feeling expressed within French philosophy in Guibert's time. Gilles Deleuze's work, especially that produced in collaboration with Félix Guattari, is particularly notable in this regard.

Deleuze and Guattari's most famous work, the two-volume collaborative writing project entitled *Capitalism and Schizophrenia*, is a sustained exploration of a subjective multiplicity that is suffocated by capital. In the project's second volume, *A Thousand Plateaus*, they go so far as to attack the visual supremacy of faces in themselves. Glossing over the history of the self we have already explored throughout this book, they note how inseparable the face itself is from the rise of Protestantism in Europe, describing the anonymity first laid over the "savages" and "primitives" of other cultures and those alive in pre-Renaissance times — those who "have no face and need none".[1] This is because, they argue:

> The face is not a universal. It is not even that of the white man; it is White Man himself, with his broad white cheeks and the black holes of his eyes. The face is Christ. The face is the typical European, what Ezra Pound called the average sensual man... Not a universal, but *fades totius universi*. Jesus

Christ superstar: he invented the facialization of the entire body and spread it everywhere (the Passion of Joan of Arc, in close-up).[2]

Dürer clearly understood this intuitively in his time, dissembling his own likeness and instead aspiring to become Christ the Redeemer — a new man, the White Man, in an era soon to be defined by individualism, colonialism and European supremacy. But as ever, the face has so many other potentials. "We are certainly not saying that the face, the power of the face, engenders and explains social power", Deleuze and Guattari continue. "*Certain assemblages of power require the production of a face*, others do not".[3] It is in this sense, then, against our many presumptions, that Deleuze and Guattari argue that faces "are not basically individual; they define zones of frequency or probability". A new European society, spreading itself across our vast world, sees its own likeness in abundance, othering those who do not look like they do. It is in this way that faces form "loci of resonance that select the sensed or mental reality and make it conform in advance to a dominant reality".[4]

But Deleuze and Guattari also note how our faces are otherwise empty when we discount the visual regimes that require us to read them in certain ways. Faces are, instead, "abstract machines", they argue, onto which we project certain codes of meaning and understanding, but which are ultimately nothing more than blank walls punctured by black holes. In this way, our faces reflect, engulf and produce sense with a strange autonomy. "The head is included in the body, but the face is not".[5] Instead, the face represents the simultaneous decoding and *overcoding* of the body. Indeed, "there is even something absolutely inhuman about the face";

it represents the "inhuman in human beings", as that which is most susceptible to capture by the stultifying reason of liberal capitalism and its apparatuses of control.[6] What is required, then, is that we get out of our faces altogether, and so, Deleuze and Guattari argue:

> if human beings have a destiny, it is rather to escape the face, to dismantle the face and facializations, to become imperceptible, to become clandestine [through] strange true becomings that get past the wall and get out of the black holes, that make *faciality traits* themselves elude the organization of the face — freckles dashing towards the horizon, hair carried off by the wind, eyes you traverse instead of seeing yourself in or gazing into in those glum face-to-face encounters between signifying subjectivities.[7]

In his 1993 book, *Downcast Eyes*, Martin Jay describes how this anti-faciality is only one aspect of a general hostility towards so-called "ocular-centric discourses" in French philosophy at this time, and his study includes many of the philosophers we have discussed so far — Barthes, Deleuze and Guattari, Foucault, et al. A "great deal of recent French thought in a wide variety of fields", he argues, "is in one way or another imbued with a profound suspicion of vision and its hegemonic role in the modern era".[8] However, this discourse is far from cohesive and systematic. Much like the contemporary chatter that surrounds the moral panic of narcissism, it is instead, Jay writes, "an often unsystematic, sometimes internally contradictory texture of statements, associations, and metaphors that never fully cohere in a rigorous way".[9] Regardless, this discourse has been hugely influential on contemporary thought, but one of the main

problems with this disdain for ocular-centricity — and one that Jay openly admits to jousting with himself — is that, "as any honest geographer will admit, mapmaking cannot escape the bias ... of the mapmaker".[10] (Here Jay echoes Deleuze and Guattari's own assertion that the face is also like a map.[11]) How we understand the faces around us is inextricably caught up with how we understand the significance of our own. In this sense, there is no "view from nowhere" for even the most scrupulously "'detached' observer".[12]

It is as if Jay is recognising the obvious: how can a species so prone to pareidolia — our tendency to see patterns, particularly faces, where there are none — ever imagine itself escaping the face in any meaningful way whatsoever? Faces follow us everywhere. Still, why is it always the face of Christ we see in oddly burnt pieces of toast? What we are truly haunted by are homogenised faces that do not signify a person but an ideological hegemony. What is the solution? In order to overcome a more liberalist pareidolia, are we to simply make ourselves blind? No. Instead, Jay offers up a far more interesting proposition:

> Ocular-*ec*centricity rather than blindness, it might be argued, is the antidote to privileging any one visual order or scopic regime. What we might call the "dialectics of seeing" precludes the reification of scopic regimes. Rather than calling for the exorbitation or enucleation of "the eye", it is better to encourage the multiplication of a thousand eyes, which, like Nietzsche's thousand suns, suggests the openness of human possibilities.[13]

We might further argue that this eccentricity is already within reach for us. The proliferation of photography and

its associated technologies has allowed billions of eyes to emerge, against the often individualising effects of power. Even though "Photography" with a capital-P is still largely confined to certain scopic regimes of aesthetic taste and composition — it is, in more ways than one, an innately conservative medium and creative industry — to cast our net wider to include the multiplicitous and ill-defined tendencies of amateur and vernacular photography, we more readily find a striking breadth of human expressivity and potential in our world of images. Jay continues:

> When "the" story of the eye is understood as a polyphonic — or rather, polyscopic — narrative, we are in less danger of being trapped in an evil empire of the gaze, fixated in a single mirror stage of development, or frozen by the medusan, ontologizing look of the other. Permanently "downcast eyes" are no solution to these and other dangers in visual experience.[14]

This is likewise true of the story of Narcissus, which perfectly encapsulates this dialectics of seeing before moving decisively beyond it. Caught between the gazes of the self and the (self as) other, Narcissus's eventually disruptive synthesis of the two is nothing less than a total transformation of not just the face but the body as a whole, against all of its signifying restrictions. In transforming himself into a daffodil, he becomes what Deleuze and Guattari might call a *body without organs* — a body freed from structural capture and organisation that can fully actualise an unregulated potential. The myth of Narcissus, then, is not a story of self-centredness in this regard but, following Jay, a story of the self's affirmation of its own eccentricity, so often restricted by society's mechanisms of

control. His actions upon the self do not unify it but explode it, turning it into something else — a flower, no less, which blooms in the thousands at the advent of spring. Though he is removed from society in his apparent death, he becomes more at one with nature as a whole.

It was arguably the Marxist-Freudian philosopher Herbert Marcuse who first made the explicit connection between this self-overcoming of the subject captured by ideology and a certain "return to nature" in the twentieth century. But such a return should not be mistaken for a reactionary sentiment; a false "return to tradition". Rather, it is a narcissism that speaks to the ecological concerns of many today, expanding our idea of the world far outside that pre-determined by capitalism.

In his 1955 book, *Eros and Civilisation*, alluding to the positive conception of narcissism we have already explored at length, Marcuse writes:

> beyond all immature autoeroticism, narcissism denotes a fundamental relatedness to reality which may generate a comprehensive existential order. In other words, narcissism may contain the germ of a different reality principle: the libidinal cathexis of the ego (one's own body) may become the source and reservoir for a new libidinal cathexis of the objective world — transforming this world into a new mode of being.[15]

In simpler terms, Marcuse is arguing that any libidinal investment in the self's constitution — our desire to keep living, to live better, happier, etc. — necessarily adapts how the self relates to and interacts with the world around it. If this sounds too simple, too diffuse, too all-encompassing, well, why shouldn't it be so? Psychoanalytically speaking, narcissism

precisely describes a fundamental relationship between self and world; though our sense of self can become maladapted by its mechanisms, we all nonetheless share the same narcissistic foundation. As discussed in this book's introduction, the preservative and conservative side of narcissism can easily manifest itself as a repression of the self, as we gaze at and produce representations of ourselves only to demonstrate our capacity to conform to regimes of seeing and being seen, but it can just as well signal a desire to overcome the self's limiting by the already repressive civilisation that controls it. In this more positive sense of narcissism, the "biological drive" of self-protection instead "becomes a cultural drive" for Marcuse. He continues:

> The pleasure principle reveals its own dialectic. The erotic aim of sustaining the entire body as subject-object of pleasure calls for the continual refinement of the organism, the intensification of its receptivity, the growth of its sensuousness. The aim generates its own projects of realization: the abolition of toil, the amelioration of the environment, the conquest of disease and decay, the creation of luxury.[16]

To return, once again, to our contemporary social justice movements, we can see this sublimation of a biological drive into a cultural drive hard at work in acts of climate protest. Members of Extinction Rebellion or other related groups, such as Just Stop Oil, are often denounced in the media for caring little about the ways their actions disrupt society's day-to-day activities. Their critics insist that these activists should instead act in accordance with society's laws and behavioural norms. But for the protester, it is precisely these norms that

are inherently repressive, in that they insist the "good citizen" walk forward like a somnambulist into a catastrophic future. As a fear for our future on this planet swells, overflowing into a prevailing sense of social catastrophe, what is seen by some as an inherently selfish act can just as easily be seen as an inherently self*less* act also, in that a restrictive sense of a "good" self is sacrificed for the sake of society at large. As Marcuse writes, in pursuing such a process of "continual refinement" and "realisation":

> The opposition between man and nature, subject and object, is overcome. Being is experienced as gratification, which unites man and nature so that the fulfilment of man is at the same time the fulfilment, without violence, of nature. In being spoken to, loved, and cared for, flowers and springs and animals appear as what they are — beautiful, not only for those who address and regard them, but for themselves, "objectively".[17]

It is thus through narcissism that repression can be overcome, allowing action and self-transformation to prevail over their stifling by societal control.

By way of another example, we can turn to the philosophy of Jacques Derrida, whose writings on narcissism concern the medium of photography explicitly. This is particularly apparent in an essay Derrida wrote for Marie-Françoise Plissart's 1985 photobook, *Droit de regards* (translated into English as *Rights of Inspection*), which contains "a hundred pages of black and white photographs, where several women love each other, pursue each other and get lost".[18] Each relationship is photographed as if by a private detective, and whilst we, as viewer-readers, may feel voyeuristic in our inspection of the

Marie-Françoise Plissart, from the series Droits de regard.
Paris: Éditions de Minuit, 1985.

women's lives, we are ultimately made most aware of how
little about their lives it is possible for us to truly know.

It hardly seems like a coincidence that the sense of observation instilled in the viewer by Plissart is like that of a police officer or a CCTV camera or the state more generally. But to truly appreciate these images as works of art, it is necessary, Derrida argues, that we transform the functioning of this "right of inspection". We must renounce "a rigorous irreversibility [that] commands whoever looks, describes, deciphers" to uncover a single and unifying truth.[19] Instead, against a normative scopic regime, which we begin to feel arise from behind our eyes, we must resist the demand to have our interpretations validated from without. If we do not do this, we will miss out on the adventure of photography left open to us, which leaves us with so many provocative and ultimately unanswerable questions — making looking itself a far more explicit form of *creation*, in that the emancipated spectator must create a narrative for themselves that fills in the poetic gaps that are inherent to sequences of still images.

Any act of interpretation is thus transformed into an unavoidable betrayal of a photographer's intent, but we shouldn't fear or renounce our own interpretations in light of this. As Rancière argued, it is precisely their construction that emancipates us. Such a statement may already appear utterly mundane. However, this is not just another way of flippantly saying that all art is subjective. This truism makes trivial the drama of art overall, which may at times illuminate meaning in the world around us, but just as often draws us closer to so much that escapes our grasp. Art is subjective, then, in that, at its best, it is a non-repressive act of communication — and this is particularly true of photography and its poetry of light and darkness, as we have already seen in the works of Friedlander and Guibert. Indeed, for a writer like Yves Bonnefoy, poetry and photography share a great deal in this regard, since each

is so often used "to examine, in a critical or supportive spirit, the ways in which the men or women of our time combat the alienation they undergo".[20]

Derrida insists that we embrace this kind of examination, which is as much our task as viewer-readers as it is the task of the poet-photographer. In fact, he is so adamant about holding open this space of examination and suspending any final resolution to its enquiries that, despite being tasked with writing an introductory essay to the photobook in question, he refuses to share any of his own interpretations of Plissart's photographs. ("You will never know ... all the stories I have told myself while looking at these images", his essay begins.[21])

We may nonetheless experience a deep desire to know the other's intentions, in order to bridge the wound of alienation that confronts us, but such a desire can lead to a misguided attempt to control the other, to "capture the other in effigy".[22] In so doing, we repress our own speculative power, leaving ourselves to passively *consume* photographs, wholly ignoring the emancipatory ways in which we might create our own narratives about them, which are just as valid as those of the photographer or her various subjects. Avoiding this, the repressive viewer instead "mourns ... internalises the other and dresses in black ... takes the other into oneself ... makes it a *part* of oneself". But this, Derrida concludes, "is always the failure of narcissism".[23] It is to see the other in the reflecting pool and entertain the fantasy that we can ever fully internalise such an image. Instead, we must open ourselves up to the mysteries of love on display, transforming ourselves and all norms of seeing so that they include the possibilities of worlds forever unknowable to us.

When we instead embrace our alienation in this way — when we look across the void between sense and non-sense,

between self and other, in search of a shared glance — we find the emergence of a *new* narcissism: the narcissism, Derrida writes, not of "I look", but of "they look at each other".[24] It is a narcissism that demands recognition, but not simply the recognition of one's own self; rather, it affirms the two-way transmission of power that any dialectic of seeing contains. Indeed, it is a dialectical narcissism. Against a repressive narcissism that only affirms the one-way transmission of our powers of observation, Derrida instead affirms how a shared glance can conjure up the power of love.

Without reducing the power of observation to a soft-focus romance, we should explore how love is acutely relevant here — lest we forget the selfie's predominance on dating apps. But this dialectical narcissism far exceeds the restrictions placed upon us by the likes of Tinder; instead, the narcissism of "they look at each other" is that same narcissism that acknowledges how *you*, whom I love, whom I concern myself with, whom I care for, are *not* myself, but I may come to love you with the same intensity as if you were. Indeed, what the viewer-reader finds, in giving themselves over fully to the innumerable and contingent narratives found in Plissart's photographs, is a love of one's view of the world, against a received perspective that can be all too easily validated by control from without. But this love, in being shared and unconsummated, is inherently expansive rather than being another form of enclosure.

It is with this in mind that we can better understand Derrida when he writes:

You can only love yourself. We will not have understood anything about the love of the other, of you, of the other as such, you understand, without a new intelligence of narcissism, a new "patience", a new passion for narcissism.

The right to narcissism must be rehabilitated, it needs time and means. More narcissism. Always more narcissism…[25]

Or perhaps the point here is not to affirm more narcissism in the singular, but rather more *narcissisms* — the constant proliferation of narcissisms; one for every image, one for every self. Sigmund Freud also seemed to think that each of us is privy to a narcissism of our own type, and believed "that another person's narcissism has a great attraction for those who have renounced part of their own narcissism and are in search of object-love".[26] It is a love that we hear about more often than such philosophical or psychoanalytic language might suggest. To engage in this other narcissism is to entangle oneself in another and see that they "bring out the best in you"; that you might love yourself *more* when you love them. It is a love we count as rare when directed towards another, but one made as natural as breathing in the love of one's children. It is an *unconditional* love, which does not simply mean that "I will love you no matter what you do", but, as Deleuze writes, echoing Derrida's challenge to the failure of narcissism, "*to love without being loved*, because love implicates the seizure of these possible worlds in the beloved, worlds that expel me as much as they draw me in".[27]

Again, this is something we intuit in our love of our children most readily. For Freud, the "charm of a child lies in a great extent in his narcissism, his self-contentment and inaccessibility, just as does the charm of certain animals which seem not to concern themselves about us, such as cats and the large beasts of prey".[28] It is a love for those who possess a "narcissistic consistency with which they manage to keep away from their ego anything that might diminish it".[29] So too for Deleuze, who notes how our more common, more

fatalistic and ultimately more negative form of narcissism gives rise to a love that only implores us "*to stop loving*, because the emptying of the worlds, the explication of the beloved, lead the self that loves to its death".[30]

With all this in mind, Derrida's affirmation of narcissism might make more sense to us. Later asked about this assertion in an interview, he adds the following clarification:

> Narcissism! There is not narcissism and non-narcissism; there are narcissisms that are more or less comprehensive, generous, open, extended. What is called non-narcissism is in general but the economy of a much more welcoming, hospitable narcissism, one that is much more open to the experience of the other as other. I believe that without a movement of narcissistic reappropriation, the relation to the other would be absolutely destroyed, it would be destroyed in advance. The relation to the other — even if it remains asymmetrical, open, without possible reappropriation — must trace a movement of reappropriation in the image of oneself for love to be possible, for example. Love is narcissistic. Beyond that, there are little narcissisms, there are big narcissisms, and there is death in the end, which is the limit. Even in the experience — if there is one — of death, narcissism does not abdicate absolutely.[31]

Unfortunately, there is no trace of this abundantly more complicated and gushing narcissism in our discourses today, subsumed as they have been by a cottage industry that thinks otherwise, or perhaps hardly thinks at all, blinkered by the moralising paroxysms of capitalist realism and its straitjacketing of the individual, which forces us to be wholly complacent in our adoption of a more negative and

ultimately question-begging understanding of the term. But there have nonetheless been a small number of more recent critical arguments to the contrary, which attempt to offer up alternatives to this understanding of narcissism today.

For instance, in her 2016 book, *The Selfishness of Others*, Kristin Dombek makes the compelling argument that our obsession with others' selfishness infects us with our own need to strike out on our own — that is, to replicate the examples that we see around us. "When you see someone else entirely concerned with his or her own hotness and not empathizing", she writes, "you do it, too, like passengers on a plane who have to tilt their seats back because the person in front of them did".[32] But rather than believing that this all-too-human trait will be the death of us, we should embrace it and the feelings it provokes within us. This is because even the most derided forms of narcissism cast shadows of a more generative variety. Indeed, Dombek argues that the "selfishness of others" — the ways that others disregard social norms of politeness, civility and reasonableness — conjures up the "feeling of being the animal you are, born of other animals, made of mirroring them"; "of time moving past you; what history feels like"; "the feeling of the center shifting, the knowledge it was never under you".[33]

Other people's narcissism isn't something to fear, then, but a mirror to acknowledge so that we can break it, allowing us to see the true nature of things that we generally cannot face: the reality that we are not simply reasonable individuals of law and order but chaotic beings captured within structures of control — structures that we nonetheless humiliate every day, even in the most mundane of ways. This acknowledgement of our own nascent animality may provoke a speculative kind of nihilism in us, which is not the utter destruction of all

meaning *as such*, but the dismantling of "givens", of "common sense" as an ideological construction. Indeed, it illuminates precisely how models of behaviour are themselves socially constructed. To be narcissistic, as we all supposedly are, is only to acknowledge the frequency of our own trespassing into spaces beyond the bounds of a liberalist reason.

Viewed in this way, our contemporary narcissism — as a folk-psychological concept that has no scientific basis in contemporary understandings of the human mind — becomes nothing more than a cultural invention that keeps this kind of truth hidden from view. In restricting narcissism to a kind of mundanely anti-social behaviour, we repress its broader potentials to challenge and transform the repressive structures of civilisation as a whole, at a time when acquiescence to their norms is transforming us into lemmings walking blindly towards social catastrophe, all in the name of politeness and a repressive sense of reason.

With this in mind, Dombek is right to compare this narcissistic decentring of the self to the feeling of history. To throw off social repression is not a move that can be accomplished overnight, but given the innately temporal injunctions that narcissism — and its primary vehicle in the present, photography — foists upon us, it is not insignificant to acknowledge that time is required for its realisation. This is not to appeal to our own patience, but rather to acknowledge the horror that photography first illuminated for us: that time itself, against all our attempts to administrate its flows, is an oceanic space where all of our restricted potentials might finally be realised.

23. Epilogue

On Thursday 23 February 1989, Derek Jarman walked out into his garden. Completely surrounding his home at Prospect House, he had spent years carefully coaxing a wide array of plants from the otherwise barren shingle beach that engulfs Dungeness, a small and declining fishing village jutting out from England's most south-easterly point. "Brilliant sunshine", he later wrote in his journal, recording the weather that day, with "skies so clear your vision is stretched to the horizon".[1] Spring was in full bloom, and so were Jarman's daffodils.

Dungeness was a little-known wilderness until Jarman made his home there. The barren nature of the headland has popularised a myth, repeated by almost all tourist brochures and travel guides, that it is technically a desert — England's only one. This is not true, but even if it were, like so many deceptively barren landscapes, Dungeness is far from lifeless.[2] It is instead an area of great ecological significance, with the beach home to a variety of shrubs, succulents and other forms of life that are seldom found elsewhere in the UK. It would prove to be a fitting home for Jarman, who was something of a rare creature himself: a queer punk and polymath of international renown. Still, further surrounded by eerily flat plains, military installations, the rot of old industry and a decommissioned nuclear power station, the atmosphere at the hamlet today is nonetheless that of a world-without-us. It is a village that time forgot, a hamlet at the end of the world,

where the regimens of normal life have run aground, leaving you to trip and fall over the tentacles of capitalism's flailing grasp.

That being said, though it may feel like nowhere else within the British Isles, Dungeness is still prone to quintessential turns in the English weather. Jarman's day may have started with brilliant sunshine, but this was later overshadowed by hail. "My poor daffodils", Jarman lamented, "are now beaten to the ground".[3]

The battering of Jarman's daffodils leaves him anxious. It feels like a bad omen. Struggling with declining health and an AIDS diagnosis, the fate of his flowers seems oddly tied to his own. Looking for something to soothe him, he calls his friend, the photographer Matthew Lewis, to

ask him if he would take a photo of a young man holding a daffodil. Last year he took a beautiful portrait of a handsome Italian, stripped to the waist, holding a lemon, the juice of which he used to dissolve heroin to fill his syringe. Narcissus, narcotics, self-absorption: benumbed retreat into self.[4]

A few weeks earlier, Jarman had first noticed his daffodils beginning to appear. "I counted well over 50 buds on the daffodils I planted last year", he writes on 7 February.[5] He was enthralled by their seasonal nature. "Daffodils 'come before the swallows dare and take the winds of March with beauty'", he writes, quoting Shakespeare.[6] However, Jarman also mourns their artificial cultivation by some horticulturalists. "One of the joys our technological civilisation has lost is the excitement with which seasonal flowers and fruits were welcomed; the first daffodil, strawberry or cherry are now things of the past, along with the precious moment of their

arrival".[7] Jarman was not some kind of anarcho-primitivist, however, bemoaning humanity's agricultural development. He greatly appreciated the abundance brought by modernity. Mushrooms, for instance, "once a luxury, are ladled out by the pound ... But the daffodil, if only the daffodil could come with spring again".[8]

What Jarman feared most, perhaps, was a silent spring, when the rhythms of life on this planet would be reduced to a consumerist homogeneity, like so much else today. He despised capitalism's impact on the natural world and its biorhythms in this regard. In a journal entry from 1982, penned whilst visiting California, he writes with disgust of Los Angeles' artificial sprawl, a city where the "sweet dream of capitalism curdles — where the seasons are scrambled".[9] There, time is out of joint, and different flora flourish incongruously alongside each other, regardless of the season. "Palm trees and daffodils".[10]

Many have argued, over the decades, that capitalism's intrusion on nature's circadian rhythms disturbs and corrupts the very thing necessary to our self-overcoming: time. Maurice Blanchot, for instance, in a defence of communism, which he enigmatically defines as our "material search for communication", argues that a new sense of time is essential if we are to fully comprehend the enormity of the task at hand — a task that should now be familiar to us:

> The immensity of the effort that must be made, the necessity of again putting into question all of the values to which we are attached, of returning to a new barbarity in order to break with the polite and camouflaged barbarity that serves as our civilisation, the unknown toward which we direct ourselves — for we absolutely do not know what man

could be — the terrible violence that the inequality in the satisfaction of needs provokes, the enslavement to things, the governance of things, as well as the dialectic proper to technology, the inertia, finally, the fatigue: everything would contribute to putting off the realization of such a movement to the time of reckoning of a dream (or of blood), if the pressure of needs did not represent a force, a reserve of great duration. One could say that the speed of the movement's progression is surprising, but in any case, time is required for it...[11]

Though we might wonder what relevance communism has to all that we have discussed so far (besides being yet another term dogged by negative connotations for so many today), it is arguably only one more name for the event-horizon we have been striving towards. Indeed, it is a political theory relevant to everything discussed thus far, from our entrapment within a Protestant-capitalist individualism to our dreams of a new and unrestricted kind of social relation, which far exceeds the bounds of our communicative-capitalist enclosures.

For Blanchot specifically, his vision of communism is principally focused on a new communality, on a new collective subjectivity, on radical friendships and infinite conversations, on subjective relations that escape the bounds of capitalist utilitarianism, that escape an understanding of life now reduced to a source of energy to be plugged directly into the impersonal machinations of capitalist production. Communism, then, is a name for a political project that demands more of the luxuries and intimacies that capitalism insists we do not have time for. To deny ourselves these things — the activities we confine to our "free time" — is to limit our potentials most brutally.

This is the violence inherent to all capitalist capture, felt most palpably when a person accepts their *thingness*, their *toolness*, their *usefulness* for the system of which they are a part, when the individual "not only breaks off communication with one who is similar or dissimilar to him but breaks off communication with himself", having little sense of the self that they are, at least outside the restrictive context of economic relations.[12] It is this interpersonal sense of alienation, most fundamentally, that communism, as the material search for communication, must first seek to remedy today.

It is for this reason that Blanchot is so hostile towards capitalist time. What interests him instead is time *in itself*, in its "metaphysical nudity" — the peculiarity of *a life-time*; "not only the time that shows itself to human consciousness but the time that is the basis of all consciousness, not time that is expressed in history but time in which history is made".[13] It is a sense of time that questions how much agency we have as capitalist subjects — that which, today, we all are by default. It is a sense of time that asks: what sorts of projects, which might produce a radically new subjectivity, do we really *have time for*? Art and philosophy have produced myriad responses to this contemporary dilemma, but the popular understanding of our ordeal often leads to pessimistic appraisals of our various crises, as if the only response to this suggestion that we take time is to act slowly and see what happens, to be patient, when time is clearly running out. In fact, the reality is far more nuanced.

What Blanchot emphases is the innately tempo-ethical dimension of communism. He suggests that we must *take time* in the sense that we must *seize time* as that mechanism which capitalism reduces and uses to administrate the day-to-day, but also, in a more radical sense, time as the ground of all

creation. We must seize anew the temporality — the speed, the time-signature — of our present moment.

But to what extent is our seizing of time even possible today? Put another way, how is a politics of time possible at all? At the very least, what we need most of all is *an ethics of time*, through which we might broaden the political scope of our philosophies and our self-images. Trapped within the enclosures of capitalist time — wherein time = money — we must reorient ourselves to understand time itself differently — that is, anti-capitalistically.

This is something that Jarman (just like Guibert) actualises through both his green-thumbed activities and a new awareness of what little time he has left. Indeed, after spending any amount of time with his journals, documenting life, death and gardening, it becomes clear that spring was the time of year he treasured most: it allowed him to once again commune with himself, his place in time, his hopes and dreams, his creative endeavours. The arrival of spring flowers, as a harsh coastal winter draws to a close, announces this time to him, with the presence of daffodils in particular being so ubiquitous throughout his life.

Not only were spring flowers Jarman's "first memory", daffodils also reminded him of his parents and their love for one another.[14] A compulsive self-mythologiser, the story of his parents' wedding is retold time and time again throughout his journals. Though stray details change here and there, their wedding photograph is always present, crisp and clear, like a flash of lightning through memory's haze. On 30 March, 1989, he marks their wartime wedding anniversary:

On this day nearly 50 years ago my parents posed for their

wedding photo under a daffodil bell hanging in the lych gate of Holy Trinity, Northwood. The photo, with my father in his RAF uniform and my mother holding a bouquet of carnations, her veil caught in the March breeze — captured the imagination of the press. It appeared in the national newspapers — *hope at a time of encroaching darkness.*[15]

Year on year, daffodils bring hope to Jarman's encroaching darkness too. His journals, though primarily about his art and garden, are haunted by his seropositivity. As the seasons repeat their cycle, his health deteriorates. But daffodils linger regardless, in vases, in childhood memories and in his garden. Their annual reappearance marks another year survived, but also encourages him to keep going too, if only to see the next year's crop.

"The sun came out and I crept along the traffic-jammed streets to St Mary's, glimpses of daffodils in parks and squares", he writes one day. "For a moment I decided to fight back, push the exhausted depression that has clung like the February mist".[16] But on years when spring is late, his impatience is palpable. In 1993, a year before Jarman's death, the entry from 30 February begins: "I'm holding my breath, like the weather, for the first daffodil".[17] Each and every year, they "flare into life to illuminate the spring", as well as Jarman himself.[18]

We would be remiss not to mention Jarman here before this book comes to a close. In many ways, he warrants far more attention than we are to give him here. But what Jarman's example offers us, perhaps even more explicitly than those we have considered thus far, is a narcissism that understands itself not through a self-limiting insularity but rather as a form of eccentric speculation that takes place in a time beyond that restricted by capitalist life. It is a narcissism that emerges

from within the depths of things, allowing us to see not just ourselves but all that flows through, with and around us, even as he grows more aware that the full actualisation of this narcissistic process takes a time that he is to be ultimately denied. It takes the time that writing and photography can only gesture towards, that capitalism can only administrate, but which the self can feel more intuitively, and in a manner prone to creative disorientation, given the right conditions.

Though we might assume Jarman only discovered an appreciation for narcissism at the moment he came face-to-face with his mortality, much like Guibert, it is in fact one of the defining concerns of his whole career. Prior to making his 1986 film *Caravaggio*, for instance, Jarman writes in his journal of his intentions:

> The film will dig and excavate and make no attempt to hold the mirror up to reality. When Caravaggio paints the reflection of Narcissus it is no true reflection but a comment on all vanity and our film should treat his life in a similar way, penetrate the surface.[19]

Here, narcissism once again becomes a tool of the self's undoing. A few years earlier, writing about his plans for his 1981 film, *In the Shadow of the Sun*, we find a similar sentiment: "A third and final image of Narcissus, a mirror which flashes the sun into the camera so that the image explodes and reinvents itself in a most mysterious way".[20]

In a study of Jarman's work, Steven Dillon emphasises further how Narcissus is a near-constant preoccupation in his life and films. He does not find, in the self's encounter with itself as other, the quicksand of self-love and its emotional molasses, but rather an apocalyptic explosion

that destroys worlds. It is for this reason, Dillon writes, that "Jarman reproduces the image of Narcissus throughout his cinematic career, from *Sebastiane* to *Edward II*", but Jarman is nonetheless "wary of the negative reading of Narcissus from the very beginning — that the desire for the same is flawed, egotistical, a kind of self-absorption".[21] Jarman, however, attacks any suggestion that same-sex love provides a stable and conservative homogeneity. He injects back into Paul Näcke's initially homophobic narcissism a vibrant political volatility, emphasising the apparent dangers that queerness poses to the actually existing stasis of heteronormative society.

This is no more true than in Jarman's love of his garden, where the return of his daffodils, those same flowers year on year, do not signify the return of the same but nature's capacity for rebirth and self-renewal. Though they are so instantly recognisable, so familiar, these daffodils are not the same daffodils he has encountered before. They are always simply *this year's* daffodils, which must eventually fade away, only to be reincarnated the following spring. The travesty of capitalism, in its capture of humanity and nature, is that it hopes to perpetuate a kind of "natural" stasis quite to the contrary. Capitalism wants daffodils all year round. It wants to exacerbate stasis by obscuring time's advance. But we cannot live in a perpetual spring, caught in a short and oppressive loop. Flowers must die so that they can bloom again, just like our very selves.

Derek Jarman's garden at the end of the world has thus become a beautiful site of pilgrimage to people everywhere. His former home remains, long after his death, a testament to another way of life, cultivated both in collaboration with and against the natural and capitalist worlds that surround it.

It is fitting, then, that on the outer walls of Jarman's former home, which he shared with his partner Keith Collins, we find the final lines of a 1633 poem by John Donne. The poem, in an irregular meter, expresses two lovers' defiance under the gaze of the rising sun, which hopes to coax them from their bed. "Busy old fool, unruly sun, / Why dost thou thus, / Through windows, and through curtains call on us?" the poem begins. "Must to thy motions lovers' seasons run?" The narcissism of "they look at each other" soon comes to override all other worldly expectations. It is a strange poem for a gardener to immortalise in a space so dependent on the sun for life, but against the heliocentricity of our world, the poem insists that other lives are capable of being lived under its glare regardless. Here the sun's gaze comes to signify more than the personification of nature, but the normative gazes of society at large, which love must always overcome. Why not orient oneself and one's life to a bed shared with a lover, rather than the administrated rhythms of night and day? The poem ends as defiantly as it began:

> Thou, sun, art half as happy as we,
> In that the world's contracted thus.
> Thine age asks ease, and since thy duties be
> To warm the world, that's done in warming us.
> Shine here to us, and thou art everywhere;
> This bed thy center is, these walls, thy sphere.

Love, like time, is eternal. It far exceeds the bounds that capitalist time calcifies in order to contain us. The beauty of flowers, too, lies in their blooming and fading; as much in their promised return and transformation as in their first appearing.

Jarman died on 19 February 1994, likely less than a fortnight before his daffodils were scheduled to bloom once again. Though he may have passed away, missing the rebirth of spring, his flowers outlived him and continue to. His garden may have been one of the last "projects" he embarked on before his death, but his house and garden are still actively maintained today, still strewn with his plants and various sculptures. Long after his death, it is fitting that it has become a memorial so full of life. The narcissism of "they looked at each other" — of lovers, of nature itself — prevails over the singularity of one man's gaze, of society's heteronormativity and its increased hostility to other forms of life. The narcissism of Narcissus cannot be thwarted or moralised away, no matter how we may try to restrict its loving rhythms. Time is not abolished by its denouncement but rather inherited in its affirmation.

* * *

I first visited Jarman's garden in 2018, then once again in 2019. The first time I was there, my girlfriend and her family in tow, I was embarrassed to be struck down by a panic attack, as the eerie landscape felt all the more barren and disconcerting then, relative to the constant activity against which we steeled ourselves in our south-east London home. The silence of the place removed all habitual defences, shunted between world and self. I found it a disturbing place, to say the least. But once this momentary existential crisis had subsided, Jarman's garden soon became one of my favourite places in the world.

Memories of the garden returned to me again and again as I began to write down my inchoate thoughts on narcissism a few years later, whilst living in Huddersfield, West Yorkshire, during the spring of 2021. At that time, I had already written

a book on community and grief, which was published just one week before the UK reluctantly implemented quarantine protocols to tackle the coronavirus pandemic in March 2020. That, too, was a disorientating experience, which played havoc with my mental health. Having garnered some media attention, I felt overly sensitive to any and all criticisms that the book may have received, even in otherwise positive reviews. Stuck inside for months on end, to have this book on community appraised during a period of intense isolation was deeply troubling. Narcissus was in bloom that spring, in more ways than one.

This book was eventually finished at the start of spring in 2023, in Newcastle upon Tyne, one year after first moving to a new city after the end of that long-term relationship. As I moved further and further north, I often thought and felt sad about the fact that Jarman's garden was increasingly out of reach to me. But his journals nonetheless encouraged a new enthusiasm, as I tracked the emergence of each year's daffodils wherever I lay my head.

Though the writing of this book has been repeatedly delayed, coming out long after I thought it would, it feels nonetheless apt to write these final words, after a tumultuous year, when spring is on the cusp of coming again. Time was so necessary to its gestation, and for so much more besides. Indeed, when I first arrived in the north-east of England, I felt torn about my situation and the crossroads at which I found myself. I was as excited to start my life over as I was bereft following the failure of a love for another. I was quite unwell for a number of months that followed, suffering again through a far more acute mental health crisis than I had ever experienced previously, which was less a direct product of the end of my relationship than it was of the more general ways in which life felt totally detached from its habitual moorings.

Throughout it all, this book lingered on the desktop of my laptop, onto which I had uploaded a photograph of some daffodils taken at night, close to my new home, in nearby Iris Brickfield Park. The book changed a great deal then, and though I have done all I can, up until this point, to remove any reference to the self that I am, writing it has been a healing process, and I am left, at the final hurdle, wanting to acknowledge the ways in which it has given me permission to rebirth myself.

As we emerge from the pandemic, with the virus nonetheless still circulating as we return to our communities and a depressingly familiar sense of capitalist normality, I have found myself newly attuned to and reactivated by each new spring. It is only through an awareness of these seasonal transformations that I have been able to throw off the self I was and affirm something new — new modes of expression, new selves, new worlds.

A narcissistic self-concern persists here, nonetheless, but I am all the more aware now of how such a concern cannot rest upon itself. Narcissism does not and cannot stop at its own apparent impasses, but must necessarily push onwards into something greater than itself. And we will all, at one time or another, become overly preoccupied with ourselves in this regard, as we consider how best to move on with our lives, in good times and bad, building new ways of living that are less defined by the poor time of capitalist drudgery that bites persistently at our heels.

But narcissism is not an end in itself, as we so often think. It is only a means. It is a process, defined by the blooming and wilting of selves, which we should not mourn or moralise, just as any gardener, like Jarman himself, must learn that you should never mourn flowers or berate them for their fleeting

lifespans. Though we may cut them, dry them, decorate our lives with them, hoping to hold onto the affectations of spring, anything cleft from its roots will surely fade. But we must remember that spring will always come again.

Matt Colquhoun, Daffodils, Newcastle upon Tyne, 2022.

Notes

Introduction

1. Narcissus Unbound

1 Ovid, *Metamorphoses*, trans. Mary M. Innes. London: Penguin Books, 1955, 87.

2 Pliny the Elder, *The Natural History*, trans. John Bostock. London: Taylor and Francis, 1855. The flower does not even need to be consumed to have this poisonous effect; the cultivated species *Narcissus poeticus*, which is the variety most closely associated with Ovid's tale, is so fragrant that the smell alone can induce headaches and vomiting in enclosed spaces.

3 Ibid.

4 Ibid.

5 Ibid.

6 Most famously, in the UK, this includes the Marie Curie cancer charity, which has been supporting "women suffering from cancer and allied diseases" since the 1930s. See: <https://www.mariecurie.org.uk>

7 Sigmund Freud, "On Narcissism: An Introduction" in: *On Metapsychology: The Theory of Psychoanalysis*, trans. James Strachey, ed. Angela Richards. Harmondsworth: Penguin Books; The Pelican Freud Library, Volume 11, 1984, 75.

8 Freud later produced a more simplified understanding of narcissism. Like so many of his concepts, his relationship to it changed over time and there is arguably no single, unitary definition that can be applied in all instances. For example, in

his later works, particularly *Civilisation and its Discontents*, Freud argues that a collective narcissism is common to many groups and communities. Men, in particular, love to self-satisfy their aggressive instincts by narcissistically presenting themselves as somehow part of a dominant group, he suggests. We could argue this sort of narcissism abounds in everything from nationalism to football hooliganism. But at the same time, even in pointing to such examples, we find ourselves on a slippery slope to moralisation in other instances, dismissing anyone as a narcissist who passionately defends something they enjoy, particularly a certain sense of group or individual identity. This more reductive version of narcissism has a lot to answer for, as it has influenced many of the applications of narcissism common to contemporary discourses, which we shall return to shortly. For now, we might note that a collective narcissism can nonetheless come from a wounded or defiant pride, even in those expressions of the so-called "aggressive instinct" found in sports. I am reminded of an old Millwall pub I used to frequent in southeast London, where the chant on match days was ubiquitous: "*We are Millwall, no one likes us*".

9 Heinz Kohut, *The Analysis of the Self: A Systematic Approach to the Psychoanalytic Treatment of Narcissistic Personality Disorder*. Chicago and London: The University of Chicago Press, 2009, 20.

10 Ibid.

11 Ovid, *Metamorphoses*, 86.

12 Ibid., 87.

2. The Selfie

1 See: Jean Twenge and W. Keith Campbell, *The Narcissism Epidemic: Living in the Age of Entitlement*. New York: Atria Books, 2010.

2 In a recent example of this sort of generic article, published annually to signal our species' general stupidity, Jane Ridley writes for the *New York Post* that narcissism "is alive and well in 2020, even if people put their lives in danger to satisfy their need for attention. A new survey found that 41 percent of us have already risked our safety in pursuit of a selfie, while more than half of us would stand on the edge of a cliff for that ideal photo… Worryingly, more than 1 in 10 (11 percent) have sustained injuries while attempting a selfie. The reported accidents range from falling down hills to falling off bikes and being knocked down by a wave… Last summer, the *Journal of Family Medicine and Primary Care* in India found that 259 people worldwide died in 137 selfie-related accidents between 2011 and 2017, compared to just 50 people killed by sharks". See: Jane Ridley, "More People die taking selfies than in shark attacks", *New York Post*, 14 February 2020: <https://nypost.com/2020/02/14/more-people-die-taking-selfies-than-in-shark-attacks-survey/>

3 @ParisHilton, Twitter post, 19 November 2017: <https://twitter.com/ParisHilton/status/932325973046984712>

4 Jonah Engel Bromwich, "Paris Hilton Said She Invented the Selfie. We Set Out to Find the Truth", *The New York Times*, 20 November 2017: <https://www.nytimes.com/2017/11/20/style/paris-hilton-selfie.html>

5 Ibid.

6 See: Samantha Stark, *The New York Times Presents: Framing Britney Spears*, 2 November 2021: <https://www.nytimes.com/article/framing-britney-spears.html>

7 Mark Fisher, *Ghosts of My Life: Writings on Depression, Hauntology and Lost Futures*. London: Zer0 Books, 2022, 175.

3. Collective Narcissism

1 Aaron Smale, "A collective narcissism", *Newsroom*, 13 June 2020: <https://www.newsroom.co.nz/a-collective-narcissism>

2 Ibid.

3 Shelby Steele, "Black protest has lost its power", *Wall Street Journal*, 12 January 2018: <https://www.wsj.com/articles/black-protest-has-lost-its-power-1515800438>

4 Ibid.

5 For more on the group's research, see: <https://collectivenarcissism.com>

6 Agnieszka Golec de Zavala, "Why collective narcissists are so politically volatile", *aeon*, 12 January 2018: <https://aeon.co/ideas/why-collective-narcissists-are-so-politically-volatile>

7 Rod Dreher, "Racial Protest and 'Collective Narcissism'", *The American Conservative*, 16 January 2018: <https://www.theamericanconservative.com/dreher/racial-protest-collective-narcissism>

8 Frantz Fanon, *Black Skin, White Masks*, trans. Charles Lam Markmann. London: Pluto Press, 1986, 12.

9 Ibid., 23.

10 As Sarah O'Conner writes in an award-winning 2017 article for the *Financial Times*: "The term ['shit life syndrome'] isn't meant to sound dismissive. People with SLS really do have mental or physical health problems, doctors say. But they believe the causes are a tangled mix of economic, social and emotional problems that they — with 10- to 15-minute slots per patient — feel powerless to fix". In this sense, it is a term that tries to address — or, at the very least, validate — the political and material conditions that effect our health, the remedies for which far exceed the institutional role of even a socialised medicine and its related services and institutions.

See: Sarah O'Connor, "Left behind: can anyone save the towns the UK economy forgot?", *Financial Times*, 16 November 2017: <https://www.ft.com/blackpool>

Birth

4. Know Thyself

1 In the *Charmides* dialogue, for instance, which tells of Socrates' encounter with the book's titular other, Plato explains that to know thyself is to know (to borrow from Socrates' own examples) that a doctor of medicine knows more about the treatment of disease than you do, relatively speaking; or that a philosopher knows more about the nature of knowledge itself than you do. But the point for Plato is not to institute a hierarchy of knowledges, between experts and ignoramuses — after all, a doctor and a philosopher will, in turn, know different things to each other. Instead, Plato's philosophy is functionally an education; it is always a dialogue. It is only through dialogue that we can come to know truth. This is not so simply understood as a "personal" or subjective truth, nor is it an adjudicated and hierarchical truth, passed on by elite institutions or a knowledgeable aristocracy. Coming to know truth, for Plato, is more a question of retaining a fidelity to an education that results from an encounter between the self and its other.

5. I, Albrecht Dürer

1 John Berger, *Portraits: John Berger on Artists*, ed. Tom Overton. London and New York: Verso Books, 2017, 56.

2 James Hall, *The Self-Portrait: A Cultural History*. London: Thames & Hudson, 2014, 85.

3 Many art historians have noted an amusing feature of Dürer's 1498 self-portrait, which gives away his relative lack of

experience and developing sense of perspective: his eyes seem to be pointing in two different directions. Having not yet mastered the theories of bodily proportion and representation that he would eventually become well-known for, it seems Dürer was met with a peculiar problem — how to paint each individual eye when both are used simultaneously for observation. It is an interesting predicament to emerge from these first attempts at an objective sense of self-possession, self-depiction and self-knowledge.

4 Berger, *Portraits*, 58.

5 Ibid., 57.

6 *Discourse on Method* is the most common abbreviation of the full and unwieldly title of Descartes' work: *Discourse on the Method of Rightly Conducting One's Reason and of Seeking Truth in the Sciences.*

7 René Descartes, *Discourse on Method* and *Meditations on First Philosophy*, trans. Donald A. Cress. Indianapolis and Cambridge: Hackett Publishing Company, 1998, 18-19.

8 Ibid., 19.

9 Berger, *Portraits*, 59.

10 Ibid., 58.

6. Self Sacrifice

1 The specific painting of the Virgin Mary referenced here — commissioned by the church of Santa Maria della Scala in Rome and later rejected on completion — is today on permanent display in the Louvre. Provocatively titled *Death of the Virgin*, not only is Mary clearly deceased and pallid-looking — we would expect even her corpse to be painted with at least *some* veneration — you can see the soles of her feet as well. Christianity may have since softened its stance on this latter aberration, but showing the soles of your feet or even your shoes

remains a deeply offensive gesture in many Muslim, Hindu and Buddhist cultures.

2 John Berger, *Portraits*, 88.

3 Ibid., 88-89. My emphasis.

4 Catherine Milner, "'Red-blooded Caravaggio killed love rival in bungled castration attempt'", *The Telegraph*, 2 June 2002: <https://www.telegraph.co.uk/news/worldnews/europe/italy/1396127/Red-blooded-Caravaggio-killed-love-rival-in-bungled-castration-attempt.html>

5 Caravaggio's true cause of death has never been confirmed. Some believe he was assassinated by relatives of Tomassoni, or one of the Knights of Malta. This was certainly the dominant rumour at the time. But the painter did not die right away, and so it is thought that Caravaggio may have succumbed to sepsis after a wound sustained in a brawl became infected. Others believe his death was due to some other disease, like malaria or brucellosis. Recent archaeological investigations, following the exhumation and examination of human remains believed to be Caravaggio's, suggest that both his death and his erratic behaviour in life could be explained by lead poisoning, caused by lead salts commonly used in paint at that time. No matter how Caravaggio met his match, he died on the run, never having been pardoned and never having truly faced up to his crimes.

7. Art's Primal Scene

1 The word *tenebroso* means dark or gloomy, and it is often used to refer to paintings that utilise Caravaggio's characteristic sense of light and darkness, obscurity and illumination. The figures in such a scene appear lit, as if under a spotlight, whilst their surroundings are cloaked in darkness. To see such paintings in situ, especially in a church, is breath-taking. Hung in already gloomy alcoves, the figures appear like spectres or holy visions floating in space.

2 Leon Battista Alberti, *On Painting*, trans. Rocco Sinisgalli. Cambridge: Cambridge University Press, 2011, 46.

3 Ibid.

4 Ibid.

5 Immanuel Kant, *Critique of Pure Reason*, trans. Werner S. Pluhar. Indianapolis and Cambridge: Hackett Publishing Company, 1996, 288-289.

6 Contemporary philosophy has since challenged this notion. Quentin Meillassoux, most famously, has taken to terming this insurmountable relation between subject and object "correlationism". Though seemingly commonsensical, Kant's argument that all thought must pass through the senses has been radically challenged by our increased knowledge of the universe. Today, for example, we are able to make claims about the nature of the universe billions of years before "thought" or life as we know it even existed. This does not stop us talking about such things, however. Clearly, we can think about our world and its history beyond the framing of our own being and time, and we remain culturally fascinated by conceptions and representations of our own existence beyond the limits of human cognition. This latter remark will become relevant again when we consider the invention of photography and its expansion of our understanding of scientific observation.

7 Kant, *Critique of Pure Reason*, 107.

8 Ibid., 72-73.

9 See: Susanna Berger, *The Art of Philosophy: Visual Thinking in Europe from the Late Renaissance to the Early Enlightenment*. Princeton: Princeton University Press, 2017.

10 Susanna Berger, "Narcissus to Narcosis", *Art History*, 43:3. London: Association for Art History, 2020.

11 Ibid.

12 John Locke, *An Essay Concerning Human Understanding*, ed. Roger Woolhouse. London: Penguin Books, 1997, 307.

13 Ibid., 312.

8. Art in the Age of Individual Reproduction

1 Reuben Wheeler, *Man, Nature & Art*. Oxford: Pergamon Press, 1968, 58.

2 Ibid., 59.

3 Jacob Burckhardt, *The Civilization of the Renaissance in Italy*, trans. S. G. C. Middlemore. London: Penguin Books, 1990, 103.

4 Ibid.

5 Ibid., 199.

9. Apocalypse Now

1 John Berger, *Portraits*, 59.

2 Erwin Panofsky, *The Life and Art of Albrecht Dürer*. Princeton, NJ: Princeton University Press, 1967, 3.

3 Ibid.

4 Ibid.

5 Ibid., 157.

6 Ibid.

7 Ibid., 158.

8 Ibid.

9 John Berger, *Portraits*, 59-60.

10 Quoted in: Jane Campbell Hutchinson, *Albrecht Dürer: A Biography*. Princeton: Princeton University Press, 1990, 164.

11 Ibid., 164-165

12 Ibid., 63.

13 Ibid., 63-64.

14 Martin Luther, "Admonition to Peace, A Reply to the Twelve Articles of the Peasants of Swabia".

15 Jürgen Müller, "Albrecht Dürer's Peasant Engravings: A Different *Laocoön*, or the Birth of Aesthetic Subversion in the Spirit of the Reformation", *Journal of Historians of Netherlandish Art* 3:1 (Winter 2011).

16 Ibid.

17 Ibid.

18 Jenny Farrell, "Albrecht Dürer — Champion of the Peasants", *Culture Matters*, 15 May 2021: <http://www.culturematters.org.uk/index.php/arts/visual-art/item/3706-albrecht-durer-champion-of-the-peasants>

10. Consciousness Deflated

1 Friedrich Engels, "Significance of the Peasant War" in: *The Peasant War in Germany*: <https://www.marxists.org/archive/marx/works/1850/peasant-war-germany/ch07.htm>

2 Ibid.

3 See: Fredric Jameson, "The Vanishing Mediator; or Max Weber as Storyteller" in: *The Ideologies of Theory*. London and New York: Verso Books, 2008, 309-434.

4 Slavoj Žižek, *For They Know Not What They Do: Enjoyment as a Political Factor*. London and New York: Verso Books, 2002, 182-183.

5 Rothko was famously averse to his artworks being reduced to nothing more than decorations in capitalist spaces. Though culturally Jewish, he grew up with a Marxist father who was "violently anti-religious", or so he claimed. But despite this upbringing, Rothko's paintings were often an expression of the transcendental power of art to free us from drudgery. Indeed, their abstract nature produces affects that resonate with a particular kind of social experience, which both capitalist and religious institutions, over many centuries, have often sought to monopolise. Against this monopolisation, Rothko

attempted to actualise such experiences anew in decisively different contexts. His Seagram murals, for instance, were originally commissioned by the Four Seasons restaurant in New York City. Eventually deciding that the restaurant was not an appropriate location for his paintings, he cancelled the contract and hoped to find a more suitable and permanent home for them. Eventually acquired by the Tate, the Rothko Room in London's Tate Modern remains perhaps its most significant acquisition and display. Against the general hubbub of the gallery-as-tourist-attraction, I often found myself visiting the room as one of the few places to find peace within the capitalist metropolis. Similarly, the Rothko Chapel in Houston, Texas, is an even more fitting space for Rothko's spiritual works. As a non-denomination chapel, it is free of any trace of religious orthodoxy, but nonetheless channels the utility of religious spaces, where the individual can reconnect with some sense of expansive infinity — that is, with society, with nature, with the universe itself. Rothko believed all art must ultimately strive to produce this kind of experience in the viewer, and for the artist themselves to recognise this is a fundamentally political gesture. The difficulty of producing such an experience, however, frustrated him greatly. As he once wrote in his influential essay, "The Romantics were prompted...": "The unfriendliness of society to his activity is difficult for the artist to accept. Yet this very hostility can act as a lever for true liberation. Freed from a false sense of security and community, the artist can abandon his plastic bank-book, just as he has abandoned other forms of security. Both the sense of community and of security depend on the familiar. Free of them, transcendental experiences become possible".

6 Wheeler, *Man, Nature & Art*, 63.
7 Ibid.

8 To return to Rothko's essay, "The Romantics were prompted…", as discussed in a previous footnote, he argues: "The romantics were prompted to seek exotic subjects and to travel to far off places. They failed to realize that, though the transcendental must involve the strange and unfamiliar, not everything strange or unfamiliar is transcendental".

9 Wheeler, *Man, Nature & Art*, 63.

11. The Return of the Gothic

1 Wheeler, *Man, Nature & Art*, 65.

2 Molière, "La Gloire du Val-de-Grâce", *Tout Molière*: <http://www.toutmoliere.net/acte-1,405502.html>

3 Jonathan Greenaway, "Towards A Gothic Marxism I: On Monsters", *The Haunt*, 5 February 2018: <https://thehaunt.blog/2018/02/05/towards-a-gothic-marxism-i-on-monsters/>

4 Many on the right wing of politics regularly denounce the apparent interchangeability of liberalism and neoliberalism by those on the left, as if the two words are deployed as vague slurs without purchase. In response, some may emphasise how each term is representative of a distinct approach to economic policy and governance: "liberalism" represents a belief in free markets and free trade; "neoliberalism" emphasises a strong state. However, any attempt at a static meaning is confounded by colloquial differences and associations across different countries. In the US, for example, the term "liberal" is often used by those on the right to describe those with "progressive" politics in general, whereas in the UK it is most often used by those on the left to more specifically describe those who orbit the centre and take the capitalist foundation of contemporary political life as a given. For the sake of clarity, having already drawn on John Locke's notion of liberalism and how it relates to subjectivity, the reader can rest assured that all uses of

the two terms in this book refer to each political project's shared foundation: the individual. Material conditions have obviously changed a great deal since Locke's time, and so his specific political philosophy has lost relevance over the centuries since. Nevertheless, an unwavering individualism is emboldened anew by the neoliberal project as it emerged in the 1970s. This book's second part will consider more explicitly how this returning sense of the individual has adapted over the years but also how it has started to wane in our contemporary moment, as an inadvertent result of neoliberalism's strange and constant mutations of the self it otherwise holds so dear.

5 Adam Kotsko, *Neoliberalism's Demons: On the Political Theology of Late Capital*. Redwood City, CA: Stanford University Press, 2018.

6 Greenaway, "Towards A Gothic Marxism I".

12. The Rise of the Photographic Self

1 Walter Benjamin, "The Work of Art in the Age of Mechanical Reproduction" in: *Illuminations*, ed. Hannah Arendt, trans. Harry Zorn. London: The Bodley Head, 2015, 213.

Death

13. Death Becomes You

1 Susan Sontag, *On Photography*. London: Penguin Books, 2019, 72.

2 Quoted in: Ibid.

3 Ibid., 75.

4 Ibid.

5 The exact year in which Daguerre's photograph was taken in unconfirmed, but most photographic historians estimate that it was made in either 1838 or 1839. In a demonstration of their

rivalry, Bayard later claimed to have taken photographs of himself a few years earlier, in 1837. If this is true, none of these images have survived.

6 Eugene Thacker, *In the Dust of This Planet*. London: Zer0 Books, 2011, 5.

7 Ibid.

8 Ibid., 6.

9 Félix Nadar, *When I Was a Photographer*, trans. Eduardo Cadava and Liana Theodoratou. Cambridge, Massachusetts: MIT Press, 2015, 4.

10 "Hippolyte Bayard", *The J. Paul Getty Museum*: <https://www.getty.edu/art/collection/artists/1840/hippolyte-bayard-french-1801-1887>

14. Photographic Exits

1 Roland Barthes, "Death of the Author" in: *Image-Music-Text*, trans. Stephen Heath. London: Fontana Press, 1977, 142.

2 Ibid.

3 Michel Foucault, "What Is An Author?" in: *Aesthetics, Method, and Epistemology: Essential Works, 1954-84: Volume Two*, trans. Robert Hurley, et al., ed. James Faubion. London: Penguin Books, 2020, 206.

4 Ibid.

5 Barthes, "Death of the Author", 143.

6 Ibid., 144.

7 Virginia Woolf, *The Waves*. London: Penguin Classics, 2000, 221.

8 Barthes, "Death of the Author", 145.

9 Foucault, "What Is An Author?", 207.

10 Kaelen Wilson-Goldie. "Gillian Wearing Channels a Spiritual History of Photography", *Aperture*, 6 January 2022: <https://aperture.org/editorial/gillian-wearing-channels-a-spiritual-history-of-photography/>

11 Robert Enright, "Gillian Wearing: The Art of Everyday
 Illumination", *Border Crossings*, September 2011: <https://
 bordercrossingsmag.com/article/the-art-of-everyday-
 illumination-gillian-wearing>

12 Jeffrey Berman, *Narcissus and the Novel*. New York: New York
 University Press, 1990, 1.

13 Foucault, "What Is An Author?", 222.

15. The Will to Know Power

1 Michel Foucault, *Discipline and Punish: The Birth of the Prison*,
 trans. Alan Sheridan. London: Penguin Classics, 2020, 201.

2 Gilles Deleuze, "Control and Becoming" in: *Negotiations, 1972-
 1990*, trans. Martin Joughin. New York: Columbia University
 Press, 1995, 174.

3 Foucault, *Discipline and Punish*, 101.

4 Ibid.

5 Ibid., 104.

6 Ibid.

7 Gilles Deleuze, *Difference and Repetition*, trans. Paul Patton.
 London: Continuum, 1994, 268.

8 Gilles Deleuze, "Postscript on Control Societies" in: *Negotiations*,
 178.

9 Ibid.

10 William S. Burroughs, "The Limits of Control" in: *Word Virus:
 The William Burroughs Reader*, eds. James Grauerholz and Ira
 Silverberg. London: Flamingo, 1999, 339.

11 Deleuze, "Postscript on Societies of Control", 178.

12 Deleuze, "Control and Becoming", 175.

13 Ibid.

14 Ibid.

15 Gilles Deleuze and Félix Guattari, *Kafka: Toward a Minor Literature*, trans. Dana Polan. Minneapolis and London: University of Minnesota Press, 1986, 4.

16 Ibid., 10.

16. Gazing Back at the Gaze

1 Laura Mulvey, *Visual and Other Pleasures*. Houndsmill: Palgrave, 1989, 19.

2 Ibid., 14.

3 Ibid., 15.

4 Jacques Rancière, *The Emancipated Spectator*, trans. Gregory Elliott. London and New York: Verso Books, 2021, 2.

5 Guy Debord, *The Society of the Spectacle*, trans. Ken Knabb. London: Rebel Press, 2005, 2.

6 Rancière, *The Emancipated Spectator*, 5.

7 Ibid., 6-7.

8 Ibid.

9 Ibid., 12.

10 Ibid., 13.

11 Ibid., 14.

12 Ibid., 15.

13 Debord, *The Society of the Spectacle*, 29-30.

14 Ibid., 30.

15 We might consider Meghan Markle's more recent critiques of both the paparazzi and the British royal family, for instance. Although Markle is someone who could benefit enormously (at least financially speaking) from the dissolution of her individuality, embracing the performatively servile roles bestowed upon her, she and her husband, Prince Harry, have publicly rejected the dehumanising compromises they are otherwise expected to accept unquestioningly, by taking aim at the institutions that have already captured them. They have

done this by producing podcasts, documentaries and books that critique the spectacle from within. It is as if, although they hold no ultimate hope of removing themselves completely from the public eye, they hope to use their visibility to question and subvert the gaze that reduces them to a particular form of impotent actor, spreading awareness of the various injustices enabled by the spectacle more broadly. Of course, they still remain individuals of immense privilege, and so they are hardly realistic examples to the rest of us. But it is also notable that their privilege and wealth is what allows them to critique those who look at them — something that more marginalised individuals, who can nonetheless find themselves subject to tabloid scrutiny, could never dream of. If their insistent critiques are at all admirable, it is for this reason. Changes to the system will not benefit the rich and powerful alone.

16 Enrico Monacelli offers up a particularly salient alternative to what he calls the "Debord conundrum" in his recent book on lo-fi music and its subcultural pioneers, highlighting the "outsider glam" of R. Stevie Moore as being constituted by the seizing of accessible technologies by someone who did not become a star and then hope to escape, but who rather chose escape from the get-go. See: Enrico Monacelli, *The Great Psychic Outdoors*. London: Repeater Books, 2023.

17 Rancière, *The Emancipated Spectator*, 17.

18 Jodi Dean, *Blog Theory: Feedback and Capture in the Circuits of Drive*. Cambridge: Polity Press, 2010, 74.

19 Ibid., 78.

20 As Dean continues: "This insecurity is not only psychic; it's a reasonable response to struggles that persist in global, reflexive financial and information systems. Most of the economic benefits of neoliberal capitalism — of the new economy celebrated by digital media gurus — follow a power law

distribution. A lucky few will get everything. Most will get very little, almost nothing". Ibid.

21 Ibid., 82.

22 Ibid., 83.

23 Michael Hardt, "Translator's Notes" in: Giorgio Agamben, *The Coming Community*, trans. Michael Hardt. London and Minneapolis: University of Minnesota Press, 1993, 107.

24 Agamben, *The Coming Community*, 1.

25 Ibid., 2.

26 Dean, *Blog Theory*, 86.

27 Many people have written on the invention of the social category of the teenager. After the psychologist G. Stanley Hall proposed a newly coherent definition of "adolescence" at the end of the nineteenth century, "teenagers" were later identified by marketeers in the post-war period as the most important new demographic of consumers. Following its enshrinement in pop culture proper in the 1950s — with James Dean's portrayal of Jim Stark in *Rebel Without a Cause* being the most famous catalyst for this — the teenager has since become a veritable obsession for power the world over. Indeed, we might argue that the very conceptualisation of the "teenager" was a cunning way for control to make this innately indeterminate period of human development into an increasingly visible object of contemplation and target for consumption. Popular culture wants nothing more than to eat its young.

28 Rancière, *The Emancipated Spectator*, 16.

17. Parodying the Gaze

1 Walker Evans, "The Little Screens", *Harper's Bazaar*, presented in facsimile in: Saul Anton, *Lee Friedlander: The Little Screens*. London: Afterall Books, 2015, 7.

2 Anton, *Lee Friedlander: The Little Screens*, 41.

3 Ibid., 44.

4 Ibid., 41.

5 Lee Friedlander, *Self Portrait*. New York: Distributed Art Publishers, in association with Fraenkel Gallery, San Fransisco, unpaginated.

6 Ibid.

7 Ibid.

8 Ibid.

9 Ibid.

10 Anton, *Lee Friedlander: The Little Screens*, 48.

11 John Szarkowski, "The Friedlander Self", in: Lee Friedlander, *Self Portrait*, unpaginated.

12 Ibid.

13 Ibid.

14 Lee Friedlander, quoted in: Nathan Lyons, *Toward a Social Landscape*. New York: Horizon Press, 1966, 7.

15 Anton, *Lee Friedlander: The Little Screens*, 46.

16 Ibid., 47.

17 Ibid., 50.

18 Sigmund Freud, "Instincts and their Vicissitudes", in: *On Metapsychology*, 124.

18. The Beyond-Death Drive

1 Sigmund Freud, "Civilisation and its Discontents" in: *Civilisation, Society and Religion*, trans. James Strachey, ed. Albert Dickson. Harmondsworth: Penguin Books; The Pelican Freud Library, Volume 12, 309-310.

2 Ibid., 310.

3 Ibid., 253.

4 Ibid.

5 Ray Brassier, *Nihil Unbound: Enlightenment and Extinction*. Houndsmill: Palgrave Macmillan, 2007, xi.

19. The Height or Interruption

1 Hervé Guibert, *Ghost Image*, trans. Robert Bononno. Chicago and London: The University of Chicago Press, 2014, 60.

2 Ibid.

3 Ibid., 61.

4 Ibid., 60.

5 Ibid., 61.

6 Ibid.

7 Ibid., 61-62.

8 Ibid., 62.

9 Ibid., 22.

10 Guibert, *To the Friend Who Did Not Save My Life*, trans. Linda Coverdale. South Pasadena: Semiotext(e), 2020, 76.

11 Ryan J. Johnson, *Deleuze, A Stoic*. Edinburgh: Edinburgh University Press, 2022, 6.

12 Jacques Lacan, *Seminar I: Freud's Papers on Technique, 1953-54*, trans. John Forrester. Cambridge: Cambridge University Press, 1988, 221.

13 Johnson, *Deleuze, A Stoic*, 6. To this end, Johnson goes on to note how the etymology of the word "perversion" is a "combination of *per* ('through, thoroughly, exceedingly') + *vertere* ('to turn')", naming perversion as a process of "turning-through such that what is inside is now outside and outside now inside", in a manner perhaps not too dissimilar to Freud's conception of the transformative function of narcissism.

14 Most famously, Foucault wrote and lectured on the plight of "hermaphrodites" — individuals who we might now identify more sensitively as being intersex or transgender — whose gendered indeterminacy has historically been subject to a ruthless juridical administration. In his lectures on the topic, he highlights the legal cases of Marie Le Marcis and Anne Grandjean — two women who chose to live as men and who

were harshly punished for transgressing gender norms in the sixteenth and eighteenth centuries respectively. Marie Le Marcis was "baptized as a girl [but] eventually adopted men's dress"; she was later arrested and sentenced to death "on May 4, 1601, for 'the crime of sodomy.'" Similarly, Anne Grandjean "dressed as a man and married Françoise Lambert", before also later being arrested and "sentenced to the iron collar and banishment for desecrating the marriage tie". See: Michel Foucault, "The Abnormals" in: *Ethics: Subjectivity and Truth — Essential Works of Foucault, 1954-1984: Volume One*, ed. Paul Rabinow, trans. Robert Hurley et al. London: Penguin Books, 2020, 56, footnotes 1 and 2.

15 Deleuze underwent a pneumonectomy in 1968, following a diagnosis of tuberculosis. His respiratory issues persisted for many years regardless, greatly affecting his health and ability to write, to the point that Deleuze's spiralling ill-health eventually led him to defenestrate himself in 1995. Despite how shocking this final act may have been, it is often not emphasised in Deleuze's biography, as is often the case when famous figures die by suicide. Instead, rather than symbolising some great existential struggle, it is often reduced to a footnote, as if it was not an act of depression but rather as a more understandably euthanistic response to his physical incapacitation. Indeed, his death has often been described as a "happy" one.

16 Michel Foucault, "Self Writing" in: *Ethics: Subjectivity and Truth*, 209.

17 Hervé Guibert, *The Mausoleum of Lovers: Journals 1976-1991*, trans. Nathanaël. New York: Nightboat Books, 2014, 325.

18 Ibid., 212.

19 Ibid., 460.

20 Ibid., 454.

21 Ibid., 443.

22 Ibid., 447.

23 Ibid., 350.

24 Ibid., 427.

25 Ibid., 21.

26 Ibid., 178.

27 Ibid., 332.

28 Ibid., 494.

29 Ibid., 387.

30 Ibid., 368.

31 Ibid., 201.

32 Ibid., 401.

33 Ibid., 182.

34 Ibid., 192-193.

35 Judith Butler, *Giving an Account of Oneself.* New York: Fordham University Press, 2005, 23.

36 Guibert, *The Mausoleum of Lovers*, 480.

37 Ibid., 509-510.

20. New Complicities, New Tenderness, New Solidarities

1 Gilles Deleuze, "Life as a Work of Art" in: *Negotiations*, 95.

2 Ibid.

3 Ibid.

4 Ibid.

5 Foucault, "Sexuality and Solitude" in: *Ethics: Subjectivity and Truth*, 176-177.

6 Ibid., 177.

7 Ibid.

8 Ibid., 177-178.

9 Ibid.

10 Andrew Durbin, "Hervé Guibert: Living Without a Vaccine",
 The New York Review of Books, 12 June 2020: <https://www.
 nybooks.com/daily/2020/06/12/herve-guibert-living-without-a-
 vaccine/>

11 Julian Lucas, "When A Virus Becomes A Muse", *The New
 Yorker*, 14 September 2020: <https://www.newyorker.com/
 magazine/2020/09/21/when-a-virus-becomes-a-muse>

12 Guibert, *To the Friend Who Did Not Save My Life*, 35.

13 Ibid., 154.

14 Butler, *Giving an Account of Oneself*, 18.

15 Ibid., 18-19.

16 Steven Bruhm, *Reflecting Narcissus: A Queer Aesthetic*.
 Minneapolis: University of Minnesota Press, 2001, 178.

17 Ibid.

18 Ibid.

19 Butler, *Giving an Account of Oneself*, 20.

20 Kate Zambreno has recently published a beautiful study
 of Guibert's work that focuses on this sentiment explicitly.
 See: Kate Zambreno, *To Write as If Already Dead*. New York:
 Columbia University Press, 2021.

Transformation

21. Narcissism Today

1 Roland Barthes, *The Pleasure of the Text*, trans. Richard Miller.
 New York: Hill and Wang, 1975, 41-42.

22. Escaping the Face

1 Gilles Deleuze and Félix Guattari, *A Thousand Plateaus*, trans.
 Brian Massumi. London and New York: Bloomsbury Academic,
 2013, 206.

2 Ibid. The Latin phrase *fades totius universi*, meaning "the face

of the whole universe", is likely a reference to Baruch Spinoza's *Ethics*, in which he describes our relationship to the universe as like our relationship to the signifying function of the human face in abstract, which, "although varying in infinite ways, remains nonetheless always the same" in thought.

3 Ibid., 205.

4 Ibid., 196.

5 Ibid., 198.

6 Ibid., 199-200.

7 Ibid., 200.

8 Martin Jay, *Downcast Eyes: The Denigration of Vision in Twentieth-Century French Thought*. Berkeley: University of California Press, 1994, 14.

9 Ibid., 16.

10 Ibid., 17-18.

11 "The face is a surface: facial traits, lines, wrinkles; long face, square face; the face is a map, even when it is applied to and wraps a volume, even when it surrounds and borders cavities that are now no more than holes". See: Deleuze and Guattari, *A Thousand Plateaus*, 199.

12 Jay, *Downcast Eyes*, 18.

13 Ibid., 591.

14 Ibid., 592.

15 Herbert Marcuse, *Eros and Civilization: A Philosophical Inquiry into Freud*. Abingdon: Routledge, 1998, 168-169.

16 Ibid., 212.

17 Ibid., 166.

18 "Droit de regards", *Les impressions nouvelles*: <https://lesimpressionsnouvelles.com/catalogue/droit-de-regards/>

19 Jacques Derrida, untitled essay in: Marie-Françoise Plissart. *Droits de regard*. Paris: Éditions de Minuit, 1985, i-ii. All quotations from this text have been translated by the author.

20 Yves Bonnefoy, *Poetry and Photography*, trans. Chris Turner. Calcutta: Seagull Books, 2017, 6.

21 Derrida, in: Plissart, *Droits de regard*, i.

22 Ibid., xiii.

23 Ibid.

24 Ibid., xxviii.

25 Ibid.

26 Freud, "On Narcissism", 82-83.

27 Gilles Deleuze, *Proust and Signs*, trans. Richard Howard. London and New York: Continuum, 2008, 92.

28 Freud, "On Narcissism", 83.

29 Ibid.

30 Deleuze, *Proust and Signs*, 92.

31 Jacques Derrida, "There is No *One* Narcissism" in: *Points... Interviews, 1974-1994*, ed. Elisabeth Weber, trans. Peggy Kamuf et al. Stanford, CA: Stanford University Press, 1995, 199.

32 Kristin Dombek, *The Selfishness of Others: An Essay on the Fear of Narcissism*. New York: Farrah, Straus and Giroux, 2016, 19.

33 Ibid., 134-135.

23. Epilogue

1 Derek Jarman, *Modern Nature*. London: Vintage, 2018, 17.

2 "[T]he suggestion that the Met Office had bestowed Dungeness with the official title of a desert was scotched on Monday. A spokesman said: 'The standard definition of a desert is that it has very little rainfall and that can be for various reasons — such as being in an area of persistent high pressure. Another characteristic is that we see large differences between day and night temperatures. Neither of these apply to areas in the UK.'" See: Aisha Gani, "Dungeness 'desert' estate goes on sale for £1.5m", *The Guardian*,

10 August 2015: <https://www.theguardian.com/uk-news/2015/aug/10/britains-only-desert-goes-on-sale-for-15m-dungeness-estate>

3 Jarman, *Modern Nature*, 18.

4 Ibid.

5 Ibid., 12.

6 Ibid.

7 Ibid.

8 Ibid., 12-13.

9 Derek Jarman, *Dancing Ledge*. Minneapolis: University of Minnesota Press, 2010, 57.

10 Ibid.

11 Maurice Blanchot, "On One Approach to Communism" in: *Friendship*, trans. Elizabeth Rottenberg. Stanford: Stanford University Press, 1997, 94-95.

12 Ibid., 94.

13 Maurice Blanchot, "Time and the Novel" in: *Faux Pas*, trans. Charlotte Mandell. Stanford: Stanford University Press, 2011, 249.

14 Jarman, *Modern Nature*, 7.

15 Ibid., 45.

16 Derek Jarman, *Smiling in Slow Motion*. Minneapolis: University of Minnesota Press, 2011, 302.

17 Ibid., 314.

18 Ibid., 308.

19 Jarman, *Dancing Ledge*, 17.

20 Ibid., 122.

21 Steven Dillon, *Derek Jarman and Lyric Film: The Mirror and the Sea*. Austin: University of Texas Press, 2004, 48.

Acknowledgements

This book is the product of almost a lifetime's preoccupation with photography's relationship to the self. As such, those who warrant acknowledgement and thanks are many.

Firstly, I want to thank my former history and photography teachers respectively: Leanne and Phil Norton — it's over fifteen years late, but here's that essay on Caravaggio and the Italian Renaissance I promised you back at school, for an NVQ qualification that I never saw through to completion... Thank you for developing my enduring fascination with Italy and its art history regardless, and for first taking me to Rome, not once but twice, as a teenager all those years ago. I will never forget seeing my first Caravaggio in situ at the Basilica di Sant'Agostino.

Thanks to the staff at the University of South Wales in Cardiff, past and present, particularly those who were formerly based at the University of Wales, Newport, when that institution still existed. I completed an undergraduate degree in Photographic Art there over a decade ago. Thanks especially to Magali Nougarède, for the introduction to Bayard and the poetry of photography; to Eileen Little, for the introduction to Foucault and Barthes; to Liam Devlin and Ronnie Close, for the introduction to Rancière; to Jason Evans, for first introducing me to Guibert and the joy of photography that persists beyond so much of its melancholic theorisation and capitalist co-optation; and to Peter Bobby and Matt White, for their guidance, support and encouragement in so many

areas. Most of the chapters in this book grew from seeds they each planted in the early 2010s. I want to further acknowledge that, as a result, this book was written with them and their inquisitive students in mind. I hope you and they may get something out of it.

In 2020, during the coronavirus pandemic, I organised a series of reading groups online. One of the texts read was Jodi Dean's *Blog Theory*. I'd like to thank those who signed up to my Patreon and engaged in discussions of this book over several months. I hope these sessions were as informative and inspiring for you as they were for me.

Thanks to Stephen Overy and his students in the philosophy department at Newcastle University, to whom I read aloud this book's introductory chapters in November 2021. Though a fleeting visit, it was inspiring enough that I eventually moved to the city to start my PhD. Thanks also to Humphrey Jordan, who interviewed me for *The Courier*, Newcastle's student newspaper, whose questions allowed me to articulate this book's concluding arguments in inchoate form.

Thanks to Lorenzo Chiesa and the Lacan reading group at Newcastle University, led by Emily Monaghan and Moritz Herrmann, for elucidating the anxiety of Lacan's split subject, which lingered over the final months of this book's gestation.

Thanks to the stewards at the Bidston Observatory Artistic Research Centre in Birkenhead, where a large part of this book was written and beaten into shape (with a little help from a storm named Arwen, which helped enforce a period of studious isolation I was so desperately seeking at that time).

I would also like to acknowledge that some parts of this book and its themes have previously been explored in other places:

I first discussed the return of the Gothic and its impact on subjectivity in an essay entitled "The Will to Deform", published in *Insufficient Armour*, a catalogue produced by Nero Editions in collaboration with Giorgio Di Salvo in 2020. I continue to appreciate the digital bond shared with the Italian "weird theory" contingent.

Parts of this book's second part were drawn from my undergraduate dissertation on the anxiety of photography, submitted to the University of Wales, Newport, in 2013.

I first wrote about Bayard, Friedlander and Guibert in 2018, in an essay entitled "Points of View", published in the ninth volume of the *ŠUM Journal for Contemporary Art Criticism and Theory*. Thanks to the whole Ljubljana crew for their continuing support.

Parts of this book's epilogue first appeared in my 2019 essay, "When Things Take Time", published by Litteraria Pragensia in the essay collection *Speculative Ecologies: Plotting Through the Mesh*.

Thanks to Tariq Goddard and the whole Repeater team for their continued support and encouragement, particularly Carl Neville, Josh Turner and Rhian Jones, whose comments and corrections during the editing process were deeply insightful and invaluable.

Thanks to Dan Taylor, Katie Lionheart, Natasha Eves, Kitty McKay, Ged Ridley, Archie Smith, Sarah Jenkins, Robin Mackay, Amy Ireland, Jon Cornbill, Jade Sweeting, Rosalia Tsikandelova, Victoria Doyle, Kuba Ryniewicz, Sarah Bird, Zoe Waters, Nicky Brignell, Pete Wolfendale, Jacob Parkin, Mark Narayn-Lee, Janina Sabaliauskaite, Jennifer Walton, Bryony Taylor, Kasia Boyle, Islam Al Khatib, Leah Hennessey, Sean Oscar, Corey J White, Siobhan McKeown, Darren Ambrose, Craig and Adam of Acid Horizon, Adam Zmith,

Iceboy Violet, Grafton Tanner, Enrico Monacelli, Liara Roux, Isabel Millar, Ian Chamberlain, Bella Whiteway, Alex Honey, Madeline Hall, and Tristam Adams for conversations that, probably unbeknownst to them, shaped this book in interesting ways.

Repeater Books

is dedicated to the creation of a new reality. The landscape of twenty-first-century arts and letters is faded and inert, riven by fashionable cynicism, egotistical self-reference and a nostalgia for the recent past. Repeater intends to add its voice to those movements that wish to enter history and assert control over its currents, gathering together scattered and isolated voices with those who have already called for an escape from Capitalist Realism. Our desire is to publish in every sphere and genre, combining vigorous dissent and a pragmatic willingness to succeed where messianic abstraction and quiescent co-option have stalled: abstention is not an option: we are alive and we don't agree.